The Social Production of Art

The Social Production of Art

Second Edition

JANET WOLFF

 NEW YORK UNIVERSITY PRESS
Washington Square, New York

Published in the U.S.A. in 1993 by
NEW YORK UNIVERSITY PRESS
Washington Square,
New York, N.Y. 10003

Library of Congress Cataloging-in-Publication Data

Wolff, Janet.
The social production of art / Janet Wolff. —2nd ed.
p. cm.
Includes bibliographical references and index.
ISBN 0–8147–9269–3 — ISBN 0–8147–9270–7 (pbk.)
1. Arts and society. 2. Communication in art. I. Title.
NX180.S6W64 1993
700'.1'03—dc20 93–7703
 CIP

Printed in Hong Kong

In memory of Mary and Rosie Gertler

Contents

Preface to the First Edition

This book is intended as an introduction to some of the central issues in the sociology of the arts, both for students of the arts and for students of sociology. It is not a textbook in the sociology of art, however, and it does not claim to be a comprehensive survey of the major developments and key figures in this field. Instead it pursues a couple of themes which seem to me to be particularly important in the study of culture. The primary focus is on the social nature of the arts, in their production, distribution and reception. A secondary issue which runs through the book is the problem of the author or the artist, and the question of how a sociological approach to the arts can conceptualise individual creativity, without depending on pre-sociological and mystifying notions of artist-as-genius. In some cases, particularly in the later chapters, the primary work I have called on is itself very complex, often obscure, and difficult to understand, and my exposition of it may consequently either remain fairly abstruse or fail to do it justice in attempting to simplify the ideas. However, I have tried to discuss these issues in reasonably simple terms, and to explain and present the material at an introductory level.

I would like to thank Michèle Barrett and Philip Corrigan for their careful reading of an earlier version of this book and their useful suggestions, as well as for the many discussions I have had with them over the past two or three years which have helped me develop my ideas. I would also like to thank Tony Bryant, Ahmed Gurnah, Stuart Hall, Dave Laing, Jim McGuigan and Griselda Pollock for their comments on the earlier draft, and Ruth M. Sweeney for her help in typing the final version. And lastly, I would like to thank Zygmunt Bauman and Bob Towler, both for their comments on this book and for their continued encouragement and support over the past six years.

Leeds
December 1979

Preface to the Second Edition

In preparing a new edition of this book, I decided against editing or re-writing. As I say in the new Afterword, if I were writing a book on this topic now, it would be likely to be rather different, in organisation and in content. It therefore became clear that it would be quite unsatisfactory to try to modify the text in minor ways. Instead, I have reviewed the book, chapter by chapter, in the Afterword, taking into account my own re-thinking on some of these issues as well as work which has been done in cultural studies and the sociology of the arts in the thirteen years since I wrote the book. In particular, I consider changes in academic disciplines (sociology, literary studies, cultural studies) and their implications for the project of a sociology of art; the relevance of post-structuralist theory for an understanding of the author/artist; the current (and, as I argue, mistaken) rejection of the concept of 'ideology'; the question of cultural politics in relation to debates about postmodernism; and the issue of 'identity politics', with regard to gender and ethnicity.

In raising these issues in the Afterword, I am to some extent critically reviewing the original text. Some of these criticisms (including criticisms made by reviewers of the book) raise important questions for a sociology of culture. In the end, though, my re-thinking has not led to a radical revision of the approach I develop here. In the belief that these are still important issues to explore in the project of the sociology of art, and that the Afterword does not negate the text, I leave the text unchanged – except in the sense that a later reading is bound to be different.

Rochester, New York
September 1992

Introduction

Art is a social product. This book attempts to show systematically the various ways in which the arts can adequately be understood only in a sociological perspective. It argues against the romantic and mystical notion of art as the creation of 'genius', transcending existence, society and time, and argues that it is rather the complex construction of a number of real, historical factors. In pursuing this argument, I shall review a number of recent developments in the sociology of the arts, many of which have taken place, for the most part, in isolation from one another. For example, theories of the reception of art, discussed at some length in Chapter 5, have rarely been integrated with theories of artistic production, despite the frequently occurring statement (usually citing Marx's *Grundrisse* in support[1]), that production and consumption must be seen as complementary.[2] I have found it unavoidable, however, that the various aspects of the social production of art should be discussed separately, at least in the first instance, both inasmuch as each chapter represents, and summarises, a particular, more or less self-contained, tradition and approach, and also because I could not see any way of dealing with the disparate arguments at the same time. Nevertheless, it should be borne in mind that the arguments in Chapters 2 and 5 are *not* independent of one another; neither are they in any sense a progressive development. In each case, I take a different starting point, and work towards a demonstration that art and literature have to be seen as historical, situated and produced, and not as descending as divine inspiration to people of innate genius. In the end, a comprehensive sociology of art must integrate

these perspectives, and it will be one of my aims in this book to try to suggest what such an integrated model would look like.

A central theme throughout this book will be the question of creativity, and this will be considered in more detail in Chapter 1. It is worth making a few preliminary comments on the problem here, because it is clear that even approaching the arts from a sociological point of view immediately poses a threat to any traditional notion of 'the artist' or 'the author', whose creative autonomy appears to be reduced to a series of social, economic and ideological co-ordinates. In the following chapter, I begin from the opposition of 'structure' and 'creativity' for two reasons: first, because a sociology of art and culture seems to counterpose these two concepts, or at the very least to hold them in tension; and secondly, because I want to argue that they are in fact *not* in competition, but that a proper understanding of each will expose their mutual interdependence. However, this involves rejecting many current definitions of 'creativity' and working towards a concept which is neither metaphysical nor beyond analysis.

In Chapter 1, I shall argue that it is not useful to think of artistic work as essentially different from other kinds of work, and that, therefore, the issue of the practical activity, including creative or innovative activity, of any agent arises in the same way in *all* areas of social and personal life. Without pre-empting that discussion, what I do want to point out here is the fact that the category of the 'subject' or the 'agent' has recently been seen as somewhat problematic in sociology in general.[3] To some extent, the recognition that it is theoretically inadequate and analytically incorrect to talk uncritically of 'actors' and 'agents' as fundamental, unconstituted, irreducible beings has come from developments in the Marxist theory of ideology, and particularly the work of Althusser and those following him.[4] Some of this work will be discussed in Chapter 6. But it is clear that questions of agency and subjectivity are also being posed as prominent issues in what one might call 'mainstream sociology'; for example, Steven Lukes and Anthony Giddens have both dealt with this topic in recent books.[5] The relationship between individual subjects/actors on the one hand, and social/ideological/economic structures on the other, can no longer be disposed of in the relatively simple way that either a

Weberian or a Durkheimian position proposes. In particular, any humanistic notion of an 'essential' individual, pre-existing social experience (language, interpersonal relations, ideological influence and induction, and the social and material structures underlying all these) must be abandoned. I think this much is widely agreed, although there is plenty of controversy and dispute about *how* individuals are constituted. The most radically anti-humanist positions appear to want to do away with any category of 'subjectivity' or 'agency' (although quite often critics of these positions misrepresent what is actually said, in their passionate defence of the human subject[6]). At the moment, I do not propose to give an account of these arguments, or to adjudicate between them; this question will be raised in Chapter 1 and discussed in more detail in Chapter 6 and in the Conclusion. But the wider relevance of the debate within sociology is important, and will, I believe, enable me to locate what appear to be parochial matters to do with cultural analysis within broader questions of sociological analysis in general. On the one hand, this supports my argument that it is wrong to posit artistic practice as somehow entirely different from any other kind of human practice; on the other hand, the fact that the problem of subjectivity has been posed most forcefully, and most fully elaborated, in the analysis of culture (as well as in feminist theory and the analysis of patriarchy) means that sociology in general can benefit from the work already done in these areas.[7]

Finally, I want to make some preliminary comments about the scope of this study, and about some of the terminology employed. These fall into four separate, though not necessarily independent, themes, namely: (i) what I mean by 'art' and 'the arts' throughout this book; (ii) what I mean by 'sociology' (in view of the multiplicity of sociologies which exist these days); (iii) the relevance of the general discussion here to the crucial question of aesthetic value (including the distinction between 'highbrow' and 'lowbrow' or popular art); and (iv) the problem of sexism in sociology, and of sexual divisions and sexual difference in artistic production in particular.

The concept of 'art'

It will become clear from the references I cite and from the rather eclectic manner in which I draw on work from a variety of sources that I intend my arguments to apply, as far as is possible, to the arts in general; in this sense, I talk about 'art' in its generic meaning. Clearly this will raise problems which would not occur if I restricted this study to literature, or to painting, or to music, and, indeed, most books on the sociology of art to date have focused on one particular area of artistic production.[8] For example, it is obvious that film is a collective product in a way in which novel-writing, on the whole, is not; in my discussion, later on, of the ways in which all the arts are in some sense collective, the important differences between art forms in this respect will therefore have to be made clear. Also, performance arts like music, opera and drama involve levels of social co-operation and mediation between conception and reception which do not apply in the case of most sculpture or literature. So in considering the social co-ordinates of the various arts, it is absolutely essential not to make sweeping generalisations which obscure some crucial differences. However, it is a social fact, so to speak, that we have a generic term 'art' which directs us to class together these diverse enterprises and activities, and if only for that reason it is interesting and alluring for the sociologist to investigate what they have in common. More importantly, perhaps, film, literature, painting and rock music can all, in some sense, be seen as repositories of cultural meaning, or, as it is sometimes put, systems of signification, and I am therefore beginning from the assumption that it will be profitable to approach them as similar in at least this respect. It may turn out that a novel is 'ideological' in quite a different way from, say, a quartet and, as I have said, these differences must not be ignored, nor must inappropriate general-isations be allowed to intrude. Nevertheless, I am arguing for a generic sociology of the arts, sensitive to diversity in art (which is in fact a decreasingly clear-cut matter, since the advent of modernism) and at the same time open to shared and general features. This will inevitably mean some fragmentation in presen-tation in the ensuing chapters, where I turn from a discussion of painting to a discussion of literature, for example. Moreover, my account will in no way claim to be comprehensive (it will certainly not be possible always to discuss each category under every

heading). These problems are unavoidable in any reasonably broad theory, and do not, I hope, detract from the basic arguments I shall want to put forward.

The nature of sociology

One of the best books to appear recently on the social history of art is Nicos Hadjinicolaou's *Art History and Class Struggle*.[9] I will have occasion to refer to this book again later, but I mention it in a particular connection now. There is very little in Hadjinicolaou's account of the history of art and of the ideological nature of painting with which I disagree, and indeed many of the arguments I shall advance have already been made in his book. However, in his dismissal of current dominant approaches to art history he says this:

> In a way one could say that the sociology of art does not exist as an independent discipline, and that what has been done in its name scarcely differs from the ideas of Taine or someone like Jacob Burckhardt. It does not exist because it has no distinct subject-matter. (Hadjinicolaou 1978a, p. 52)

His argument against so-called sociologists of art (he refers to Guyau, Lalo, Tomars, Herbert Read and Pierre Francastel) is that their work does not really differ from art history. While proposing to criticise traditional art history for its lack of attention to the social context of the development of painting, it fails to take the necessary further step of constituting its own distinctive subject matter, which is left as vague and unscientific as it is in art history. More specifically, the sociology of art, arising like sociology in general as a 'concession made by the bourgeoisie' (p. 51) and a 'reaction to the rising working-class movement and its Marxist ideas' (pp. 50–1), usually serves the purpose of burying the 'rôle of social classes and class struggle under an infinite number of different headings' (p. 52). Hadjinicolaou does not dismiss all sociology as 'unscientific', since he believes that whatever its origins it can be transformed into a science. His view is, however, that the sociology of art is still in a pre-scientific stage, since it has not proved the scientific validity of its subject matter. Moreover, once it *has* achieved this, like other branches of sociology which

have done so, it will be a discipline 'belonging to historical materialism' (p. 54.).

It is fairly common to read dismissive comments on sociology, often much less prepared to be conciliatory than that I have quoted, in Marxist texts.[10] I think it is important to be clear about this. Sometimes this is simply a crude rejection of sociology as a 'bourgeois discipline', on the grounds that it is taught in established institutions, or because the writer is ignorant of the variety of sociological approaches which exist, and identifies them all as anti-Marxist. The better critiques make the more specific counterposition of historical materialism to what is (or what certainly was before the 1960s) mainstream sociology, namely structural-functionalism and/or Weberian sociology. In the case of early studies in the sociology of art, there is little doubt that these were often narrowly positivistic, and certainly open to critique and demolition by both Marxists and more sophisticated sociologists.[11] I do not want to defend the more limited types of sociological analysis which seem to me to have been adequately disposed of by several others.[12] My own view is that historical materialism offers the best method of analysis of society at the moment, though it is seriously inadequate in certain respects, and most notably in the analysis of sexual divisions and the oppression of women. To that extent, I think Hadjinicolaou is right when he says that a mature sociology (I am less happy with his use of the Althusserian notion of 'scientific') *is* a part of historical materialism. I do not see why we need to be apologetic or defensive about using the term 'sociology'. It does not necessarily align us with work which goes under the same name which we might consider trivial, or limited or ideological (in the sense of not recognising, or denying, its own particular stance and background interests). Historical materialism *is*, amongst other things, the study of society, and it is with this meaning that I intend the term 'sociology'; my dependence on work with such titles as *Marxism and Literary Criticism*,[13] *The Marxist Theory of Art*,[14] *Criticism and Ideology*,[15] *Marxism and Literature*[16] and *Art History and Class Struggle*[17] makes apparent the kind of sociology I have found to be most adequate in explanatory and analytical power.

The question of aesthetic value

The sociological study of the arts has done a good job in exposing many of the extra-aesthetic elements involved in aesthetic judgement – the values of class,[18] or the influence of political or moral ideals, for example. It has been less successful to date in substituting a new aesthetic, which does not pretend to a false neutrality on non-aesthetic questions. Even the better attempts at this conclude by collapsing artistic merit into political correctness,[19] and where they do not resort to this equation, they retain some aspects of a universal, timeless, aesthetic quality which it is difficult to defend. So let me say at the beginning that this book will not attempt to deal with the question of aesthetic value. I do not know the answer to the problem of 'beauty' or of 'artistic merit', and will only state that I do not believe this is reducible to political and social factors; nor do I believe it consists in some transcendent, non-contingent quality. I hope that this agnosticism does not impair the arguments of this book; I am inclined to think it is not a serious handicap (and in any case I prefer to state it rather than smuggle in such judgements, or collapse distinct discourses in an illegitimate way). But the issue is of relevance in the following way. Understanding art as socially produced necessarily involves illuminating some of the ways in which various forms, genres, styles, etc. come to have value ascribed to them by certain groups in particular contexts. In other words, whether or not Thomas Mann was 'really' a good writer (whatever that would mean), the conditions in which his work was acclaimed as valuable can certainly be investigated, and grounds for such a judgement discovered. This applies too to the vexed question of 'levels' of art – not just 'highbrow' versus 'lowbrow' (Edward Bond versus *Coronation Street*), but also avant-grade as against popular (Carl André or Gauguin), or traditional against new (Alan Ayckbourn and Ibsen, or street threatre), or restricted as opposed to mass reception (a West End play or a televised drama), all of which are different, and cross-cutting, oppositions. Again, without engaging directly with the question of which of these is 'really good art' (and with this variety of examples, I do not think anyone would be prepared to suggest this has anything to do with extent of reception, for example), the following chapters might begin to indicate some of the ways in which these categories and divisions are historically created and sustained.

Sexism in the sociology of art

Sociology is permeated with sexism – in the language it uses, in the body of work which makes up its hundred-year history, and in the areas of analysis it has progressively mapped out as worthy of study.[20] This has increasingly become recognised in the last ten years, and one of the results of this has been an attempt to redress the balance by actually taking the sexual divisions in society as a topic for study.[21] Sociologists have seen that traditional areas, like the sociology of the family, have largely rested on sexist assumptions and now have to be rethought in a different framework.[22] Cultural analysis and the sociology of the arts has been particularly active in exposing sexism both in society and in analysis; this has taken the two forms of analysing images and representations *of* the sexes in art and culture, and of examining the structures which allow differential access to artistic production to men and women.[23] I have the considerable advantage, therefore, of this growing body of work to refer to and depend on. However, it is still the case that a totally non-sexist sociology does not exist. It is not just a question of remembering to write 'he/she' or some equivalent instead of always using the male pronoun, though I believe this is important and not merely a superficial linguistic matter. The point is that insofar as one is *not* primarily interested in enquiring into sexual divisions in society and in the arts, it is very difficult to incorporate feminist insights into analysis consistently. I have already referred to a central weakness in Marxism, and the fact is that in developing a class analysis of society, in which literature is understood as, in some sense, ideological, questions of sexism and patriarchy are necessarily marginalised, to be appended, shelved or ignored. There is a good deal of work being done on socialist–feminist theory[24] and on the ways in which class and sex are systematically related, but no complex model has emerged which combines the two axes of division.[25] At a number of points in this book I shall have occasion to take sexism and sexual divisions as a topic of investigation. However, to the extent that we do not have a Marxist-feminist theory of society, this book fails to provide a Marxist-feminist sociology of art.

Chapter 1

Social Structure and Artistic Creativity

Everything we do is located in, and therefore affected by, social structures. It does not follow from this that in order to be free agents we somehow have to liberate ourselves from social structures and act outside them. On the contrary, the existence of these structures and institutions enables any activity on our part, and this applies equally to acts of conformity and acts of rebellion. One of the themes I shall develop in this chapter is the relationship between social structures and individual action, and I shall argue that all action, including creative or innovative action, arises in the complex conjunction of numerous structural determinants and conditions. Any concept of 'creativity' which denies this is metaphysical, and cannot be sustained. But the corollary of this line of argument is not that human agents are simply programmed robots, or that we need not take account of their biographical, existential or motivational aspects. As I have indicated already, I will try to show how practical activity and creativity are in a mutual relation of interdependence with social structures. The second main argument of this chapter is that in this respect artistic creativity is not different in any relevant way from other forms of creative action.

The 'Tonio Kröger problem'

Georg Lukács talks about the 'Tonio Kröger problem' which runs

throughout the novels of Thoman Mann, from *Tonio Kröger* itself to *Doctor Faustus*.[1] This concerns the dilemma faced by the artist or writer in deciding whether to separate him/herself from life, in order to depict it in fictional form. Kröger expresses it like this:

> The artist must be unhuman, extra-human; he must stand in a queer aloof relationship to our humanity; only so is he in a position, I ought to say only so would he be tempted, to represent it, to present it, to portray it to good effect. The very gift of style of form and expression, is nothing else than this cool and fastidious attitude towards humanity; you might say there has to be this impoverishment and devastation as a preliminary condition . . . It is all up with the artist as soon as he becomes a man and begins to feel. (Mann 1955, p. 152)

The conflict of 'art' and 'life' is portrayed as a tragedy for other Mann heroes, particularly Aschenbach and Leverkuhn. As Lukács sees, however, this dilemma is posed as one which is historically specific, and arises for Mann because of the isolation of the modern artist in capitalist society. 'The time, the present is at every point unconducive to art, to music – how then is it possible to create music of a really high artistic order without breaking free of one's time, without firmly and actively renouncing it?' (Lukács 1965, p. 65). That is, it is not seen as the universal tragedy of the artist, who must escape his/her social and temporal environment in order to create. Often, we do come across this paradox posed as one of the timeless problems for the artist; the artist is seen as outside society, marginal, eccentric, and removed from the usual conditions of ordinary people by virtue of the gift of artistic genius.

The true nature of the artist's isolation

Now there are a number of different positions confused in this kind of statement. In the first place, it has been argued convincingly and interestingly, for example by Terry Eagleton, that writers who *are* for one reason or another marginalised in a particular society may often have an excellent vantage point from which to describe that society.[2] Secondly, the specific conditions of contemporary capitalist society are certainly hostile to artistic production in a way which was not the case, say, in the eighteenth century in

Europe.[3] (Indeed, this was beginning to be apparent in earlier stages of capitalism, and Marx is often cited to this effect.[4]) For both these reasons, it is important to point out the isolation of artists, in comparison both with other kinds of worker in the modern age, and with artists in other societies and earlier centuries in our own society. What is inadmissible is a third view, which holds that it is in the nature of art that its practitioners are not ordinary mortals; that they necessarily work alone, detached from social life and interaction and often in opposition to social values and practices. The artist/author/composer as social outcast, starving in a garret, persists as a common idea of a social type, and one particular form of an historical figure is transformed into a universal definition. It is not difficult to show that this ideology surrounding artistic production is itself the product of a particular period and set of social relations; more specifically, it is a descendant of the nineteenth-century Romantic notion of the artist.[5] Although it is not possible to analyse this in any depth here, what can be said is that there were two crucial historical developments which paved the way for such a notion. The first was the rise of individualism concomitant with the development of industrial capitalism.[6] The second was the actual separation of the artist from any clear social group or class and from any secure form of patronage, as the older system of patronage was overtaken by the dealer-critic system, which left the artist in a precarious position in the market. Before this period, however, artists and writers were well integrated into the social structures in which they worked, painting and writing to commission from aristocratic patrons, exhibiting in Academies, and in no sense defining themselves as outcasts or as opponents of the social order.[7] Some of the conditions of work of such pre-capitalist artists will be discussed in the next chapter. Indeed, even as a contemporary type, this view of the artist is misleading, since it refers to only one particular type of artist – the struggling, self-employed painter, trying to sell his or her work through the dealers and galleries (composers, musicians and writers being in a rather different position, though still often working freelance and hoping to be discovered). This is correct in noting the decline of the secure commission and the reliable patron, but it ignores new forms of patronage and employment for artists, many of whom are indeed integrated, *as* artists, into various branches of capitalist production

and social organisation.[8] In the plastic arts, this would include graphic artists working in industry, designers, artists in advertising, community artists, and so on.

The concept of the artist/author as some kind of asocial being, blessed with genius, waiting for divine inspiration and exempt from all normal rules of social intercourse is therefore very much an ahistorical and limited one. Its kernel of truth lies in the fact that the development of our society *has* marginalised artists (though one would not want to exaggerate the numbers of artists who were patronised and supported in earlier times). The artist is more likely to be alienated and isolated from society and production today than in any earlier period; moreover, the subject-matter of his/her work is necessarily a fragmented and inhuman society. But this does not mean that it is the essence of art to transcend life, and to surpass the real, the social, and even the personal. Tonio Kröger's problem is a quite specific one, which concerns capitalism more than the nature of art.

The nature of artistic production

So far, I have argued that art is not necessarily produced in isolation and in opposition to any social group. I now want to examine the actual nature of artistic production, and compare this with other forms of production. For this discussion it does not matter that artists may well have been marginalised and forced to work alone in modern society, in a way which other workers have not. The issue is that of how they work in general, and of what is particular about artistic work.

Art as manufacture

The myth of divine inspiration was nicely pilloried by Mayakovsky about fifty years ago:

> Our chief and enduring hatred falls on sentimental-critical Philistinism . . . This facile Black Mass is hateful to us because it casts around difficult and important poetical work an atmosphere of sexual trembles and palpitations, in which one believes that only eternal poetry is safe from the dialectical process, and the only method of production is the inspired

throwing back of the head while one waits for the heavenly soul
of poetry to descend on one's bald patch in the form of a dove, a
peacock or an ostrich. (Mayakovsky 1970, pp. 11–12)

Mayakovsky goes on in the rest of this pamphlet, *How are Verses
Made?*, to describe what actually does happen in the writing of
poetry, and discusses in detail how he came to write his poem on
Esenin's suicide. The work emerges as a long and laborious
process of production, using 'tools' (language, techniques and
material equipment, including a pen, pencil, telephone, 'a bicycle
for your trips to the publishers' and 'an umbrella for writing in the
rain'[9]). As well as the internal factors necessary in the construction
of a poem, Mayakovsky also insists on the external stimulus of 'the
presence of a problem in society' with which to deal, and an
understanding of the standpoint of one's class or group.[10]
Mayakovsky, himself an acclaimed poet, talks of this enterprise as
the 'process of poetic production' (p. 21), and sums up:

> Poetry is a manufacture. A very difficult, very complex kind,
> but a manufacture . . . The work of the verse-maker must be
> carried on daily, to perfect his craft, and to lay in poetical
> supplies . . . You mustn't make the manufacturing, the so-
> called technical process, an end in itself. But it *is* this process of
> manufacture that makes the poetic work fit for use. (p. 57)

This is a set of instructions for writing good poetry, which
therefore implies that bad poets do not follow these instructions,
but work unsystematically and uncritically, deriving their ideas
from nowhere in particular, and noting them down on paper
without due attention to the productive process. We can go further
than this, I think, and argue that whether or not the poet, or artist, is
self-consciously aware of the productive process, art is *always*
'manufacture'. The mystification involved in setting artistic work
apart as something different from, and usually superior to, all other
forms of work can be combatted by showing that all forms of work
are (potentially) creative in the same way, and that artistic work,
like other work, loses its quality as 'free, creative activity' under
capitalism. Here I follow closely the arguments of A. S.
Vazquez.[11]

Marx's theory of art

Marx argued that creative practical activity, engaged in transforming the material environment, was one of the major features distinguishing humans from animals.[12] In non-alienated conditions, people have the ability and potential to act, consciously and with the use of abstract thought and imagination, to change nature and their surroundings. This labour, then, is creative; it arises out of human needs and intentions, it is freely exercised on its object and it is constructive and transformative. There are, however, two rather well-worn debates which suggest that this formulation is more controversial than at first appears, both on the level of exegesis (interpreting Marx correctly) and on the level of social-philosophical analysis (whether Marx was right). In the first place, it is a view taken by many Marxist writers that in his later writings Marx abandoned such notions as 'creative labour' and 'practical activity' (or 'praxis'), seeing them to be unscientific abstractions based on a concept of human essence which could not be sustained, and which was, in the end, as metaphysical as that of the Hegelians he was criticising.[13] I do not propose to take up the general question of whether or not 1845 represents an 'epistemological break' in Marx's work,[14] rendering the *1844 Manuscripts* (an 'early work') and *The German Ideology* (a 'work of the break')[15] less worthy of serious attention. Instead, let me point to a section in *Capital* (Volume 1), which I think demonstrates that Marx always retained the view of human labour as essentially creative in this particular sense. This is the famous discussion comparing the bee and the architect, which is often quoted to support an account of Marx's theory of art.[16] The interesting thing about this paragraph, though, is that it isn't about art at all, but about the nature of human labour in general.

> We are positing labour of a form that is exclusively characteristic of *man*. The operations carried out by a spider resemble those of a weaver, and many a human architect is put to shame by the bee in the construction of its wax cells. However, the poorest architect is categorically distinguished from the best of bees by the fact that before he builds a cell in wax, he has built it in his head. The result achieved at the end of a labour process was already present at its commencement, in the *imagination of the worker, in its ideal form*. More than merely working an

alteration in the form of nature, he also *knowingly works his own purposes into* nature; and these purposes are the law determining the ways and means of his activity, so that his will must be adjusted to them. (Marx and Engels, 1973, pp. 53–4)

So the architect is presented as an example of a human worker in general, though possibly an example of the epitome of human creativity.[17] It is quite clear from the context that Marx is not arguing that there is some special distinguishing feature about architectural work, as art, which sets it apart from more mundane tasks; on the contrary, the universal characteristics of all types of work, including artistic work, are emphasised.

Art and work: Vazquez

The second controversial matter concerns the epistemological status of Marx's comments on labour. The argument against following him on this is that the central concept of *homo faber* is taken as a premise, and depends on an unproved (and unprovable) philosophical anthropology, or theory of human nature.[18] In other words, it is not possible to do anything other than *state* that the essence of human beings is to work and create. Alternative theories of human nature might posit instead *homo ludens* or *homo politicus*, for example. This is both a difficult and an extremely important criticism because the historical analysis of specific forms of social organisation and particularly the critique of capitalist modes of organisation of work depend on a basic concept of the possibility of *non*-alienated work and its desirability. It must therefore be more than an arbitrary starting point to claim that a better, more human way of life consists in free, creative labour. I think the primacy of *homo faber* lies in its actual, historical primacy, and not in any a priori theory of human nature. As Vazquez says, following Marx, practical activity was always absolutely essential to existence (for people as well as for animals), and with the development of consciousness, social interaction and power of abstraction from the immediate situation, human activity takes on a uniquely new character:

As a human natural being, man continues to live in the realm of necessity; more precisely, the more human he becomes, the

greater the number of his *human* needs. These needs are either
natural needs (hunger, sex, etc.) that are humanized when
instincts take on a human form, or new needs, created by man
himself in the course of his social development... Under the
imperative of human needs, man ceases to be passive, and
activity becomes essential to his existence. But his activity is not
that of a direct natural being. As a human natural being he is no
longer driven to and cast upon objects... Human needs
characterize man as an active being, and his activity consists of
creating a human world that does not exist by itself, outside of
him. (Vazquez 1973, pp. 60–1)

He goes on to argue that human needs and human creativity or
productivity have an indissoluble relationship: 'Work is the
expression and fundamental condition of human freedom, and its
significance lies only in its relationship to human needs' (p. 61).
So practical activity is the necessary result of human needs (natural
or created), and is 'essential' in this contingent, non-metaphysical
sense; it happens to be the case that people need to eat.
Furthermore, an understanding of the progressive division of
labour, eventually creating groups of people who did not need to
engage in manual labour or direct production, and increasingly
subdividing the tasks performed by those who did, shows that the
possibility of *homo ludens* and *homo politicus* arose much later,
and is not in the same sense 'essential' to humanity.[19]
 I start then with labour, or work, as the basic, necessary human
activity, and also from the statement that insofar as it is not forced,
distorted or alienated, it is a free creative activity. It follows that
there is no immediate reason to distinguish artistic work in this
respect; it shares common ground with all labour, as Vazquez
says, in being a manifestation of the creative nature of men and
women (p. 66): 'The similarity between art and labor thus lies in
their shared relationship to the human essence; that is, they are
both creative activities by means of which man produces objects
that express him, that speak for and about him. Therefore, there
is no radical opposition between art and work' (Vazquez 1973,
p. 63).[20]

The effects of capitalism on art

In the next chapter, I will show how the idea of the artist as an individual creative worker, engaged in some supra-human special task, emerged from the period of the Renaissance. Before that time in Europe, what we refer to as artistic work was performed by people working much more under conditions of other types of worker, and painting, designing and building as artisans and craftsmen, with collective commitment and shared responsibility. Though there were master builders and painters to whom others were apprenticed, they were not yet seen as sole producer and the single genius behind the work. Similarly, the division we generally make between the 'high' arts and the 'lesser' or 'decorative' arts can be traced historically, and linked to the emergence of the idea of 'the artist as genius'. It is difficult to defend the distinction between, say, the painting of an altar-piece and the design of furniture or embroidery on any intrinsic grounds.[21] In other words, artistic activity as a uniquely different kind of work, with a unique, indeed transcendent, product is a mistaken notion based on certain historical developments, and wrongly generalised and taken to be essential to the nature of art.[22]

The dehumanisation of labour

The historical developments concerned are really two. First, the increasing dehumanisation of human labour in general and the erosion of its potentially creative aspect under the division of labour and, particularly, under the relations of production in capitalist society, has obscured the real nature of work by its perverted form.[23] In the *Grundrisse*, Marx talks about the elimination of labour's character of specificity under capitalism, both for worker and for capitalist, and contrasts this with labour of craftsmen and guild-members.[24] Thus, the work done by artists, musicians and writers, not yet affected by or integrated into capitalist relations and the domination of the market, becomes seen as an ideal form of production, because it appears free in a way in which other production is not. The potential similarity of the two areas – art and work – has been lost, as the latter is reduced to its alienated form.

The breakdown of traditional ties

Secondly, artistic production *is* affected by the advance of capitalism, though not initially in the same way as other forms of production. With the disintegration of traditional ties between producer and consumer (Church, patron, Academy) of the arts, particularly in Europe during the nineteenth century, the artist actually is, in certain ways, a free-floating, unattached individual not bound by patron or commission. In this way, the conditions of artistic work are even more sharply contrasted with those of other types of work. It is easy to see, in this context, how the artist comes to be idealised as representative of non-forced and truly expressive activity (overlooking, where necessary, the virtual impossibility in very many cases of actually making a living wage out of such work). In the long run, as Vazquez argues, even artistic work comes under the general law of capitalist production, and becomes regarded as merchandise (p. 86); many artists will work as wage-labourers (in industry and advertising or for the media), and the rest have to resort to the art market to sell their work.[25] The latter will be 'freer' to pursue their own creative inclination than the former, but as Vazquez says:

> The artist is subject to the tastes, preferences, ideas, and aesthetic notions of those who influence the market. Inasmuch as he produces works of art destined for a market that absorbs them, the artist cannot fail to heed the exigencies of this market: they often affect the content as well as the form of a work of art, thus placing limitations on the artist, stifling his creative potential, his individuality. (Vazquez, 1973, p. 84)

Of course, any suggestion that in earlier times artists were totally free to pursue their 'creative potential' without regard to audiences and buyers is quite mistaken, and it may be that in placing most emphasis on the effects of capitalism on art Vazquez implies an incorrect account of the condition of art in pre-capitalist society. But to the extent that artistic work becomes increasingly like work in general under capitalism, it too becomes alienated, unfree labour, in the specific technical sense in which I have used these terms. Even then, the Romantic idea of the artist as one of the few people unaffected by capitalist relations and market constraints persists. A modern variant of it is the common situation of, for

example, painters who teach in art school to make a living, while doing their 'real' work (painting) in their spare time.[26]

The concept of creativity

I have argued that, essentially, artistic work and other practical work are similar activities. All, in the long run, have been affected by the capitalist mode of production and the social and economic relations thereof. For historical reasons, artistic work came to be seen as distinct, and as *really* 'creative', as work in general increasingly lost its character as free, creative labour, and as artists lost their integrated position in society and became marginalised and isolated. In the last section of this chapter, I want to look at the concept of 'creativity' in general, taking it now that what is said will apply to all types of human activity, and not just to the special category of artistic creativity. More particularly, I will consider the question of how it is possible to talk of human acts as 'free' and 'creative', and of how this is compatible with the sociological understanding that all people and all acts are socially located, and that even individuality is constructed in socialisation. It should be noted that in turning from an anthropological to a philosophical discourse, I shall be examining an accordingly different concept of 'creativity'.

The nature of human agency

Variations on the debate about agency and structure have been common in sociological theory for a long time. This has usually been seen as the problem of whether to put the central emphasis on social actors or on social structures.[27] Since on the whole we all believe that both Durkheim and Weber were right – there are social facts, confronting and pre-dating individuals, and social action itself is a primary category of social understanding – the fact that some sort of battle over priority has developed necessarily appears somewhat confusing. In a way, Berger and Luckmann solved the problem neatly, by demonstrating that it is all dialectical: that is, society is constructed, historically, by people and groups of people, and those people themselves have been constructed in and by society (through socialisation and intern-alisation.)[28] Reality is socially constructed, and that reality takes

on an objective character, facing the next generation as an existent fact. But this does not engage with the specific question of the nature of human agency; indeed, in demonstrating that any act is socially determined, it throws into question the notion of free action.

There can be no doubt that any human act is determined. Not only that, but it is multiply determined – by social factors, psychological factors, neurological and chemical factors. A causal account can be given for any one act at a number of levels of explanation. Nor are these levels of explanation in competition with one another, in the sense of only one being right. (It can be argued, however, that some are more comprehensive than others, and thus have better explanatory value.) This issue will come up later in this book, when I discuss the 'determinants' of writing, but let me take it now as an illustration. It can be said that Flaubert wrote the particular novels he did because of his particular social and class position, and his consequent perspective on the France of his period; Lukács' account of Flaubert is along these lines.[29] On the whole, sociological approaches to literature attempt to link novel form and content to social-structural features. But it could also be said that to understand Flaubert's novels adequately, we need to know something about the author himself, including biographical and psychological facts, and this is the direction taken by Sartre in his work on Flaubert.[30] As Sartre says in a much-quoted sentence: 'Valéry is a petit bourgeois intellectual, no doubt about it. But not every petit bourgeois intellectual is Valéry' (Sartre 1963, p. 56). And he is surely right that a more thorough investigation of the creation of an author's work involves not only locating him or her in the appropriate social and historical structures, but also examining the specific personal, familial and biographical influences which turned that person to writing in the first place, and determined the focus of the work. Similarly, there is an abundance of psychological and psychoanalytical accounts of great artists, usually concentrating on the personal at the expense of the broader social features.[31] Apart from the obvious fact that some of these studies – psychological, sociological, or whatever – may actually be bad pieces of work, and therefore wrong, the question does not arise that only one level of analysis is 'appropriate'. There *are* biographical, psychological and social

reasons for most of the things we do, and each level of description is legitimate. (This even applies to the currently popular biological accounts of human behaviour, though I believe these approaches are exceedingly limited in any explanation of human action as well as politically and ideologically suspect in their refusal to recognise the crucial importance of cultural and social factors.)

The true nature of 'freedom'

If human action is free and creative, this quality cannot consist in its somehow escaping from social (and other) determinants, for these apply universally.[32] To put this another way, there is always a multiplicity of causes for anything which happens, including a human act. In the philosophical sense of 'freedom', the Kantian view that freedom and determinism are antinomies, belonging to different spheres of experience or modes of discourse but not actually contraries, is more correct. Today, this could be translated into phenomenological language and freedom recognised as a distinct phenomenological mode. We act under the idea of freedom, and the universality of determinism has no bearing on this existential reality. It could then be objected that freedom is posed as a myth – a kind of false consciousness on the part of actors. Let me make the following points on this:

(1) All actions are 'determined', in the ways I have described.
(2) Some actions are not 'free', for example reflexes, or movements caused by direct external force. (Weber would not, of course, call these strictly 'actions' at all.)
(3) Some actions are not 'free' because they are performed under the threat of violence, or as a result of some other external threat, human or natural (e.g. leaving one's home because of an impending earthquake).
(4) Some actions are not felt to be 'free' by the agents, because they are performed habitually, without the exercise of choice, and/or because of the expectations of one's employers, associates, friends, etc. (These actions Sartre would say are actions 'in bad faith'.)
(5) Some actions are 'free' in that the agent makes a deliberate choice of what to do, and is not in any way constrained. This is

the primary example of a voluntary act. (I will leave aside, for the sake of simplicity, the question of the extent to which choices and wishes are themselves created.)

There are clearly different uses of the word 'free'. I have already ruled out freedom as non-determined activity. I think it most useful to consider as a free action any which falls into categories (3) to (5), regardless of the degree of constraint or pressure put on the agent. What they have in common is the fact that the agent *could* have done otherwise. I am ignoring, therefore, any questions of moral superiority of any type of action over another. For my purposes, human agency in each case is the same kind of thing, and its relation to structural conditions and determinants is my main concern. Because this is a study of the social nature of artistic creativity, moreover, I shall not be interested in psychological or other determinants, but concentrate on the relationship of agency and social structure. The question can now be rephrased: Given the social determination of any human act, what is the nature of (i) human agency in general, (ii) creative human agency, and (iii) creative human agency in art?[33]

The 'duality of structure'

Anthony Giddens has introduced the concept of 'the duality of structure' to indicate that structures are both the product of human agency and the conditions for human agency.[34] He criticises theories of action which ignore the institutional conditions and determinants, but similarly criticises structural theories which give an account of action as completely determined. He argues that it is less misleading to focus on structuration as a process whereby structures are constantly reproduced in social interaction. Sociological theory must be concerned with 'connecting the theory of action to the analysis of the properties of institutional structures' (Giddens 1976, p. 156). Neither institutions nor agents/acts must be taken as primary, and thus the notion of the duality of structures gives the correct and equal emphasis to each. On the question of the nature of agency, the following two of his 'new rules' (the first clearly echoing Marx[35]) are relevant:

The realm of human agency is bounded. Men produce society,

but they do so as historically located actors, and not under conditions of their own choosing. (p. 160)

Structures must not be conceptualized as simply placing constraints upon human agency, but as enabling. This is what I call the *duality of structure*. (p. 161)

That is, the existence of structures and institutions actually enables people to act. For example, language as a structure is a condition for any particular speech (p. 127). There are two problems with this formulation. In the first place, despite the discussion of the rôle of reflexive monitoring in human action (p. 114), and of meaning as 'actively and continually negotiated' (p. 105), it is not made clear either how structures generate meanings or how meanings are involved in, or generate, action. The actual nature of agency as anything other than 'enabled' by structures remains unclear. Secondly, there is no room in this formulation for *innovative* action, or at least its conditions are not indicated. This is important, clearly, for the analysis of artistic work, but also for innovative action in all spheres of social life. The conception of agency as bounded but enabled by structures entails a view of human history in which people produce and reproduce social structures in an endless series of acts, whose only originality can consist in an unusual combination of 'enabling structures' in which they operate. In one particular respect, Giddens's criticism of Parsons (pp. 95–6) applies to this more sophisticated theory of action; though trying to build in 'a conception of the actor as a creative, innovative agent' (p. 95), the system ends by being 'a wholly deterministic one' (p. 96).

However, the solution to this problem as I have argued earlier, is not to counterpose agency to determinism, or to devise an analysis which is in some respect *not* wholly deterministic. Agency *is* wholly determined. In his more recent book, Giddens develops the theory of human agency more fully, and here we get a better idea of what, in its context of structural conditions, agency consists of.[36] The important 'lack of a theory of action in the social sciences' (p. 2) which *New Rules* discussed is central to this later work. One of two major sources of limitation Giddens refers to (which, it must be added, also applies to his own earlier book) is the lack of a *theory of the acting subject*. The second is the failure of theory to

situate action in *time and space*. With the aid of recent developments in post-structuralist theory, he proceeds to present a theory of the acting subject, and an account of the relationship of agency and structure, within the framework of his earlier model (with the notions of 'duality of structure', p. 18, and 'reflexive monitoring of conduct', p. 25). And here the agent, the actual site of the actions taken earlier as more or less unproblematic, is more satisfactorily accounted for.

Theories of the human subject will be one of the topics dealt with in a later chapter (Chapter 6), and I will come back to some of these questions there. I conclude this discussion by making some points about agency, creativity and structure, not in any conclusive analysis, but by way of introduction to what follows.

(1) Human agency is situated in and determined by a complex of structures. (In the chapters which follow, I shall look at the material, social and ideological structures affecting artistic practice.)

(2) Structures enable human practices, by providing the conditions of action and offering choices of action.

(3) Agents are therefore 'free' not in the sense of being *un*-determined, but in their ability to make situated choices and perform situated practices (as well as in an existential sense), and in their conscious and reflexive monitoring of their actions.

(4) However, the concept of 'agent' cannot be left as an unproblematic, empty category, an entity which somehow acts out the interplay of structural influences. The theory of structure and agency needs equally a theory of the human agent or subject, so that the locus of these choices may be considered analytically.[37]

(5) The specific issue of innovative (or 'creative' in this particular narrow sense) practice is not problematic, but can be understood as the practical outcome of a uniquely specific combination of structural determinants and conditions. That is, the originality is not a peculiar quality of the act, but a retrospective judgement on its product or form.

(6) All of these comments refer to artistic practice and creativity in exactly the same way as any other, despite its different product and social position.

(7) Actions which are 'free' in the sense discussed here are not necessarily 'free' in the Marxist sense used earlier in this chapter; that is, in arising from specific historical human needs, and being free from distortion by capitalist relations of production and organisation of work.

The next four chapters of this book will systematically consider the social production of art, and each in turn will move progressively away from the idea of artist-as-creator. I hope to show that the named artist plays much less of a part in the production of the work than our commonsense view of the artist as genius, working with divine inspiration, leads us to believe. I will argue that many other people are involved in producing the work, that social and ideological factors determine or affect the writer/ painter's work, and that audiences and readers play an active and participatory role in creating the finished product. This, of course, increasingly removes the artist from the centre of the stage, and in the following chapter (Chapter 6) I will directly address the question of the artist/author in the light of this de-centring. The discussion in the present chapter was intended as a preliminary discussion of some of the issues in the theoretical paradox of agency:structure. A more conclusive position on this issue, with specific reference to the artist as agent, will have to wait until a later chapter.

Chapter 2

The Social Production of Art

The fundamentally new element in the Renaissance conception of art is the discovery of the concept of genius, and the idea that the work of art is the creation of an autocratic personality, that this personality transcends tradition, theory and rules, even the work itself, is richer and deeper than the work and impossible to express adequately within any objective form . . . The idea of genius as a gift of God, as an inborn and uniquely individual creative force, the doctrine of the personal and exceptional law which the genius is not only permitted to but must follow, the justification of the individuality and wilfulness of the artist of genius – this whole trend of thought first arises in Renaissance society, which, owing to its dynamic nature and permeation with the idea of competition, offers the individual better opportunities than the authoritarian culture of the Middle Ages. (Hauser 1968, p. 61)

Arnold Hauser shows that the social organisation of artistic production before the late fifteenth century is very much along communal lines and based in guild workshops. In the early Renaissance, the work of art is 'not yet the expression of an independent personality, emphasizing his individuality and excluding himself from all extraneous influence' (p. 48). According to Hauser, Michelangelo is the first modern artist in this respect, and in 'the claim independently to shape the whole work from the first stroke to the last and the inability to co-operate with pupils and assistants' (p. 48). The artistic labour process up to the

end of the fifteenth century still took place entirely in collective forms. From that date, the artistic profession began to differentiate itself from craftsmanship, and artists began to become emancipated from the guilds. It has become a commonplace, documented by others since Hauser, to point out that the artist is a relatively modern figure. It is certainly true that the conception of the artist as unique and gifted individual is an historically specific one, and that it dates from the rise of the merchant classes in Italy and France, and from the rise of humanist ideas in philosophy and religious thought. Over the next couple of centuries this concept narrowed and sharpened, and the artist (or writer) was increasingly conceived of as a person with no institutional ties whatsoever. (Even in the seventeenth century it was common, and in no way shameful, to write for commission on political matters, and, moreover, to change one's allegiance without apology.[1])

This chapter will be a study of the social history of art and literature, investigating particularly the variety of processes and institutions involved in the production of art in different periods, and considering the changing rôle of the artist/author. I shall, therefore, show how the artist in the pre-modern period was, as we would see it, severely constrained by political and financial pressures to paint or write in rather narrowly defined ways, and following instruction from patrons and sponsors. Before the modern idea of artist-as-genius, such interference did not appear in the least unacceptable. However, I shall also argue that it has *never* been true, and it is not true today, that the artist has worked in isolation from social and political constraints of a direct or indirect kind. Furthermore, although the formal communal organisation of artistic work has disappeared almost entirely, the idea of the artist as sole originator of a work obscures the fact that art has continued to be a collective product.[2]

Marxist aesthetics and 'art as ideology'

For about the past ten years, there has been a growing dissatisfaction among British literary critics and art historians with the state of their respective disciplines, and in particular a concern to expose what they recognise as the false and ideological assumption that literature and art are 'above' social and political considerations. Earlier writers, like Arnold Hauser and Frederick Antal in

art history, and Arnold Kettle in literary criticism, had already argued the necessity for situating painting and the novel in their social and economic setting in order to attain an adequate understanding and analysis.[3] But these were really isolated voices in the main body of literary and art studies, and it is only more recently that this kind of view has been taken up by large numbers of writers and students, and a considerable body of work informed by this perspective developed. One particularly influential article was published in the *Times Literary Supplement* in May 1974, in which T. J. Clark argues for a return to the nineteenth-century German tradition of art history, which was far more open to situating art in its actual conditions of creativity than is contemporary art history. He insists that the relation of art to ideology must be a central part of any analysis of works of art.[4] Other such injunctions to the art historian have followed.[5] In literary studies there have been similar developments from within the ranks, as it were (as opposed to by infiltration by sociologists wishing to colonise the area). The best known work of this kind is by English scholars like Raymond Williams and Terry Eagleton,[6] but there has also been a proliferation of studies in new journals like *Red Letters* and *Literature and History*[7] with a distinctly sociological/Marxist slant on the literature.[8] Although this tendency is very much in a minority within departments of art history and English literature, there is no doubt that it is growing both in size and volume of work and in influence. It is interesting, though not perhaps surprising, that in this area there is a certain amount of convergence in Britain between people working in traditionally separate disciplines: English literature, art history, sociology and aesthetics.[9] The relatively new, and expanding, discipline of cultural studies is one important manifestation of these developments.[10] The common ground is an interest in investigating the social grounds and social history of the arts.

Now these developments are extremely important, because they begin to show the real nature of art, and to demystify the ideas of our age which maintain the autonomy and universal quality of works of art. They question what is meant by the 'Great Tradition',[11] and expose the social and historical processes involved in its construction, as well as the construction of the belief that it is somehow 'above history' and social divisions and prejudices.[12] The hidden meanings of art are laid bare, and the

particular interests of specific groups which are implicitly served by those meanings becomes clear.[13] This is in no way to devalue the works as masterpieces of painting, sculpture or writing (or at least not in the majority of studies), but it is to point out what other, extra-aesthetic elements intrude into what purport to be purely aesthetic judgements. The origin and reception of works is thus made more comprehensible by reference to social divisions and their economic bases.

But despite the great value of this work, broadly defined as Marxist aesthetics and the sociology of art, it is becoming apparent that it is rather limited, and that it follows one particular direction, leaving unexplored several important areas. Its emphasis is primarily on art-as-ideology. This applies to Eagleton's work on the novels of the Brontës, which examines the situation and consequent world-view of the sisters,[14] as well as to Clark's study of Courbet, which locates the painter in his social and political environment, and 'reads' his paintings in a new way, as the political expression of the urban proletariat, despite the transposition of the subject-matter to a rural setting.[15] And it applies to many of the papers published in *Literature and History*, and collected in the Sociological Review Monograph on *Applied Studies in the Sociology of Literature*.[16] In the following chapter, I will discuss the notion of art-as-ideology, and attempt to show that this is important, but also that one must take care not to employ any crude conception of this ideological identity. Clearly insofar as art *is* ideological (and I shall try to clarify more exactly what this means in that chapter), it is important to say so. It is one vital way in which contemporary work has managed to assist in the progressive demystification of the idea of the artist and of the 'divine creative inspiration'. But the emphasis on this aspect of art and literature has as its corollary a curious lack of interest in institutional factors involved in the production of art, and in the actual processes through which art – and its ideology – are constructed. It is to these processes and institutions that I want to turn in the rest of this chapter.

Media studies in Britain

Having said that there has been a general tendency to ignore institutional factors in artistic production, I must immediately

qualify that in a couple of ways. In the first place, this does not apply to work in media studies in Britain, which has produced an enormous amount of material on the financial, economic and organisational factors involved in the production of, for example, television programmes or the news.[17] This may be to do with the much more clearly collaborative and non-individual production of cultural work in this area, which necessitates the recognition and study of mediating influences and organisational constraints on cultural producers. Whatever the reason, media studies have differed from the Marxist sociological study of art and literature in paying more attention to the very material, and non-ideological, aspects of the social production of art. The study of literature and painting can learn a good deal from this body of work.

Indeed, there are at the moment the beginnings of a critique on these lines, suggesting the need for the broadening of the analytical frame of reference. In his latest book *Criticism and Ideology*, Eagleton proposes a model for the analysis of literary texts, which includes not only reference to ideological components (general, aesthetic and individual-authorial), but also to questions of the mode of production in general, and how this locates and affects artistic production and the mode of literary production in particular (systems of publication and distribution, for example.)[18] The literary product is seen as the complex result of this variety of determining factors, and the ideological is no longer suggested as of sole, or even of primary, importance. And from within media studies, critical comments on recent trends have also been published. In opposition both to the emphasis on the ideological level and to current work on 'representation theory',[19] which, it is thought, hypostatise the ideological and systems of representation and signification to the extent of rendering them totally autonomous from economic and social features, Nicholas Garnham and, in somewhat different terms, Golding and Murdock, have argued for a return to a 'political economy of culture'.[20] In Garnham's case, he particularly suggests we pay attention to the real financial determinants of the content of cultural products – the rôle of multi-national corporations in the control of television companies, and so on.[21] Without limiting the discussion to questions of finance and ownership, I will support the argument that ideological analysis is insufficient if it is not supplemented by an understanding of groups, pressures, hierarchies and power relations within

organisations involved in the general process of the production of culture.

Cultural studies in the USA: the 'production of culture' approach

The second main area where sociologists have been addressing themselves to the processes and institutions of artistic production is in work in this area in the United States. Sociologists of art and culture, in this case with virtually none of the overlap with scholars in the humanities I have shown to be characteristic of work in Britain, have been engaged in developing a very different and parallel tradition of study over about the same period of time. This consists in very detailed, often small-scale, studies of particular art institutions and organisations, to discover the very specific ways in which people like publishers, gallery owners, sound mixers, sponsors for radio and government patrons affect and determine the final product, which is generally taken as unproblematic and simply 'created'.[22] This type of work is sometimes collectively categorised as 'the production of culture' approach, which is in fact the title of two collections of essays.[23] There are, of course, differences within this body of work. For example, Barbara Rosenblum has criticised the majority of these empirical studies for failing to pay attention to 'features of the art object itself',[24] and she argues that simply looking at external aspects like technology and social organisation will not help us understand the social construction of art products. Her own work attempts to link structural processes in the production of photographs to the variety of styles of photograph which are produced. (Eagleton's view that 'aesthetic ideology' is as much a part of a Marxist aesthetics as 'literary mode of production' seems to me to be a similar argument, although he does not argue that the former is a *function* of the latter.) There are other, more serious, criticisms which can be made about the American tradition. In particular, it tends to empiricism, and is usually not interested in locating specific institutions in the wider social context. It is also, usually, ahistorical and its consequent limited and static perspective produces a serious weakness in explanatory power, and an ideological short-sightedness resulting from the lack of a critical sociological perspective. However, I think this kind of work, like a lot of American sociology, is probably written off too quickly by

more theoretically-minded European and British sociologists, for our own tendency to over-theoreticism in this area can to some extent be corrected by looking at this work.[25] In what follows in this chapter, therefore, I shall draw somewhat eclectically from studies in the social history of art and literature, and from studies of contemporary cultural organisations and structures, including recent American work.[26]

The collective production of art

In some cases, it is quite obvious that the production of art is a collaborative affair. For example, although films tend to be known as their directors' product, clearly there is crucial work involved by producers, camera crews, actors, scriptwriters and many others, just at the production stage.[27] The same applies to the production of television programmes.[28] In a rather different way, the performance arts in general are 'collective' products, in the sense that whether they have been composed by Mozart, choreographed by Martha Graham, or written by Brecht, they depend for their realisation on other people: musicians, conductors, dancers, actors and a variety of what Becker calls 'support personnel'.[29] Here, interpretation as well as extra-artistic constraints (how much money can be afforded on designing a set, or what hours a camera crew will work on making a particular programme, or the size and shape of a stage in a particular provincial town[30]) all affect the finished product. But the argument that art is a collective product is broader than this. First, it refers to aspects of cultural production which do not feature in the immediate making of the work, but are necessary preconditions for it – certain technological prerequisites (stroboscopes, electronic equipment, and so on, or even the simple fact of the invention of printing or of oil paint in an earlier time), and particular aesthetic codes or genres, on which a new work will call and which it will, to some extent, even in innovating, employ. Howard Becker provides quite a comprehensive list:

> Think, with respect to any work of art, of all the activities that must be carried on for that work to appear as it finally does. For a symphony orchestra to give a concert, for instance, instruments must have been invented, manufactured and maintained, a

notation must have been devised and music composed using that notation, people must have learned to play the notated notes on the instruments, times and places for rehearsal must have been provided, ads for the concert must have been placed, publicity arranged and tickets sold, and an audience capable of listening to and in some way understanding and responding to the performance must have been recruited. A similar list can be compiled for any of the performing arts. With minor variations (substitute materials for instruments and exhibition for performance), the list applies to the visual and (substituting language and print for materials and publication for exhibition) literary arts. Generally speaking, the necessary activities typically include conceiving the idea for the work, making the necessary physical artifacts, creating a conventional language of expression, training artistic personnel and audiences to use the conventional language to create and experience, and providing the necessary mixture of those ingredients for a particular work or performance. (Becker 1974, pp. 767–8)

Secondly, then, the notion of art as collective applies also to those arts which appear most 'private' and individual. Even writers need materials, need to be literate, benefit from acquaintance with some literary tradition and conventions (though they do not need to be 'trained' in the way ballet dancers or pianists do), and need access to publishers and printers, as well as then being affected by both the book market and (possibly) literary critics. The simple idea of an artistic idea being penned (in whatever form) by an inspired individual, and then available for recognition and consumption by the waiting audience/reader begins to recede into the realm of myth.

In considering the social and institutional co-ordinates of artistic practice it seems best to range rather freely, if somewhat idiosyncratically, over different periods in history and different areas of artistic production, rather than starting from pre-Renaissance painting and working through the period of the Renaissance, the Classical period, the nineteenth century and finally the modern age, or taking separately the analysis of painting, literature, music, and so on. There already exist chronological studies of the social history of art,[31] and particular studies of specific periods in the history of art and of

literature,[32] and what I shall do is to make use of the information contained in some of these works in order to make some general points about the social nature of artistic production in all spheres and all ages (though restricting myself to the Western world). My examples will mainly be taken from literary and artistic (fine art) production, and even then will necessarily be fairly selective. For convenience, I shall discuss these examples under three broad headings: (i) Technology, (ii) Social institutions and (iii) Economic factors. It must be emphasised, however, that there is no clear-cut division between them, and in practice and in the real world it will be seen that economic and institutional constraints and determinants on art may be closely interlinked. The other thing to notice about the following discussion is that the effect on artistic production of the processes and institutions considered may be either direct or indirect. That is, in some cases the artists may adjust their work, and the finished product may be affected, as a result of certain economic or other factors. (For example, certain nineteenth-century novelists tailored their novels to the demands of the circulating libraries and of the journals.[33] Similarly, painting can be affected explicitly by commission and patronage demands, and implicitly by the type of training the artist has received.) Where social influences are indirect, the work itself may not be affected, but the conditions surrounding its production, distribution and reception will still be. (So, for example, the fact that the work of the Impressionists in France in the 1860s was 'discovered' and thus entered 'the History of Art' was in large part due to the emergence of the new dealer-critic system during the nineteenth century, which both took up this officially rejected new work, and connected it with its potential and eager new market of newly rich middle-class buyers.[34] The rôle of publishers, in general, operates in this way, not usually affecting what authors decide to write, but certainly determining which writing is distributed and how widely. Less directly, the activities of critics will often affect the reception and success, and subsequent historical position, of works in the literary, visual and performance arts.) I shall not be particularly interested in this distinction, though, because my main concern will be to show the multiplicity of social factors implicated at every stage in artistic production, whether or not the content of the work is directly affected.

Technology

As Becker has pointed out (above, p. 32), particular instruments need to have been invented before anyone can either compose for them or perform on them. This is the most obvious level at which technology affects the artistic product. The same applies to oil paint, to printing, and to electronic means of communication. Febvre and Martin's study of the invention of moveable type in the fifteenth century, and the change from manuscript to printing, documents in fascinating detail the consequent rise of the book and some of the social changes associated with it.[35] Not just prinitng techniques, but also the use of paper instead of parchment was a necessary technological precondition for the production of printed books; according to the authors, paper was in use in Europe generally by the late fourteenth century, having arrived earlier in Italy, brought from China by Arab merchants, although there was a scarcity in paper until wood replaced rags as a raw material in the nineteenth century.[36] The consequences of printing were, of course, enormous. It meant that students no longer had to employ copiers to copy manuscripts which they needed. It meant that vastly greater numbers of copies of texts could be produced and circulated, and ideas disseminated far more widely, accurately, and speedily. In short, say the authors:

> . . . the printed book was something more than a triumph of technical ingenuity, but was also one of the most potent agents at the disposal of western civilisation in bringing together the scattered ideas of representative thinkers . . . Fresh concepts crossed whole regions of the globe in the very shortest time, wherever language did not deny them access. The book created new habits of thought not only within the small circle of the learned, but far beyond, in the intellectual life of all who used their minds. (Febvre and Martin 1976, pp. 10–11)

In a more recent work, Elizabeth L. Eisenstein also looks at the development of printing, and the effects of the communications revolution which followed in the shift from medieval to early modern times.[37] Her main interest is in changes in methods of data collection and storage, and in communications networks of learned communities in Europe (p. xvi). An important change is the decline of hermeticism and of esoteric knowledge.[38] Eisenstein

also suggests that, parallel to the rise of the artist in the visual arts, there was a shift from artisan to artist with the rise of printing (p. 253). Moreover, the use and development of print, by making possible the growth of literary learning in journals and treatises, enhanced the tendency for individual artists to emerge out of the hitherto collective conditions of guild and workshop production.

> When attempting to account for the changed rôle of artists during the Renaissance, it is not enough to point to humanist antagonism to graduate faculties or to the recovery of texts showing that artists were esteemed in antiquity or to parvenu patrons who invested in beautiful objects to satisfy various needs. The position of artist and the nature of his products were fundamentally changed by the shift from script to print. (p. 254)

The two-volume book goes on to look in detail at the specific effects of print on the revival of classicism in Italy in the later Renaissance, the rise of Protestantism in Germany, and the transformation of natural science, in more than 700 pages which I do not propose to summarise or evaluate here.[39] In general, Eisenstein's thesis is that the shift from script to print brought about profound cultural and intellectual transformations in Europe, affecting the content of knowledge, its dissemination, and the social organisation of scholars, artists and others involved in intellectual life.[40] She has some harsh words for the type of approach which attempts to relate intellectual and cultural change to social and economic transformation in any simplistic way, without proper examination of the actual technological realities involved in this transformation, a criticism which I think can fairly be levelled at some of the theories of ideology which will be referred to in the next chapter.

> Attempts to relate ideas to social action, to link the Marxist 'superstructure' to actual modes of production, or to develop a 'sociology of knowledge' are likely to produce strained and awkward solutions when the communications revolution is not taken into account. Most speculation about mind and society or mentalities and material conditions seems premature and excessively abstract. Before theorizing in general about these issues, should we not consider more concretely how specific

forms of book learning may be related to specific techniques for producing and distributing books? (p. 25)

The invention of print had an enormous impact on cultural and intellectual life and on social relations. At a later period, in the early decades of the nineteenth century, another technological revolution in print had wide and important social implications. This was the use of iron-frame presses instead of the wooden printing press, producing more than double the number of impressions per hour.[41] Together with the growth in literacy in that period, this meant both a rapid expansion in the reading public and an equally rapid expansion in the literature produced. The new popular literature of ballad sheets, periodicals and newspapers, religious and political tracts and, later in the century, cheap books, can be directly related to developments in printing techniques.[42]

I have only considered the technology of print in this section, and of course it is not possible to generalise about the equivalent impact of technological inventions in other areas without examining the nature and conditions of those events.[43] However the work of Febvre, Eisenstein and James[44] shows how, at least in one particular area, technology affects the nature and spread of ideas. Insofar as science was affected in general by the accessibility of methods of printing, the work of any one scientist was similarly affected; he or she had access to a wide range of collective knowledge and was, also, accountable to a newly created and perhaps international body of peers. New rules and methods of argument and demonstration had to be followed. For the painter, too, the advent of printing and of the book was important, as Eisenstein argues, in contributing to the setting up of a learned trade and profession, with accompanying discourses and journals and the founding of the Academies. All these things applied equally to writers, with the additional fact of new audiences reached by the multiplication of texts.[45] Writing for new audiences inevitably meant the growth of new kinds of literature; Ian Watt, for example, has maintained that the rise of the novel in the eighteenth century, with its characteristic focus on private experience, love and individualism, is closely related to the growth of the new middle class, particularly the newly leisured group of middle-class wives, with time to read.[46] Potential audiences produced specific types of writing.

However, although Watt mentions the rôle of print rather briefly, pointing out that 'the novel is perhaps the only literary genre which is essentially connected with the medium of print' (p. 223), it is important to see that his account of the rise of the novel is *not* in terms of technological change. The growth of a reading public, as a social and economic historical phenomenon, is seen as the fundamental transformation influential in this literary innovation. (Indeed, it would be rather difficult to cite any particular technological change which might have been relevant in the eighteenth century, in order to counter his thesis with a claim for the primacy of technology.) Even in the case of the expansion of the reading public a century later, James (cited above) clearly refuses to reduce the expansion of literacy to the technological innovations, which he appears to see as independently determinant of the growth of certain types of literary product. Altick takes this further in the opposite direction: 'Everybody knows that in the nineteenth century the number of English readers, and *therefore* the productions of the press, multiplied spectacularly' (Altick 1957, p. 1. Emphasis added).

He seems to see various technological innovations (like the high-speed Hoe press, techniques for the reproduction of photographs and illustrations, and typesetting machines for newspapers) as a *response* to the demands of the reading public (pp. 306–7). Febvre and Martin, too, in considering the rise of the book, point out that a new reading public *preceded* the invention of print. From the late thirteenth century, they say, the new bourgeois class, particularly lawyers and merchants, constituted such a public, needing better methods of reproduction of written works than scribes and illuminators could produce (pp. 22–8). However, although theirs is by no means an argument for technological determinism, their central emphasis on the relatively autonomous development of the printing and spread of the book on the whole indicates a refusal to collapse the history of the book into either technological or social determinism. This is so, despite occasional apparent lapses in one direction or another. For example, sociological determinism is implied in the following: 'At the beginning of the 19th century, in order to satisfy the new needs for information and education, more books, administrative publications and, soon, newspapers were required and consequently

more paper had to be produced. Here lay the reason behind the mechanisation of the book and paper trades' (p. 44).

In general, the authors are content with more or less agnostic and non-reductionist formulations, like: 'All things considered, the work of copyists and scriveners paved the way for the printers. On the eve of the appearance of the first printed texts a growing demand for books was obvious, particularly among the emergent social classes . . .' (p. 28).

In discussing the development of television, Raymond Williams opposes the idea of technological determinism (that is, the view that scientific and technological developments take place as a result of the internal expansion of an area of study and research, producing inventions and equipment without reference to, or dependence on, outside factors, such as economic or social demands or constraints), and offers a different kind of interpretation:[47]

> It is especially a characteristic of the communications systems that *all were foreseen – not in a utopian but in technical ways – before the crucial components of the developed systems had been discovered and refined.* In no way is this a history of communications systems creating a new society or new social conditions. The decisive and earlier transformation of industrial production, and its new social forms, which had grown out of a long history of capital accumulation and working technical improvements, created new needs but also new possibilities, and the communications systems, down to television, were their intrinsic outcome. (Williams 1974, p. 19. Emphasis in original)

This concerns a particular historical period, of course, and is not necessarily a general pronouncement about the relationship between scientific advance and social conditions. But it is always as well to keep an open mind to the interplay of these (and other) factors. What is certainly true is that technological and scientific discoveries never take place in a social vacuum. They may not be intended to meet a social need, in any obvious and direct manner, and they may indeed be the cause of important and far-reaching social transformations. But there is every likelihood, for example, that the direction of scientific inquiry is motivated, in complex

ways, by social issues and the needs of particular groups in some position of power; and it is more than likely that incipient discoveries can be capitalised on in entirely different ways in different cultures, as Eisenstein suggests was the case with the printing press in China and Korea (Eisenstein 1979, pp. 702–3). In general, she argues, we must recognise the importance of institutional context when considering technological innovation (p. 703). One of her concluding formulations, while insisting squarely on the independently determining effects of print, allows exactly the kind of openness and sensitivity to the interaction of technology with other forces which, following Williams, I am recommending:

> Yet the fact remains that once presses were established in numerous European towns, the transforming powers of print did begin to take effect. The new shops themselves interacted with the urban élites who received them in a manner that produced occupational mutations and intellectual regroupment. Here again, one may agree that even when acting as agents of change, early printers could be effective only in combination with other forces. Indeed, the very fact that they functioned as catalysts and as coordinators was of special significance. However much one may wish to stress reciprocal interaction and avoid a simplistic 'impact' model, one must leave room for the special features which distinguish the advent of printing from other innovations. (p. 703)

Social institutions

In the production of art, social institutions affect, amongst other things, *who* becomes an artist, *how* they become an artist, how they are then able to *practise* their art, and how they can ensure that their work is produced, performed, and *made available* to a public. Furthermore, judgements and evaluations of works and schools of art, determining their subsequent place in literary and art history, are not simply individual and 'purely aesthetic' decisions, but socially enabled and socially constructed events. (One of the best examples of this is the rise of the rôle of the art critic in the nineteenth century, and the peculiar, and novel, power of John Ruskin in making or breaking the career and reputation of an

artist.[48] The Pre-Raphaelites and Turner were amongst those who owed a great deal to his support in the art journals of the period.) This can be considered under the headings of: (i) Recruitment and training of artists; (ii) Patronage systems, or their equivalent; (iii) Mediators, or 'gatekeepers',[49] although it is not always as clear-cut as this. For example, when, in the nineteenth century, the dealer-critic system took over from earlier forms of artistic patronage, it was probably more a case of mediators replacing patrons than of new types of patron emerging. In any case, I shall look at selected examples of these agencies and institutions under these headings. (In doing so, I should point out that I am no longer talking about the kind of 'social production' of art with which Becker is concerned – that is, the way in which a variety of personnel is actually involved in the production of a work itself. I now take the act of painting or writing or whatever as unproblematic, although, as I indicated earlier in this chapter, I do not believe it necessarily *is*, particularly in the case of the more complex forms of art, like film, television and the performance arts in general. The process of production itself, I have already accepted, is often a collective process, belying any simple ideas of 'authorship'. Here, however, I am looking at processes and conditions behind and beyond that particular one; the conditions which made the production possible, and those which determine its subsequent course.)

Recruitment and training of artists The manner in which people become artists is and always has been very much a structured affair, and this was particularly true in earlier centuries. It is true in some rather obvious ways: for example, becoming a full-time writer involves literacy (and therefore education, not always available to all sections of the population) and leisure (and therefore some kind of secure income or means of support). In the light of this, it is not surprising to learn that in the nineteenth century most writers were born into the professional middle class,[50] or that a very large number of novelists in that century were women, the newly leisured wives of the wealthy middle classes.[51] (I shall come back to the question of women's access to literature, which is a rather more complicated issue.) In the twentieth century, the recruitment of artists appears to be less rigidly structured. Diana Laurenson, for example, has shown that the

class background of writers is far less homogeneous than it once was,[52] and much the same can be said for music and painting, where it was once almost a prerequisite and at least an advantage to have been born into a musical or artistic family.[53] However, as Mason Griff has argued, 'Because recruitment into the art world is neither tightly limited nor carefully controlled, we should not be led to assume that artists somehow drift into art. There exists a whole social paraphernalia for getting persons committed to their artistic identities' (Griff 1970, p. 147).

He investigates, in the American context, the influence of parental and familial values and pressures, the rôle of schools, and other social factors involved in the initial choice of a career in painting. There have also been studies on how, having chosen this career, art students are taught, and on the rôle of the art school as producing artists.[54] In all periods, then, the way in which artists and writers take up their careers, and therefore the particular values and attitudes they bring to them from their family and class backgrounds, affects the kind of work they do as artists. And if specialised training is also involved, the processes of the institutions of training are also likely to 'form' the artist and influence the direction of his or her development. Of course these things are differentially applicable in different forms of art and in different periods.

The importance of institutions in creating, or enabling, artists, is demonstrated if we look at the case of women in the history of art, particularly painting and sculpture. With the rise of the Women's Movement and women's studies, there has been, on the one hand, an articulate and sustained objection to the way in which women have been 'written out' of the history of the arts, which appears to consist almost solely of men; and on the other hand, a growing number of books about women artists, obscured or ignored in traditional art history books, and anthologies of work by women writers, poets and painters in history.[55] It is quite true that many excellent women painters are little known, and that it is therefore important to correct this glaring omission in the history of art. However, it is just as important to look at the social conditions which created this myth, and which, moreover, did on the whole exclude women from painting or make it extremely difficult for them to succeed. This kind of work is being done by a number of feminists,[56] and what they have shown is that the social organis-

ation of artistic production over the centuries has systematically excluded women from participation. For example, even though it was usual for male artists to be the sons of artists,[57] female artists were almost without exception daughters of artists, or, in the nineteenth and twentieth centuries, closely connected with 'a strong or dominant male artist' (Nochlin 1973, p. 30). Although the guilds were not closed to women, in practice it was extremely difficult for them to gain acceptance. With the rise of the Academies (in 1648 in Paris, and 1768 in London[58]) new obstacles were put in the way of women painters, and in particular the banning of women from life drawing, an essential part of artistic training in the pre-modern period, effectively barred them completely from 'serious' art.[59] The discovery of a number of excellent women painters in the history of art appears all the more surprising, then, when we realise the forces in operation which systematically worked to exclude them from the profession.

It should be said, too, that in the case of writing, where problems of training and acceptance into male-dominated and male-defined academies did not exist, women's entry into the profession was not a simple matter, and was by no means on equal terms with men. It is no accident that even the most successful women novelists of the nineteenth century (the Brontes, George Eliot, and George Sand in France) assumed male pseudonyms to avoid any prejudice on the part of publishers and critics.[60] And the general social restrictions on women severely curtailed their possible involvement in the literary life, such as the eighteenth-century London coffee houses, where journals were read and literature discussed,[61] or the simple possibility of travel in order to participate in the general exchange of ideas.[62] So that even with the basic prerequisites of time, money and 'a room of one's own',[63] women remained, at least until very recently, marginal to literary as well as artistic production. From their marginal position, in art as in social life in general, the work they produce differs in important ways from the work of men, and there is a growing body of literature on women's art to this effect,[64] an important analytical development in cultural studies, and one which must be made increasingly central to the sociology of art.

Patronage systems. In the fifteenth century and before, patrons

exercised what we would now consider an outrageous degree of interference into the artist's work, to the extent of specifying what colours (particularly gold and ultramarine) the painter should use, and how the figures on the canvas should be depicted.[65] In the later periods, the rôle of patrons remained important, though direct involvement in the work of the artist (now become more of a professional figure[66]) was more unusual.[67] Literary patronage, though less well known and perhaps less well documented, has also played a central rôle in the history of literature, moving in this country from the monarch and the church in the fourteenth and fifteenth centuries, to a larger circle of aristocrats in the sixteenth century, and to political patrons in the period after the Restoration in 1688.[68] Whereas in feudal times the nature of the texts was clearly affected by the close association between writer and patron, when the writer or poet often lived in the patron's household and was bound in loyalty to the patron, this close link and dependence declined after 1600,[69] and patronage might consist merely in a matter of dedication, for which the writer would be paid.

From about the mid-eighteenth century, however, both painters and writers faced a new situation, offering more freedom as a result of the decline of the system of direct patronage, but at the same time rendering the artist's life more precarious and subject to market relations and economic uncertainties.[70] Increasingly, publishers and booksellers took over from literary patrons as facilitators for the writer;[71] and the patrons of art, as well as the central rôle of the Academy, were displaced by the dealer-critic system in painting. In other words, people and institutions who were in effect mediators took on a more crucial place in the very immediate problem of economic survival for artists. Insofar as artists have become 'institutionally displaced',[72] working in isolation and depending on the vagaries of the market to make a living, then these mediators are vital agents for them.

It should not be overlooked, however, that not all artists do maintain this type of precarious existence, and that certain modern forms of patronage have to some extent taken over from the traditional relationship. Writers may write on commission for television, for example.[73] Photographers may be employed by newspapers or by advertising agencies, instead of relying on freelance earnings for 'art' photography.[74] Painters are often

commissioned by industrial corporations to execute works, or employed as community artists or as artists-in-residence at universities.[75] And perhaps the most important development in the twentieth century has been the growth of government patronage of the arts (what Janet Minihan has called 'the nationalisation of culture').[76] In Britain, this operates at the moment through the Arts Council and the Regional Arts Associations, working in conjunction with local authorities, through grants to artists and writers and funding for projects.[77] Although one would not expect any direct intervention by the respective 'patron' into what the artist actually produces, it is clear that funding bodies are no more neutral than any social organisation, and that the success of some artists at gaining sponsorship and the failure of others is likely to be related to the type of work they do.[78] (In Britain, for a variety of reasons, it is probably the case that preference of sponsors and patrons has less to do with political content than with aesthetic conformity, though this would need to be argued at greater length.[79]) That is to say, it is still true in our own day that art which is successful in reaching a public by being 'bought' achieves this through various social structures and processes, and not simply because it is, in some sense, just 'good' art.

Mediators. In the United States there have been numerous studies of the rôle of mediators in affecting cultural products, and I have already referred to some of these (p. 31 above). In constructing the 'great tradition' of literature or painting, the rôle of publishers, critics, gallery owners, museum curators and journal editors cannot be overestimated. In the nineteenth century, there is a good deal of evidence that writers took into account the demands of the powerful mediators of the time in actually writing their novels. Some examples of this are documented by Sutherland in *Victorian Novelists and Publishers*.[80] Novels intended for serialisation in the new journals or for public readings (another important arena of presentation) were written to that form, for example with cliff-hanging endings for each episode; Dickens wrote *Pickwick* in this way (Sutherland, p. 21). The demand by the extremely powerful circulating libraries, particularly Mudie's, for the three-decker novel, forced novelists to comply with this particular form; George Eliot's novels were written in three-decker issues (pp. 188–205). And publisher and library owner would also impose

moral demands on authors, occasionally sending back manuscripts thought too 'suggestive' or 'vulgar' (pp. 25–7).

One of the best examples of the formative role of the mediators is White and White's study of the rise of Impressionism in nineteenth-century France, and its peculiar relationship of reciprocity with the emerging dealer-critic system.[81] The work of the Impressionists would not have found acceptance through the existing Academic system, partly because of the entrenched and traditional ideology of the latter, and partly because the Academy simply did not have the capacity to cope with the vastly enlarged number of painters, particularly those seen as marginal. At the same time, there was a growing new market of potential buyers for works of art, which was not successfully catered for by the existing system. These were primarily the new wealthy middle classes (White and White 1965, pp. 78–82), interested in financial speculation in art as much as in possessing fine works (p. 99). This made the new buyers more adventurous than traditional aristocratic buyers. The dealers and the critics made their success by bridging this gap, and by connecting the 'glut in painting' with the new eager buyers. The rôle of the critics in this was to legitimise the new work to this public (pp. 119–24). The dealer-critic system could not have arisen except in circumstances of a changed social situation, with newly emerging social groups and an outmoded institution of artistic production, but its growth and power were essential for the discovery and success of what we now take to be one of the most important movements in the history of art.

Economic factors

In this short final section, I simply want to emphasise the fact that economic considerations, often of a quite fundamental kind, are always relevant to the social production of art. This is often overlooked both by sociologists and by social historians of art, concerned to investigate the ideological nature of novels or paintings, or the social position of a particular group with control over artistic production. What gets produced and performed and received by audiences is often determined by straightforward economic facts. An American study a couple of years ago, for example, demonstrated that the repertoire of opera companies in the United States is very seriously constrained by box office

considerations, which in effect limit innovations in the music, and standardise the selection of repertoire.[82] The use of gold, silver and ultramarine in fifteenth-century painting, which I have mentioned in an earlier context (p. 44), was entirely an economic matter, to do with the expense of these three pigments.[83] Peterson and Berger have argued that when the popular music industry tends to be more oligopolistic there is less innovation in music, whereas in periods of increased competition among firms (they cite 1956–59 and 1964–69 as examples) the music is more diverse and innovative; they dispute the hypothesis, then, that consumers 'get what they want' or even 'want what they get'.[84] In general, it is clear that funding and financing cannot be taken for granted, and that the way in which these may fluctuate with general economic cycles or with political change can crucially affect the nature and even the existence of the arts.[85] In the twentieth century, where the arts no longer have the clearly institutionalised position they had in the feudal and classical periods, it is perhaps even more necessary to understand the dependence of culture on economic factors, and the extreme sensitivity and vulnerability of the arts and culture to the fortunes of the economy. As Nicholas Garnham has argued, it is vital to develop a political economy of culture.[86] (It is worth repeating, however, that the economic is not independent of the social-institutional or of the technological, and of course the way in which, say, economic crises will reverberate in the arts will be mediated by the class structure of society, and in particular by the contemporary organisation of culture, both politically and socially.)

The call for a return to a political economy of culture is a reaction, for the most part, to what has been a tendency in the Marxist analysis of culture to ignore economic determinants altogether, in a desire to avoid economic reductionism (seeing culture as simply a reflection of economic factors), and to analyse the specific nature of culture and of modes of representation in culture.[87] These positions will be discussed at length in the following chapters, and it is therefore inappropriate to precede them with their critique. Nevertheless, whether or not it is correctly posed as a counter-position to this work, there is little doubt that culture has to be seen as materially, as well as socially, situated. As Garnham points out: 'There is then, and this cannot be sufficiently stressed, no necessary coincidence between the effects

of the capitalist process proper and the ideological needs of the dominant class' (Garnham 1979a, p. 137). His argument is that we can only understand contemporary changes in culture by recognising its increasing costs of production, and its gradual invasion by multi-national capital,[88] an argument more specifically addressed to media analysis. In all areas of cultural production, however, economic determinants operate – through control of cultural institutions, through policy-making about the arts, or even at the level of box-office considerations by cultural producers. The social production of art can only be properly comprehended in a political economy of cultural production.

Chapter 3

Art as Ideology

Part of the task of a Marxist art history ought to be to reveal the work of art *as* ideology. (Clark 1977a, p. 3)

The major focus of critiques of traditional studies of literature, art and culture in general, from Marxists and sociologists, has probably been the task of exposing the ideological nature of art.[1] A secondary concern has been to expose the ideological nature of art criticism and literary criticism.[2] This is opposed to approaches which see art as somehow 'above' historical and perspectival determinants, and the history of art as the intrinsic development of style, independent of social or historical factors outside the aesthetic sphere. These approaches themselves are shown to be partial and historically specific, and thus, in a particular sense, ideological.[3] Works of art, on the contrary, are not closed, self-contained and transcendent entities, but are the product of specific historical practices on the part of identifiable social groups in given conditions, and therefore bear the imprint of the ideas, values and conditions of existence of those groups, and their representatives in particular artists. In this chapter, I want to look at what is meant by the claim that art is ideological, and to review some of the work on the theory of ideology in general and the analysis of art in particular in order to try to arrive at an adequate understanding of art as ideology. Some problems with the notion of 'ideology' itself will be raised in this connection; others will be discussed in the following two chapters.

The theory of ideology

Although there is some agreement about the fact that art is
ideological, there is unfortunately a good deal of disagreement
about what 'ideology' is. Even within the Marxist tradition (and
there are also non-Marxist concepts of 'ideology') there are
controversies about what Marx actually meant, about what the
implications of the Marxist theory of ideology are, and about a
variety of epistemological, sociological and other issues which
follow from this theory.[4] Williams identifies three common
versions of the concept in Marxist writing.[5] Alan Hunt recalls that
Gurvitch 'discovered no less than thirteen different meanings of
"ideology" in Marx'.[6] And Colin Sumner lists ten main
definitions of the concept 'currently on offer',[7] all of which, he
says, would cite Marx for authority and claim to be interpretations
of his texts. There is disagreement about what ideologies are, and
there is also disagreement about how ideologies are related to other
aspects of social life. I do not propose either to engage in the
pursuit of ascertaining 'what Marx *really* meant', or to adjudicate
between the numerous positions and analyses and their competing
definitions of 'ideology'. Instead, I shall take the easier path of
using that concept of 'ideology' which seems to me to be the most
useful and to have the best analytical value. It is one which, I
happen to think, does derive from Marx, or at least from one of the
chief ways in which he discusses ideologies; no doubt Marxolog-
ists will be able to dispute this.

Put most simply, the theory of ideology states that the ideas and
beliefs people have are systematically related to their actual and
material conditions of existence. This formulation is carefully
agnostic on a number of crucial points of dispute. In the first place,
it does not specify what form this relationship takes, or how
material conditions of existence produce ideas. Secondly, it does
not indicate how we are to conceive of 'people' – whether in terms
of class, nation, sex, or anything else – and I do not believe it is
possible to give a general formulation in these terms. Thirdly, it
does not identify particular conditions of existence as primary, for
similar reasons. And fourthly, it does not commit itself on the
question of whether or not these ideas and beliefs may be true, or
whether they are necessarily false.[8]

The interrelationship between thought and material activity

On the other hand, this formulation does commit me to the view that, first, ideas are not independent of material conditions of existence; and secondly, the relationship of the two is not accidental or haphazard, but structured and systematic. It begins from the recognition that thought and consciousness originate in material activity, and in the human capacity to reflect on such activity.[9] In this sense, material and economic activity (gathering food, building houses) is primary, because based on fundamental human needs, and communicating about these activities and planning them is secondary. In this simple (and, it should be added, non-historical) example, consciousness arises in material activity. It is bound up with the unique human capacities of linguistic communication and social interaction. The latter also give rise to the ability to abstract from the immediate – to think and talk about things and events which are not immediately visible or at hand. But this is a further development of thought-in-action, extended to other situations.

The detachment of thought from material activity: 'separated theory'

In complex societies, two further developments take place. The first is that thought can be completely detached from immediate practical activity; it becomes 'separated theory'.[10] One aspect of this development is that, with the division of labour and the ability of the general population to be fed and sustained by the work of one section of that population, a group of people exists who do not need to engage in manual labour, and who live as thinkers and intellectuals. Thus the connection between material activity and consciousness has become at least indirect and tenuous:

> From this moment onwards consciousness *can* really flatter itself that it is something other than consciousness of existing practice, that it *really* represents something without representing something real; from now on consciousness is in a position to emancipate itself from the world and to proceed to the formation of 'pure' theory . . . (Marx and Engels 1970, pp. 51–2)

Dominant ideology

The second development is that, with this attenuation of the connection of practice and consciousness, the possibility arises for inappropriate systems of thought to be imposed. Indeed, insofar as consciousness arises in practical activity, and insofar as society is increasingly divided into groups of people engaged in totally dissimilar types of activity, the natural consequence of this would be for a variety of 'ideologies' to develop and to co-exist, each appropriate to a particular type of labour and practice. The fact that this does not generally happen is the direct result of the growth of 'separated theory', and of the abstraction of thought from activity. The theory of 'false consciousness' depends on this dual historical process of the division of labour.[11] The relatively uniform mode of thought and ideology of a society is seen as the successful claim to universality of what is in fact a partial perspective, namely that of the group in power in society, and its intellectuals or ideologues. In a society like our own, where power is based on economic position, and more specifically on relationship to the means of production (though in complex and mediated ways),[12] the ideas which tend to dominate in society are those of the ruling class.[13]

This seems like a contradiction. If non-distorted ideas (still ideology, in the sense in which all thought is ideological) arise directly in material activity, then it ought to be the group furthest removed from material activity (owners of capital, managers, professionals and intellectuals) whose ideology is furthest removed from real material existence. The reason this is not so, however, is that the ruling group or class also controls the means of mental production;[14] again, this is no simple equation, since what constitutes 'the ruling class' is not easily decided, as it is likely that there are competing sections within that class, and as its control over, for example, the media cannot be assumed, but must be investigated as a specific historical matter.[15] But on the whole, it can be shown that the economically and politically dominant sections of society generally dominate ideologically too. The relationship of dominant ideology to material factors has now shifted from the micro-level of producers engaged in practical activity to the macro-level of the actual material interests of a large, economically defined group. The ideology of a society in general[16] is founded on that society's material and economic basis,

and promulgated (not necessarily consciously, and in no sense conspiratorially) by those groups in a privileged position of power in relation to that basis. Marx's most famous, and probably most abused, statement, in the 1859 *Preface*, summarises this analysis.[17]

As I have said, the question of the actual manner in which ideology is constructed on the basis of material existence is an open question at the moment, and one which should certainly not be taken as involving a simple or automatic relationship of causality. This is something I shall discuss a little later in this chapter. But before I go on to consider the place of art and culture in the framework of the theory of ideology, I want to insert a couple of modifications to what has so far been proposed.

Alternative ideologies

The so-called 'dominant ideology' of a society is never monolithic or totally pervasive. A number of sociologists have investigated the various ways in which subordinate classes have 'negotiated' the dominant ideology, or operated with an alternative ideology.[18] Raymond Williams makes a useful distinction between dominant ideology and its co-existing alternatives.[19] Alternative ideologies may be either *residual* (formed in the past, but still active in the cultural process), or *emergent* (the expression of new groups outside the dominant group); they may also be either *oppositional* (challenging the dominant ideology), or *alternative* (co-existing with it). These refinements in terminology prove to be extremely useful in dealing with the complexities of actual cultural analysis, and Williams himself employs them to good effect in his study of the literature of 1848.[20] The conditions under which alternative ideologies may persist or arise are always a matter for historical investigation; this is to say that the extent of penetration of the dominant ideology cannot be decided *a priori*.

Generational, sexual and ethnic social groupings

Secondly, the material basis of ideologies is not necessarily social class. Mannheim, the founder of the sociology of knowledge (which is to all intents and purposes the same thing as the theory of ideology discussed here[21]), argues that there are other significant

social groupings which give rise to their own peculiar mode of thought. In one of his best known essays, he considers generation as an independent variable, fashioning ideology.[22] Studies of youth culture in post-war years have confirmed that it is a unique phenomenon (with a variety of forms and expressions), and a sociology of ideas should certainly be aware of generational distinctions and their implications.[23] (The fact that these youth cultures can only be fully understood when they are located in their *class* context does not invalidate this argument, for to reduce them to class would be to ignore some important sociological distinctions.[24]) Emphasis on both sexual and ethnic divisions in society also ensures that the analysis of ideology looks to other determinants of world-view than just class position,[25] though here too it is likely that these divisions and their ideological correlates are formed and affected by the class nature of the society they inhabit.

Ideology and culture

With these qualifications, ideology then refers to 'a system of beliefs characteristic of a particular class or group',[26] where for 'beliefs' we could substitute 'knowledge' in Mannheim's sense, or 'consciousness', which is equally vague, but which Marx elaborates as including 'legal, political, religious, aesthetic or philosophic – in short, ideological forms'.[27] In the same passage, Marx uses the term 'superstructure' to refer to these forms, with the general statement that the 'legal and political superstructure' and 'forms of social consciousness' correspond to 'the economic structure of society, the real foundation'. (The question of complexities in the economic structure, and corresponding distinctions and variations at the 'superstructural' level, is not raised in this brief and general summary, which is not to say that it is not dealt with in great detail throughout the rest of Marx's work.) This is the origin of the now notorious 'base-superstructure' metaphor which has both aided and confused the study of ideology and culture for at least the past fifteen years.[28] Some of the problems associated with this formulation of the relationship of ideology to social-economic structures will be discussed in the following pages.[29] In the meantime, it is important to notice that ideological forms are not only ideas, cultural values and religious beliefs, but also their embodiment in cultural institutions (schools, churches,

art galleries, legal systems, political parties), and in cultural artifacts (texts, paintings, buildings, and so on). Indeed, the material embodiment of the cultural has been one of the confusing aspects of a model which insists on keeping the 'superstructure' apart from the material world.

This broad definition of ideology clearly includes the arts and culture. Inasmuch as culture is also produced by people, or groups of people, in specific social and historical situations, like all aspects of 'consciousness' it is affected by material conditions. We have already seen that this is a complicated matter (quite apart from the question of how economic conditions may inform something like a painting or a symphony). The cultural producer has his or her own location in the social structure, potentially generating its own ideological form; but at the same time, the society as a whole will be characterised by general ideological forms arising out of the general economic conditions and the mode of production of that society.[30] As always, it is an historical matter to discover the overlap, independence or opposition between these 'ideologies'. In both cases, art is clearly an ideological activity and an ideological product. It will be helpful at this point to look at some specific studies and analyses of cultural products, which demonstrate their particular ideological nature.

Ideology in painting: Gainsborough's 'Mr and Mrs Andrews'

John Berger has argued that there has been a 'special relation' between oil painting and property in the history of Western art, and his interpretation of a painting by Gainsborough has embroiled him in heated debate with more traditional art historians.[31] The painting is Gainsborough's *Mr and Mrs Andrews*, which in fact sets its subjects well to the left of the painting, the rest of which is a landscape.[32] Berger disputes Kenneth Clark's 'innocent' account of this painting. Clark says: '[Gainsborough's] pleasure in what he saw inspired him to put into his pictures backgrounds as sensitively observed as the corn-field in which are seated Mr and Mrs Andrews' (Berger 1972, p. 106). Berger's interpretation, however, is that the landscape, recognisably the property of the Andrews, is not such an accidental feature, dependent entirely on the artist's inclination, but integral to the commission: 'Among the pleasures their portrait gave to Mr and Mrs Andrews was the

pleasure of seeing themselves depicted as landowners and this pleasure was enhanced by the ability of oil paint to render their land in all its substantiality' (p. 108).

In this particular context (a short book, based on an earlier, very successful, series of four television talks), Berger does not attempt to present an adequate and systematic analysis of this work or any other. His intention is to illustrate his argument that painting is *not* innocent of political and economic considerations, but must instead be interpreted as expressing these; in other words, that it is ideological. In another chapter, he considers the portrayal of women in the history of art, showing how they are predominantly presented as potential possessions for the implied male viewer/ spectator.[33] Again, the argument necessarily appears crude and over-simplified, but its intervention into the discipline of art history has proved to be extremely critical and influential, and it has stimulated a good deal of more detailed analysis.[34]

Ideology in literature: the novels of Jane Austen

In the sociology of literature, there is an abundance of studies of particular authors and the ideology of their novels.[35] To take one example, Terry Lovell has reviewed a number of studies of Jane Austen by literary critics, and proposed in their place an analysis of the novels as 'a study in literature and ideology'.[36] Locating Jane Austen in the specific historical conditions of her period (late eighteenth century) in England, with careful attention to her own particular situation (family, class, sex), Lovell argues that the main ideological thrust of her novels is one of gentry conservatism, concerned for 'the moral self-regeneration of her class to legiti- mate its ascendancy' (Lovell 1978, p. 22).[37] For example, Lovell says, Austen's heroines guarantee the renewal of gentry society by marriages into it (p. 32). The novelty and strength of this analysis is that it is able to take account of what had seemed to other com- mentators contradictory elements of the texts. At the same time, this sociological-historical approach does not need to abandon any sensitivity to textual and literary features, as Lovell's essay demonstrates, though unfortunately there is a good deal of much cruder, reductionist work in the sociology of literature.

The works of Lucien Goldmann

I have cited, briefly and largely uncritically, a couple of examples of studies of art and literature as ideological products. These studies, though empirical, are theoretically informed (both, as it happens, by Marxist theory), and the categories of class, aristocracy, gentry, male spectator and landowner are not invoked out of the blue to complete the analysis. The output of particular literary and art historical essays of this type is more than matched by the development of theory in recent years; it is probably fair to say that many of the studies depend implicitly on this development and are informed by its refinement of concepts and analysis.[38] In many cases the theorists are also amongst those who have contributed some of the practical analyses.[39] I want now to look at the work of Lucien Goldmann, who has been a central figure in the development of a sociological theory of literature in Europe.[40] For many of his ideas he is clearly indebted to Georg Lukács, who was his teacher.[41] However, in his early work *The Hidden God*,[42] a study of the tragedies of Racine and the philosophy of Pascal, he elaborates a sociological theory of literature more sophisticated than anything Lukács wrote on the subject, and without the distortions and narrowness imposed by the political constraints on Lukács' work.[43] (Goldmann's later work, particularly his analysis of the modern novel,[44] is less impressive, however. It is generally accepted that he reverts to a more mechanistic and simplistic account of the relationship between literature and society.[45])

The 'world vision'

Goldmann's view is that great literature is the expression of a cohesive social group. He follows Marx (and Mannheim) in believing that ideas develop from social conditions, and that they are not individual but collective, or based in social groups. In certain historical conditions, these ideas cohere in an explicit 'world vision' or 'world-view',[46] and this occurs when the group in question is forced to define its own identity in struggle with and in opposition to other groups in society. Goldmann asserts that it is an historical fact that these groups have nearly always tended to be social classes,[47] not, as he says, 'for dogmatic reasons of faith or because of preconceived ideas', but because 'our own research, as well as the studies with which we have been able to acquaint

ourselves, have almost always shown us the outstanding impor-
tance of this social group in comparison with others' (Goldmann
1969, pp. 101–2). Great literature is the expression of such a world
vision (Goldmann 1964, p. 19), and is a product of a collective
group consciousness. In his study of seventeenth-century France,
Goldmann examines the position of the class he refers to as the
'noblesse de robe', and in particular identifies their contradictory
position in society, expressed in Jansenism (1964, p. 99). This
group was at the same time economically dependent on the
monarchy (but not integrated with it in the same way as the
noblesse de cour), and also ideologically and politically opposed
to it (p. 120). Bound to the monarchical state by their legal
functions, they were 'enticed by the rationalistic individualism of
the bourgeoisie' (1969, p. 109). This contradiction gave rise to
what Goldmann calls 'the tragic vision', representing in
philosophical and religious terms this conflicting claim as a
contradiction between absolutism and faith on the one hand, and
individualism and rationalism on the other. Goldmann goes on to
argue that the tragic vision informs the philosophical writings of
Pascal and the plays of Racine. The study is supplemented with
discussions of the biographies of these two men, in relation to the
class structure of seventeenth-century France and to Jansenism.

Genetic structuralism

Goldmann's early work is important for a number of reasons. He
relates literature and ideology to class structure without using a
simple reductionist equation, but instead insists that social life is a
totality (1969, p. 62). The relationship between economic divi-
sions and literary production is not defined as causal or crudely
deterministic, but is presented as mediated through social groups
and their consciousness.[48] And his sociology of literature insists
throughout on the level of meaning, refusing to talk about social
structure and artistic product without reference to people's
perceptions and intentions regarding these (1969, pp. 31–4). In all
these respects, it represents a great advance on many earlier
Marxist theories of literature and positivistic sociologies of
literature, and deserves its central place in courses, books and
anthologies on this subject. There are various criticisms of some
aspects of his work which I have not dealt with,[49] and as I have

pointed out, his later work is considerably weaker. At the end of this chapter, I will look at one problem which Goldmann's method involves – that of the place of the author in this type of sociological approach to literature. I shall also be discussing the more serious lack of any theory of literature itself as a 'mediation' in Goldmann's work. Nevertheless, the theory of 'genetic structuralism' of his earlier writings is an important contribution to the sociology of the arts.[50] It shows how literature may be comprehended as a human production formed in and informed by the political and ideological forms taken by social groups in specific periods, and in doing so, on the whole, in a non-reductionist manner, makes respectable the notion of art as ideology.

The complexity of ideologies

Though Goldmann talks of social classes as historically the most significant groupings, when he comes to look at literature he finds that it is not quite as simple as this. In the case of the seventeenth century in France, the group he identifies as critically important is actually a fraction of a class or perhaps, more accurately, a group indecisively poised between two major historical classes. Indeed, it will rarely be the case that any helpful account of a novel or painting will consist in relating it, say, to the ideology of the bourgeoisie, the proletariat or the declining aristocracy. For one thing, the historical situation is always more complex than this. Each class, dominant or subordinate, generally comprises sectional interests and therefore varying ideologies. Neither is ideology always, or usually, the kind of coherent 'world vision' Goldmann discusses as a special categòry. Raymond Williams has shown how the popular fiction of 1848 makes little sense unless one understands the complex social structure of Britain at that time, moving away from the 'epochal analysis' which will only tell us that in 1848 there was a characteristic 'bourgeois ideology' and its appropriate fictional form. As Williams demonstrates, other forms of fiction were also prominent, themselves comprehensible in terms of his analytical categories of 'emergent' and 'residual' cultures, related to particular sectors of the contemporary society.[51] And, lastly, the nature of literature and artistic production is itself a complex matter, interposing itself between the idcology of a class or other group, and its expression in aesthetic form. As

Nicos Hadjinicolaou says: 'Neither social classes nor the struggle between them appear *as such* in painting' (Hadjinicolaou 1978a, p. 15).

His own view, in relation to painting, is that since the visual ideology of the dominant classes permeates that of the dominated classes, conflicting visual ideologies are more usually between layers or sections of the ruling classes (p. 102). So, for example, he looks at four paintings by David as the battleground of competing ideologies of successively dominant groups in Revolutionary and post-Revolutionary France, identifying four distinct visual ideologies: baroque, revolutionary bourgeois, Directory and bourgeois Restoration (pp. 107–23). Whether or not this is an acceptable dissection of the ideological components of these four paintings, and whether or not Hadjinicolaou is right in general to assert that visual ideologies are predominantly those of dominant groups, the important argument is that ideologies cannot be assumed to be uniform, or to be neatly related to unified and identifiable social classes, either in general or in their visual and literary expression.

Aesthetic mediation

This brings me to the last major argument of this chapter, which concerns what might be called 'aesthetic mediation'. In the work of Lukacs, Goldmann and a number of other sociologists who have written about the relationship between the arts and society, analysis has developed a long way beyond so-called 'reflection theory'.[52] It is no longer necessary to argue that literature does not simply reflect social structures and processes in a passive and epiphenomenal way, the connection between the two taken as uni-directional, causal, and unproblematic. The ideological character of works of art and cultural products is recognised to be extremely complex, their determination by economic and other material factors mediated both by the existence and composition of social groups, and by the nature and interrelationship of their ideologies and consciousness.[53] Nevertheless, even this more sophisticated model raises two problems. The first is the question of the extent to which ideologies in general, and culture in particular, may be independent or autonomous of social and economic determination, and also, in their turn, affect the material

structures of society themselves. That is, even though it is not reflectionist, the model is still more or less uni-directional, and does not appear to allow the possibility that culture can determine historical development. This problem will be raised and discussed in the next chapter.

The second problem I take up here. One way of putting it is to say that the kind of sociology of art and literature which has been discussed so far takes the level of the aesthetic itself as unproblematic. It appears to assume that ideologies, once mediated through social groups, simply appear in visual or literary form. One might say that this kind of work suffers from a residual reflectionism, because it implicitly assumes that ideology, however complexly constructed, is simply reflected in art. It is to correct this particular blindness of analysis that a number of writers have recently been addressing the issue of the 'specificity' of the aesthetic level.[54] In doing so, interestingly, they have found occasion to invoke analytical tools which in the early days of the new approach to the arts would have been rejected as ahistorical and formalist. But with the acknowledgement that sociologists and Marxists have been paying too little attention to the nature of particular genres and artistic forms, it has proved extremely useful to go back to the kind of analysis offered by literary critics. The work of the Russian Formalists, between about 1915 and 1929, has had a central place in this reconstruction.[55]

The way in which the ideology of a class or other group is expressed in literature or painting will be affected, or mediated, by two sets of conditions at the aesthetic level (quite apart from the mediations already discussed in this chapter and the last, of divisions and relations within groups, questions of dominance and power, and processes and institutions which affect cultural production). These are (i) the conditions of production of works of art, and (ii) the existing aesthetic conventions.[56] Both of these at the same time make possible the construction of a particular work, and set limits to this construction.

Conditions of artistic production

By 'conditions of production of works of art' I mean here specifically those conditions surrounding cultural production. I have already suggested that, in a more general sense, the actual

historical conditions in which any work is produced must be considered in giving an account of that work, rather than resorting to some generalised or *a priori* formula (p. 55). This means, for example, recognising the extent of political censorship (including censorship of the arts) in a particular society, or understanding the sexual division of labour in general, and women's position within the family, in order to understand women's apparent absence in the history of art. More specifically, artists and cultural producers are faced with particular conditions of work, affecting what kind of work they produce and the manner in which they can do this. In the last chapter I looked at the rôle of cultural institutions in the production of art, and this is partly what is meant here.[57] In what is now sometimes referred to as 'materialist aesthetics' or 'production aesthetics',[58] the emphasis is on 'the author as producer', using some of the ideas of Brecht and Benjamin contained in essays written in the 1930s.[59] Although it appears to contradict the main arguments of the production-of-culture approach more common in the United States, which shows art as 'collective action' (Becker), by taking as its starting point the author/artist and his or her specific location, in effect the analysis leads to similar conclusions. The author is not conceived of as an ideal, free, creative spirit, but precisely as someone with a given social and historical situation, confronted by conditions of artistic production external to him/herself. The author is seen *as* a 'producer', whose work it is to use the technical and material tools available and to fashion these into a literary work: 'Literature, like any other social practice, employs determinate means of production to transform a determinate "raw material" into a specific product' (Eagleton 1977, p. 100).[60]

The existing techniques of artistic production (methods of printing and reproduction, institutions of publication and distribution, and so on) situate and confront the artist. Furthermore, the social relations of artistic production, based on these techniques and institutions, also form the conditions of artistic production. They determine, for example, whether or not authors are independent and free to sell their works to publishers, or how cultural producers working in the media are subject to certain constraints inevitable in hierarchical structures.[61] In a way, this is to repeat some of the arguments of an earlier section of this book; that is, that the technological and institutional conditions of the produc-

tion of art are crucially important, and that they help us see the artist as a producer, working in these conditions. For very different reasons, and from quite different perspectives, American sociology of art and Marxist aesthetics do indeed converge on this point.[62] The latter has the advantage of greater explanatory power, since, unlike these particular studies in the sociology of art, Marxist aesthetics situates cultural production and the artist more adequately within the total social structure and within their historical context. Tim Clark has said: 'The study of patronage and sales in the nineteenth century cannot even be conducted without some general theory – admitted or repressed – of the structure of capitalist economy' (Clark 1973, p. 11). Without investigating what kind of theory is 'repressed' in some of the apparently atheoretical analyses of cultural institutions, not only in the United States but also in Britain, we can agree that conditions of literary and artistic production are themselves part of, and related to, wider conditions of production in society. As Terry Eagleton argues, the 'literary mode of production' must be analysed in its relation to the general mode of production of a society as well as to the general (i.e. not specifically literary) ideology of that society.[63]

The level of the aesthetic interposes its own mediations therefore between ideology and its cultural expression (in a painting, a novel or a play). This is not to deny what was argued earlier – that the artist is in some sense the agent of ideology, through whom the views and beliefs of a group find expression. It is to insist, however, that this does not take place in any simple fashion, whereby political, social and other ideas are simply transposed into an aesthetic medium. The actual material conditions of artistic production, technological and institutional, mediate this expression and determine its particular form in the cultural product.

Aesthetic conventions

It is confusing that the second type of aesthetic mediation often also uses the term 'materiality', although it is not concerned with material conditions of artistic production. For example, Raymond Williams follows the work of Volosinov in talking about the 'materiality of the sign' and the 'materiality of language'.[64] Language, he maintains, is 'a special kind of material practice'

(Williams 1977a, p. 165). The argument, which is an important one, is that language and other codes, as existing sets of rules and conventions, determine what can be said in a particular cultural tradition.[65] However, this is a very specialised use of the term 'materiality', which does not necessarily indicate that an actual material existence of the language, or artistic code, can be identified. (In this context it is particularly confusing, since in the preceding chapter Williams has been discussing the 'inescapable materiality of works of art' in the sense in which these actually *are* visible, physical objects (p. 162).) Here, it concerns the specific level of operation of codes and conventions (in this case, aesthetic codes and conventions). A good deal of the work in this area has been done under the general name of 'semiotics' or 'semiology' – the science of signs and codes. It has contributed enormously to our understanding of how languages and cultural forms operate, and it has also corrected what was a rather simplistic notion of the relationship between social and cultural forms.[66]

In some ways, it is clear how the study of signs and codes comes to be associated with the concept of 'materiality'. Signs are recognised in this perspective as 'the living socially embedded utterance in context'.[67] Insofar as one is looking at occasions for using language, rather than the abstract system of language itself (the more usual direction taken by structuralist linguists following Saussure's identification of *langue* as a system of rules of speech, as opposed to *parole*, the act of speaking), then these 'utterances' are indeed socially embedded and concrete acts. Secondly, even with a semiotic analysis which focuses on codes and structures rather than their concretisation in specific utterances, it is recognised that these 'languages', arbitrary in the sense that there is no necessary link between a particular word and its associated referent, were originally formed in specific material conditions and in particular social interactions (and, indeed, are constantly in process of modification and re-formulation).[68] So codes and languages are not remote from material practices, inhabiting some entirely autonomous and ideal realm.

But it is not these aspects of codes which are at issue here. The point is that aesthetic codes operate as mediating influences between ideology and particular works of art by interposing themselves as sets of rules and conventions which shape cultural

products and which must be used by artists and cultural producers. In this sense, it is extremely misleading to discuss these codes in terms of 'materiality'. They are *only* material insofar as they originate in material practices, and in their concrete appearance in particular texts; as systems of signification themselves, they are not.[69]

The forms of artistic production available to the artist play an active part in constructing the work of art. In this sense, the ideas and values of the artist, themselves socially formed, are mediated by literary and cultural conventions of style, language, genre and aesthetic vocabulary. Just as the artist works with the technical materials of artistic production, so he or she also works with the available materials of aesthetic convention.[70] This means that in reading cultural products, we need to understand their logic of construction and the particular aesthetic codes involved in their formation. Ideology is not expressed in its pure form in the work, the latter acting as a passive carrier. Rather, the work of art itself re-works that ideology in aesthetic form, in accordance with the rules and conventions of contemporary artistic production. For example, in order to understand how a particular painting is subversive, it is necessary to look beyond its explicit, or implicit, political content, and to investigate its particular use of aesthetic conventions, and its position in relation to other works of art. (Hadjinicolaou analyses the 'critical visual ideology' of paintings by Rembrandt, Hogarth and Goya in this way.[71]) This is also important because it enables us to recognise the significant ways in which certain things – ideas, values, events – are *not* contained in the text. The conventions of literary and artistic production may disallow certain statements. Exposing these limitations in the texts – these 'silences', as it has been put by Macherey and Eagleton – is an important part of revealing the ideology which lies behind the text and speaks through it.[72]

It is clear that earlier theories of art as ideology were somewhat naive in their view of the mode of operation of the aesthetic. They made the mistake of taking 'signifying systems' and aesthetic codes as 'transparent', and of therefore mistakenly seeing the relationship of ideology and art as one of exact replication, expression or reflection. Aesthetic codes and conventions, however, transform ideology in a particular way. (Macherey, in discussing Lenin's essays on Tolstoy, suggests that if literature is a

mirror reflecting reality, it is more like a *broken* mirror, fragment-
ing, refracting and distorting this representation.[73]) The study of
art needs to be, as Macherey says, a 'dual study': 'art as
ideological form, and as *aesthetic process*' (Macherey 1977b,
p. 50). As Eagleton puts it: 'It is essential, then, to examine in
conjuncture two mutually constitutive formations: the nature of the
ideology worked by the text and the aesthetic modes of that
working' (Eagleton 1976a, p. 85).

It is the necessity for understanding these 'aesthetic modes of
working' which has led cultural studies back to the formalist
analysis of texts, and particularly the work of the Russian
Formalists in the 1920s.[74] This revival of interest in semiotic
analysis in particular[75] has facilitated a sociological aesthetics
which is capable of incorporating the aesthetic as a determining
level in its own right, specifying the literary and artistic structures
in which ideology is formulated. In the case of literary production,
Formalist analysis enables us to analyse the structure of plot, the
various literary devices employed and the specific uses of
language,[76] and to investigate the way in which these literary
elements work on, and transform, ideology. In a parallel manner,
the sociology of art must incorporate a theory of visual 'forms', in
order to analyse the ideological nature of painting.

The ideological nature of art, then, is mediated by the aesthetic
level in two ways:[77] through the material and social conditions of
production of works of art, and through the existing aesthetic
codes and conventions in which they are constructed. Ideology is
not simply reflected in art, not only because it is mediated by a
variety of complex social processes, but also because it is
transformed by the modes of representation in which it is
produced: 'A work of art may have ideology (in other words, those
ideas, images, and values which are generally accepted, domi-
nant) as its material, but it *works* that material' (Clark 1973, p. 13).

The rôle of the artist/author

Before concluding this section, it is worth raising the question of
the author in this particular connection. In looking at the
ideological nature of art and literature, the rôle of the artist/author
has apparently been completely eclipsed. Works of art now appear
as the product of social groups or dominant classes, or perhaps

even of their own conventions of construction. In all this there does not seem to be much room, at least analytically, for individuals as creators.

Criticisms of Goldmann et al.

David Caute once criticised Goldmann's sociology of literature for displacing the author and allocating to him or her merely the rôle of 'midwife', assisting in the birth of a literary work whose real 'parent' is a social class.[78] More recently, John Berger has taken issue with Hadjinicolaou in similarly humanist terms, arguing that he has 'no theory about *the act* of painting or *the act* of looking at pictures'.[79] I have already mentioned (p. 20) Sartre's objection to the kinds of analysis which omit reference to the psycho-biographical development of individual writers. He says the following about Flaubert, in the context of a critique of what he calls 'frozen' (p. 28) or 'lazy' (p. 53) Marxism:

> Contemporary Marxism shows, for example, that Flaubert's realism offers a kind of reciprocal symbolization in relation to the social and political evolution of the petite bourgeoisie of the Second Empire. But it *never* shows the genesis of this reciprocity of perspective. We do not know why Flaubert preferred literature to everything else, nor why he lived like an anchorite, nor why he wrote *these* books rather than those of Duranty or the Goncourt brothers. Marxism situates but no longer ever discovers anything. (Sartre 1963, p. 57)

An adequate sociology of literature, he believes, will incorporate existentialism and psychoanalysis. Sartre talks of the necessity for a 'hierarchy of mediations' (p. 56), and what all three of these critics share is the belief that one important and irreducible level of 'mediation' between social and economic structures and work of art is the *individual*. This is one mediation which so far I have not discussed, except to criticise some false notions of individuality and creativity. Indeed, in the two chapters which follow, the artist/individual will appear to be displaced even further from the centre of the activity of artistic production, when I consider, for example, the abdication of the author's dominance over a text in favour of the creative, active rôle played by readers and audiences.

In chapter 6 I shall address directly the question of the author, summarising what has gone before and attempting to develop out of this an adequate conception of the author/subject. Here I want to conclude by making a few comments in relation to the theme of this chapter. These take the form of a provisional defence of Goldmann and others against their 'humanist' critics.

In defence of Goldmann et al.

In relation to Goldmann, this criticism is particularly inappropriate. He quite explicitly insists on the importance of human meaning as a level of analysis within Marxism,[80] criticising reductionist accounts, and his study of Racine and Pascal pays a good deal of attention both to biography and to the question of what Weber calls 'adequacy at the level of meaning'. That is to say, he will only attribute to someone a specific world-view if it makes sense in relation to that person's general social experience and situation, to the extent of deducing the former from the latter. It is true that he argues that literature has to be understood as the creation of groups, or 'transindividual subjects',[81] the product of a collective consciousness. But, of course, he does not deny that it is actually individual writers who *write* books. He introduces the notion of the 'exceptional individual'[82], to 'mediate' between social group or class and text. This is a person in whom the world-view of the group reaches its most coherent expression for a variety of reasons (not least, presumably, biographical ones), and who, in this particular case, also has certain literary ability. I think it would be unfair to suggest that the exceptional individual is hurriedly invoked to disguise the fact that this is actually a reductionist theory of literature. As far as I can see, Goldmann, at least in his earlier work on seventeenth-century France, is here doing exactly what Sartre prescribes (although not in quite the same psychoanalytic detail): inserting the necessary mediation of individual meaning and location into a general structural theory of ideological determination. In a sense, the author *is* just the midwife. Social and ideological effects appear in the text, facilitated by their mediation in particular writers who represent those social positions and ideological beliefs. At the same time, the literary work is a unique product, the result of its author's very specific position in society and ideology (what Eagleton calls 'the

effect of the author's specific mode of biographical insertion':
Eagleton 1976a, p. 58). The question of how far one goes into
biography, psychology and psychoanalytic detail is both a matter
of choice and a matter of convenience. It is not essential, or always
possible, to write a detailed and lengthy study of the childhood and
biography of Flaubert, Genet, Baudelaire or any other writer,[83] but
this does not mean that the sociology of literature is prevented from
showing that the texts are expressions of particular social
viewpoints. It is interesting to know more about exactly what kind
of petit bourgeois intellectual Valéry was, and this information
certainly adds to our understanding of his work.[84] In the absence of
such a close study, it is still important to say that Valéry was a petit
bourgeois intellectual, and to see how this informs his literary
work.

There has been plenty of Marxist and sociological work on the
theory of art and literature which *has* been reductionist, and which
has been inclined to deny the intermediary level of author/artist.[85]
But it is a misunderstanding of the theory of ideology to argue that
any such approach is reductionist. This is something I shall come
back to later, when I discuss the somewhat hysterical over-reaction
to those Marxists (particularly Althusser and his followers) who
explicitly state their 'anti-humanism'. The sociology of literature
of Lukács, Goldmann and other neo-Marxists,[86] whatever its other
weaknesses, does not reduce individuals to passive bearers of the
ideology of classes or other groups. There is room for a hierarchy
of mediations, even where the emphasis has been centrally on
social rather than biographical issues.

Humanist criticisms of the sociology of literature and art are
often actually attempts to rescue a notion of 'creativity' which
allows to art a special transcendence of all contingencies,
particularly social and ideological contingencies. Berger's criti-
cism of Hadjinicolaou's 'reductionism' is founded on this kind of
view, as the following passage makes clear:

> The new reductionism of revolutionary theory . . . sees [paint-
> ings] as only a visual ideology of a class. [It] eliminate[s] art as a
> potential model of freedom, which is how artists and the masses
> have always treated art when it spoke to their needs.
>
> When a painter is working he is aware of the means which are
> available to him – these include his materials, the style he

inherits, the conventions he must obey, his prescribed or freely chosen subject matter – as constituting both an opportunity and a restraint. By working and using the opportunity he becomes conscious of some of its limits. These limits challenge him, either at an artisanal, a magical or an imaginative level. He pushes against one or several of them. . . .

Ideology partly determines the finished result, but it does not determine the energy flowing through the current. (Berger 1978, pp. 703–4)

I have argued that this concept of 'creativity' or 'freedom' is untenable, and it cannot therefore be used to criticise analyses of art as ideology. Insofar as people, including artists, are socially and historically located, and are members of particular social groups, then their thought, including their artistic ideas, is ideological in the sense in which I have been using this term. Unless they crudely overlook the complexities of specific groups and individuals' often contradictory position within them, theories of ideology are not reductionist but essential to analysis.

I have said, however, that this defence of Goldmann and others is provisional, and it will be necessary later on to criticise some of the work discussed in this chapter with respect to the concept of the subject and the artist which they employ. As this will be in a different direction from that urged by Berger, Caute and Sartre, this discussion is best left until then. Here I have simply wanted to argue that showing the ideological nature of art does not eliminate authors/artists as analytical categories (or as real people); and that criticism of the theory of ideology on these grounds is often based both on a misunderstanding of that theory, and on a mistaken notion of creativity.

Chapter 4

Aesthetic Autonomy and Cultural Politics

Culture is not just a reflection of economic and social structures. It is mediated at a variety of levels. It is mediated by the complexity and contradictory nature of the social groups in which it originates; it is mediated by the particular situations of its actual producers; and it is mediated by the nature of operation of aesthetic codes and conventions, through which ideology is transformed and in which it is expressed.[1]

But even with this hierarchy of mediations inserted into the sociological analysis of culture, there is one important problem with this model. However complex and multiple the mediations, it still appears to be a uni-directional relationship, where economic and social divisions, eventually and indirectly, affect and determine cultural products. This is inadequate for the following reasons:

(i) It does not always appear to be the case that cultural products are determined by social factors, even allowing for mediating levels.

(ii) The model does not allow for the possibility of art and literature in their turn affecting other elements of society and of being historically effective. At most, so far, we can say that their aesthetic codes and stylistic conventions guarantee them a degree of aesthetic autonomy from automatic social determination.

I shall consider each of these problems in turn, and devote the rest of this chapter to a consideration of the concept of the autonomy of ideology and of culture, and to a discussion of the possibility of political intervention in the cultural arena.

The apparent autonomy of ideology and culture

In some cases, it is difficult to see in what sense one could talk about the ideological nature of art or its expression of the world-view of any group. For example, a symphony, a quartet or any music without lyrics is hard to assimilate to ideology of any sort, although there have been interesting attempts to develop a sociology of music on these lines.[2] Similarly, it is not as simple a matter to detect the ideological nature of abstract art as it is with Gainsborough's paintings of the landed gentry.[3] However, this particular problem may be said to be connected with the relatively immature state of our analysis of non-figurative forms and of musicology in general.

Changes in art forms: temporal discrepancies

What is more relevant is the obvious historical fact that different art forms change at different times and at different rates, and are therefore not connected in any straightforward or identical way with social change. To put this very simply, one could point out that some of the most important developments in painting and sculpture took place from the fourteenth to the sixteenth centuries; the beginning of modern classical music is usually dated from the seventeenth and particularly the eighteenth century; and the novel more or less originated in the eighteenth century, to be developed through the nineteenth century. (This, as I have said, is extremely over-simplified, and it overlooks the fact that these developments also took place in different parts of Europe, and that, for example, painting developed in different conditions and consequently different ways in Italy and The Netherlands.) It is sometimes suggested that different areas of culture are more or less responsive to social change, and some will change more slowly than others.[4] No doubt this is true; one would expect political influences to be more visible in both literature and painting than in music, and the actual technical nature of production will render literature more

immediately responsive to social change than architecture. However, this will not really do as an explanation of the discrepancy in rates of cultural change. In this case, one would expect literature *always* to respond first and most immediately, and music *always* to 'lag' behind more than the rest. Clearly the specific conditions of a particular society, and the peculiar position of particular art forms in it, will determine which arts are affected and in which ways.

Cross-cultural influences on art forms

Another possibility which is ignored in a simple model of cultural determination is that of cross-cultural influence. Cultural and artistic ideas have often spread from one society to another, without any necessary colonisation or political or economic convergence or transformation. In pre-modern Europe, national barriers were far less important than they have become in preventing the exchange of ideas and the experience of culture internationally. In the modern age, culture is transmitted to other societies through the media, replacing, it has been argued, economic and political imperialism with cultural imperialism.[5] An overemphasis on culture as the product of a particular socioeconomic 'base' risks obscuring this type of cultural development and change which comes, as it were, from outside that base.

The persistence of artistic value

Lastly there is the notorious problem of 'the Greeks'. Almost every book on Marxist aesthetics tries to solve for Marx the problem he found in explaining why it is that the art of the Greeks still gives us pleasure today, even though our conditions of existence are so entirely different from theirs.[6] The solutions offered include: (i) the conditions are not so different, as we all share the same history (Eagleton); (ii) Greek art represents an ideal, because Greek society was free, or because the Greeks in some sense represent the essence or childhood of humanity (Lifshitz; Marx himself); (iii) even though art originates in a particular period and society, it can be rediscovered and enjoyed by later periods and other societies in certain appropriate conditions (Hess); (iv) art by its very nature has the potential to transcend its origins, and communicate with people of any society

(Fischer).[7] It is interesting, however, that this is a question of the reception and appreciation of art, and not of its creation. It would usually be quite inappropriate, for reasons which probably include sociological and art-historical ones, for a contemporary composer to write music in the style of Mozart, or for a poet to write in alexandrines. Nevertheless, these earlier forms of artistic production can be enjoyed centuries after their composition, though no doubt with an altered mode of perception.[8] The persistence or rediscovery of artistic value poses a problem for a sociological or Marxist account which merely relates cultural production to its contemporary socio-economic base.[9]

Having raised these problems in order to point out that a simple, uni-directional model of base-superstructure is often inadequate, I do not propose to try to offer answers to each of them.[10] It is the second set of problems I want to deal with more carefully, and which I take to be more centrally relevant to the arguments of this book. The present section is intended to alert ourselves to the limitations of a rigid model which asserts that any art form may be understood as an expression of the ideology of the class in which it originates, the latter in turn explained by its relationship to the political and economic divisions of society.

Political intervention in the cultural arena

Many Marxists who have written about art have indicated how they think artists and writers can best become committed and how they can direct their art towards political and social transformation.[11] The debates about aesthetics in the Soviet Union during and after the Revolution of 1917 largely concerned the question of the type of art most appropriate for mobilisation and political effectivity.[12] Certain well-known and important debates between Marxists have concentrated on this same problem.[13] And a large number of essays and books have been produced on the radical nature and potential of the arts.[14] Behind all this necessarily lies the belief that art, at least in certain conditions, has this potential transformative power, and that cultural practice and cultural politics have a part to play in social and political change.[15] From the opposite point of view, as it were, the importance to the state of censorship in the arts[16] indicates that the latter are seen to have a certain power, and that their influence may not only be at the aesthetic level if they are

allowed complete freedom. This belief in the radical, educative, transformative power of culture does not seem to have anything to do with any model of base and superstructure; indeed, if anything, it appears to reverse it.

What usually happens is that books on Marxist aesthetics take up one issue or the other (art as ideology/reflection/superstructure, and art as radical/cultural politics), or else they are divided into different sections, with no analysis of how the two are related. Where writers have contributed to the debate on both topics (Marx and Engels, Trotsky, Benjamin, Adorno) they appear twice.[17] This is not necessarily a criticism. There are two problems: one, the analysis and formation of art in society; and two, the rôle of the artist and the particular conditions in which particular types of art may be effective in social change. The relationship between the two only becomes problematic either if a uni-directional model of cultural production is proposed, in which art is produced, in mediated form, by social and economic processes, in which case there does not appear to be any possibility for culture itself to 'react back' on its determining base; or if art is granted some unacceptably supra-historical, transcendent status, so that one only needs to be an artist to be in a position to gain political understanding, express it in literary or other form, and thereby influence readers and audiences. I shall argue that the possibility of the radical potential of art is itself historically determined, and that there is no contradiction between the view that art is socially and ideologically constructed, and the view that artistic and cultural intervention in politics is a possibility. In order to do this, I shall go back to the basic idea of the relationship between art/ideology and social structure contained in the base-superstructure model.

Marx's 'base-superstructure' model

Marx formulates the relationship between ideology and social base in the following way, in the *Preface* of 1859:

> In the social production of their life, men enter into definite relations that are indispensable and independent of their will, relations of production which correspond to a definite stage of development of their material productive forces. The sum total of these relations of production constitutes the economic

structure of society, the real foundation, on which rises a legal
and political superstructure and to which correspond definite
forms of social consciousness. The mode of production of
material life conditions the social, political and intellectual life
process in general. It is not the consciousness of men that
determines their being, but, on the contrary, their social being
that determines their consciousness. (Marx and Engels 1976,
p. 41)

On the question of how society and ideology change historically,
he continues:

At a certain stage of their development, the material productive
forces of society come in conflict with the existing relations of
production. . . . Then begins an epoch of social revolution.
With the change of the economic foundation the entire immense
superstructure is more or less rapidly transformed. In consider-
ing such transformations a distinction should always be made
between the material transformation of the economic conditions
of production . . . and the legal, political, religious, aesthetic or
philosophic – in short, ideological forms in which men become
conscious of this conflict and fight it out. (p. 41)

This passage is so often quoted, and taken as the starting point for
cultural analysis, not because it is the most concise formulation to
be found in Marx (this fact, indeed, has led to more problems than
it has solved), and not simply because Marx wrote it, but because
people have continued to find it the most suggestive and valuable
summary of what happens, in general, in historical change. That
is, concrete historical analyses, including Marx's own studies of
mid-nineteenth-century France and of the development of capital-
ism in Britain, confirm that on the whole the dominant forces for
change are transformations in the 'material productive forces'
(land, machinery, capital, etc.) and in the relations of production
between groups of people (i.e. in the class structure) which
develop from and correspond to those productive forces. On the
whole, too, changes in ideology (religious belief, philosophies,
aesthetics, political ideas and even science[18]) develop as a
response to these social and economic changes. This, it must be
stressed, is an historical fact and a generalisation based on

historical observation. It is not an absolute model or a statement of *a priori* truth.[19] Most of the problems which have occupied Marxists concerning the model of base and superstructure have arisen because the model has, wrongly, been taken to embody a philosophy of history and not an historical generalisation. This has meant that writers have inevitably found it necessary to refine the model, so that it is not a crudely deterministic one, and so that it can take account of many of the complexities recognised to exist in the real world, not explained by the simple division into base and superstructure. In the process, the original model has been practically defined out of existence. I shall look at some of these developments in Marxist theory, and consider how it is that they have come about.

Limitations of the 'base-superstructure' model

One of the problems with base and superstructure is that there are too many things which will not fit into this analysis. In concrete social and cultural analysis, one discovers institutions, events and practices which do not seem to be entirely 'superstructural', but which are not obviously part of the 'base' of society either. A good example of this, which has to some extent occupied feminist analysis, is the family. As a number of people have clearly shown, the family is closely related to and implicated in the process of production of society in general, although the actual technicalities of, for example, the relationship of domestic labour to the production of surplus value in capitalist society is still a disputed topic.[20] Not only is domestic labour related to the nature of production in general; the particular form taken by women's waged labour is connected with their position in the family.[21] The family is also relevant to the productive 'base' in its operation as a unit of consumption, crucial to capitalist production. So in a number of ways, it is important to see the economic functions of the family. To put it even more strongly, the forces and relations of production of society are not properly described and understood without taking into account the nature and rôle of the family. On the other hand, the family is one of the central agencies of socialisation in society. In reproducing the next generation, it also reproduces the class structure, and serves to transmit ideology to a new generation. (Of course, it is not the only such agency, others

being the school, the media, and, in some sectors, the church.) The family is also 'superstructural' in its rôle in the reproduction and maintenance of sexist and patriarchal attitudes, and in the construction of gender differences in children.[22] In short, the family must be understood in both its economic and its ideological aspects, as well as in the relationship between the two. It is both part of the 'base' and part of the 'superstructure'.

The same problem occurs with cultural analysis. Williams refers to a discussion in Marx's own work on this matter:

> There is a difficult passage in the *Grundrisse* in which he argues that while the man who makes a piano is a productive worker, there is a real question whether the man who distributes the piano is also a productive worker; but he probably is, since he contributes to the realization of surplus value. Yet when it comes to the man who plays the piano, whether to himself or to others, there is no question: he is not a productive worker at all. So piano-maker is base, but pianist superstructure. (Williams 1973, p. 6)

In fact, the last sentence here does not follow, because the difference between base and superstructure is not the same thing as the difference between productive and non-productive labour. Non-productive work, in the specifically Marxist and technical sense, is not thereby non-economic and thus ideological or superstructural. But apart from the issue of productive and non-productive labour, there is clearly a sense in which the piano-maker is base, and the pianist superstructure, and this is what is both interesting and confusing for the model. Perhaps a better example might be film-making, which is both an economic activity (in the sense of involving its own technological and economic conditions and determinants, as well as in the sense of being located in and affected by the general economic structures and relations of its surrounding society), and an ideological one (being involved in the business of reproducing, or perhaps subverting, ideology in representations).[23]

Williams' solution to this problem is to suggest we use rather more flexible definitions of 'base' and 'superstructure', seeing them as 'processes' rather than fixed entities.[24] If we do this, he argues, it will be easier to comprehend the interrelations of aspects

of each level, and the way in which they are analytically inseparable. What is lacking in the more static model, he says, is 'any adequate recognition of the indissoluble connections between material production, political and cultural institutions and activity, and consciousness' (Williams 1977a, p. 80). It is quite right to emphasise the dynamic nature of social structures, and to reject notions of economic base and superstructure which are 'uniform or static' (p. 82). It is also important to recognise that structures are composed of human activities, as Williams points out (though they are also more than that). But I am not sure this helps with this particular problem of defining the location of specific practices in terms of base and superstructure. After all, to insist that the two are indissolubly connected assumes in the first place that it is possible to identify discrete entities which *are* so connected. Analytically, even with a 'dynamic' conception of base and superstructure, there is still a problem concerning social facts or institutions which overlap this division. Redefining the concepts only helps to the extent that they are defined in such a vague manner that it becomes unclear where anything is located, and it therefore does not much matter. The answer is not that there is something wrong with the concepts (although I agree that there *is*, to the extent that they refer to static or uniform entities). It is rather that the real world is more complex than that, and that the concepts of base and superstructure have to be used carefully, recognising that things will not just fall neatly into one category or the other. This does not seem to me, either, to be any reason for abandoning these concepts, because it does not demonstrate that it is any less important to distinguish between the economic aspects of society (forces and relations of production) and its ideological aspects.

Williams also confronts the second problem with the base-superstructure model, namely the fact that it suggests a one-way relationship of determination. On this question he makes two suggestions: first that we conceive of the base as 'setting limits', rather than determining;[25] and secondly that we may replace the model of base and superstructure with one of 'totality'.[26] The idea of setting limits is opposed to a notion of 'prefiguration, production or control',[27] which he rejects as too deterministic. But the trouble with the notion of setting limits is that (i) we still need to know what kind of limits, and how they are set; (ii) there seems to be a suggestion that it is a weaker kind of determinism, which

allows people to 'escape' from it; and (iii) it is still, in any case, a kind of determinism, where what people do is conditioned by material and economic factors. Similarly, substituting the concept, derived from Lukács, of a 'totality' for what Williams calls the 'layered notion of a base and a consequent superstructure'[28] simply avoids the problem instead of confronting it. Williams is well aware of this danger, and is careful to insist that the concept of 'totality' can only be used in conjuction with 'that other crucial Marxist concept', 'hegemony'.[29] This concept, taken from the work of Antonio Gramsci, and meaning ideological and cultural domination by certain social groups, facilitates an analysis of the way in which political, cultural and other ideas are related to other social factors in a structured, though complex, manner.[30] Otherwise, as Williams points out, conceiving of society as a variety of social practices, all related to each other in an overall totality, rather than in a 'layered' model which accords primacy to certain sectors, risks abandoning altogether a historical materialist perspective. Like Williams,[31] I would be unwilling to withdraw from the claim that there is any process of determination.

Althusser and 'relative autonomy'

So if one retains the view that economic structures and practices are, in some sense, determinant in the course of historical development, and that consciousness and ideology are determined (or limited) by them, it is still necessary to rescue the model of base and superstructure from degeneration into a crude uni-directional model of determinism. In Marxist theory, the concept of 'relative autonomy' has been introduced to indicate that elements of the superstructure may not always be entirely determined by the base, and may, indeed, sometimes be historically effective themselves. Louis Althusser, in particular, has proposed this modification. Its authority derives mainly from a letter written in 1890 by Engels, defending himself and Marx against the charge of economic determinism.[32] The idea of 'relative autonomy' has been grasped with some relief by those unprepared to abandon historical materialism, but aware of the independent operation of politics, religion, or culture, at certain historical periods.

 Engels wrote to Bloch:

The economic situation is the basis, but the various elements of the superstructure – the political forms of the class struggle and its results: to wit constitutions established by the victorious class after a successful battle, etc., juridical forms, and then even the reflexes of all these actual struggles in the brains of the participants, political, juristic, philosophical theories, religious views and their further development into systems of dogmas – also exercise their influence upon the course of the historical struggles, and in many cases preponderate in determining their form.[33]

According to Althusser, the economy is determinant *in the last instance*; but the superstructure has its own *relative autonomy* and its *specific effectivity*.[34] The conditions of the 'specific effectivity' of the superstructure – of politics, for example – cannot at the moment be stated in general, however. Althusser argues that:

> *the theory of the specific effectivity of the superstructure and other 'circumstances' largely remains to be elaborated*; . . . this task is indispensable if we are to be able to express even propositions more precise than these approximations on the character of the *overdetermination* of Marxist contradiction, based primarily on the existence and nature of the superstructures. (Althusser 1969b, pp. 113–14)

I think this, rather than the concepts of 'relative autonomy' and 'determination in the last instance', is what raises new difficulties. It is correct to argue that in each historical period we need to investigate the specific effectivities of various 'levels' of society (or of the social formation, to use Althusser's own term). But it is not possible (or necessary) to develop a *general theory* of specific effectivities.

Althusser has often been criticised for only pretending to offer a solution. In particular, the notion of the 'last instance' has been attacked, for Althusser is thought to be invoking it in desperation so that his admission of the relative autonomy and effectivity of superstructures does not result in idealism (whereby it is ideas and consciousness which determine historical development), or, like the concept of 'totality', in abandoning any theory at all. If, as he

himself says in the same essay, 'the lonely hour of the "last instance" never comes' (Althusser, 1969b, p. 113), it is not easy to see what is left of a materialist theory of history, or what is actually meant by the statement that the economy is determinant in the last instance.[35]

One thing that is meant by this formulation is that although different superstructural levels – the political, the ideological, the religious, and so on – have their own 'effectivities', including that of a reciprocal action back on the base,[36] it is ultimately the economic – the mode of production – which determines when this occurs, and how.[37] The fact that the 'last instance' never comes only means that historically the economic is never the sole determinant.[38] But the extent of determination or effectivity of the superstructure is itself determined, ultimately, by the economic level. The second argument, contained in a later essay,[39] is that while it is the economic which determines the superstructure in general, the relative autonomy of the superstructures consists in the particular way in which these operate, and especially in their rôle in reproducing the relations of production. In this context, Althusser considers the 'ideological state apparatuses' like the family, the school, cultural ventures, etc.[40] Taken together, these two modifications of the base-superstructure metaphor constitute an important advance, for they retain the recognition of economic determinism without reducing this to a uniform and uni-directional process.

> The great theoretical advantage of the Marxist topography, i.e. of the spatial metaphor of the edifice (base and superstructure) is simultaneously that it reveals that questions of determination (or of index of effectivity) are crucial; that it reveals that it is the base which in the last instance determines the whole edifice; and that, as a consequence, it obliges us to pose the theoretical problem of the types of 'derivatory' effectivity peculiar to the superstructure, i.e. it obliges us to think what the Marxist tradition calls conjointly the relative autonomy of the super-structure and the reciprocal action of the superstructure on the base. (Althusser 1971d, p. 130)

This is not an uncritical acceptance of Althusser's views on ideology, for I am only concerned with one aspect of these here.[41] I

agree with Stuart Hall's assessment of Althusser's contribution to the base-superstructure debate, that it represents a 'seminal advance'.[42] The notion of determinacy is retained, but rendered acceptable, without connotations of necessary reductionism. The way is opened up for Marxist analyses of the levels of the superstructure *as* relatively autonomous realms, particularly with regard to their operation in the process of social reproduction.

The concept of 'relative autonomy' only poses problems when it is thought to be the basis of some *a priori* model of social analysis, where, for example, the extent and nature of this autonomy ought to be able to be specified in general theoretical terms. For example, Paul Hirst argues that in rejecting economism (or reductionism), Althusser cannot then retain any notion of determinacy; the concept of *relative* autonomy is untenable:[43] 'Once any degree of autonomous action is accorded to political forces as means of representation *vis-à-vis* classes of economic agents, then there is no necessary correspondence between the forces that appear in the political (and what they "represent") and economic classes' (Hirst 1977, p. 130). In other words, superstructures are completely, not relatively, autonomous.[44] Now it may be that Althusser or Poulantzas (Hirst's other target in this essay) has wrongly analysed the specific nature of the political structure at a particular historical moment. If so, this is an empirical, historical weakness, and not an inadequacy in theory, although it may be influenced or caused by a particular theoretical prejudice (like economism, for example). But the dispute about a concrete case, and the extent of autonomy – relative or total – of the political from the economic, cannot be used to make a logical point about a necessary choice between economism and 'non-correspondence'. The matter of whether the political is more or less autonomous in a particular situation is a question for historical investigation. The question of whether in general the political is completely autonomous of the economic is *also* an historical one, to be answered only by reference to a broader historical range and by discovering the extent to which, and the occasions on which, *in general* political and other superstructural features are determined by economic ones, or have a reciprocal effect on these.[45]

The relative autonomy of art and literature

Cultural production, then, as part of the level of ideology and of the superstructure, is relatively autonomous. At certain historical moments, and in certain conditions, it is more or less independent of economic determination, and in some cases can also be historically effective and a force for change. Eagleton has shown that in relation to literary production, it is necessary to take into account the specific historical relations between the general mode of production and the general ideology of a society, and the literary mode of production and the existing aesthetic ideology of that period, in order to discover the degree of autonomy and effectivity of literature in each case.[46] For example, the social relations of the literary mode of production (the way in which books are produced and distributed) are 'in general determined by' the social relations of the general mode of production, although not entirely.

> In developed capitalist social formations, the dominant LMP of large-scale capitalist printing, publishing and distributing reproduces the dominant GMP, but incorporates as a crucial constituent a *subordinate* mode of production: the artisanal mode of the literary producer himself, who typically sells his product (manuscript) rather than his labour-power to the publisher in exchange for a fee. (Eagleton 1976a, p. 51)

Literary production is also affected by general ideology, particu-larly its linguistic and political aspects. As an example, Eagleton cites as a 'radically political act' Milton's decision to write *Paradise Lost* in his native tongue; its radical nature is only comprehensible in the context of the contemporary ideological and linguistic structures. Literacy is another important factor, deter-mined 'in the last instance' by the general mode of production, but in turn a significant determinant of the literary mode of production (p. 58). Again, the relationship between ideology and literature is not simple or uniform.

> . . . different LMPs may, in terms of the ideological character of their textual products, reproduce the same ideological formation. There is no necessary homology between GI (General Ideology) and LMP: a serialised and directly published Victorian novel, despite belonging to alternative modes of

production, may inhabit the same ideology. Conversely, the same LMP may reproduce mutually antagonistic ideological formations: the fiction of Defoe and Fielding. An LMP which reproduces the social relations of the GMP may conflict with some of its dominant ideological modes: the Romantic dissent from bourgeois values and relations is in part determined by the very integration of the LMP into general commodity production. Conversely, an LMP in conflict with GMP social relations may nevertheless reproduce its dominant ideological forms. (pp. 57–8)

Moreover, particular aesthetic ideologies may be determinant, restricting the possibility of certain forms of expression, or facilitating new or radical departures. Although Eagleton indicates that it is usually the general ideology which determines the relative autonomy of the aesthetic (p. 62), presumably it is also possible for the aesthetic to influence ideas in general. (However, clearly not all permutations are possible. No possible change in the literary mode of production could conceivably react back to transform the general mode of production, except perhaps exceedingly indirectly, through aesthetic ideology, then consciousness in general, then political activity.)

The conditions under which art may be effective, politically and historically, are determined both by the nature of cultural production at that moment, and its possibilities, and by the nature of the contemporary society, and in particular of its general ideology. In a society where artistic production is highly ritualised, leaving little room for innovation of form or introduction of new or radical content, then the potential effectivity of art is obviously severely restricted. In a society where culture is restricted to a very small minority, or to the dominant group, then again its transformative power is extremely limited, whatever the aesthetic conventions prevailing. This means that any attempt at political intervention through cultural politics cannot be made in ignorance of these conditions, but must be based on an analysis of the specific relations of culture, ideology and society. That is why sweeping demands for cultural activism are both meaningless and pointless. Unless it is firmly linked with an understanding of contemporary cultural production, cultural intervention may be impossible, inappropriate, or completely ineffective.[47] In the rest

of this chapter, I want to look at some debates about the kind of art and culture which have been thought to be most effective, and the conditions under which this would be so. Although I begin by discussing these as two separate issues, it will become clear that they are necessarily connected.

Cultural politics: the rôle of various art forms

A good deal of the discussion in the classic debates about commitment in art centred on literature and drama,[48] possibly because a cultural form with narrative content can be more easily related to political ideas than one (like music) without, the visual arts, particularly insofar as they are figurative, coming somewhere in the middle. But it is not quite as straightforward as this, and it seems to me to be quite possible and useful to discuss culture generally in this context, remaining aware that each cultural form has its own conditions of production and its own specific codes of representation. Benjamin, for example, talked about film, poetry and photolithography, as well as about drama. Adorno investigated the revolutionary potential, or lack of it, in music, the mass media and literature. The debates in the Soviet Union up to about 1930 covered literature, painting, film and popular culture.[49] Today in Britain there is a convergence of ideas and work from people involved in the different media, and as well as specialist journals on film (*Screen*), literature (*Literature and History*, *Red Letters*), and the media (*Media, Culture and Society*), there are often pieces in all of these on cultural politics in general. There are also feminist journals which publish articles on questions of cultural practice and analysis (*m/f*, *Feminist Review*), and journals covering the broad range of cultural forms in relation to the question of commitment and political intervention (*Wedge*, *New Left Review*, *The Leveller*).[50] This is not to argue for a unified or global understanding of cultural politics, however, for just as the conditions of cultural production vary within one cultural form, from one period to another, and from one sector to another, so these conditions will be significantly different from one cultural form to the next. Nevertheless, I shall continue to talk about the arts in general, and to move from literature to popular music to television without constantly inserting provisos, in the conviction that problems of cultural politics are similar in enough

relevant respects in all these arenas to allow me to do so.

Marxist literary criticism: the orthodox and para-Marxist traditions

George Steiner has distinguished between the *orthodox* and the *para-Marxist* traditions in Marxist literary criticism.[51] The former, originating from a programmatic statement by Lenin on party literature (which, incidentally, Steiner acknowledges not to be representative of Lenin's views on literature in general, but to have been an explicitly polemical and tactical statement),[52] equates good literature with 'correct' political line. It is a question, on this view, of taking a stance, following the Party view, and basing one's writing on this political position. This is what is sometimes called 'tendency-literature'. The para-Marxist position, on the other hand, following some comments made by Engels,[53] opposes explicit political commitment in literature. Engels, and, following him, Lukács, believed that good literature displays an understanding of social reality, and portrays this in fictional form, without the author imposing political comment from outside. Rather, the political and social analysis and critique should emerge from within the text. This means, in fact, that a text might be 'realistic' in this way even without the author's conscious understanding of the nature of contemporary social reality. It is well known that both Marx and Engels admired the writings of authors who were not only not socialists, but were actually in reaction to the bourgeois revolution; Balzac is the best known example, preferred by Engels to Zola, despite the latter's commitment to radical causes, and despite Balzac's Royalist ideology. Most of the authors who merit Lukács' greatest praise (Balzac, Tolstoy, Mann, Solzhenitsyn) would certainly fail the test of 'correct' political understanding and commitment.

Not surprisingly, Steiner's argument is that the second Marxist tradition has a good deal more to offer to literary criticism than the first, and indeed it would be difficult to find many serious proponents of the view that good literature consists in explicit political message.[54] One important reason for this is that it completely ignores any questions of the literary qualities of the work, quite apart from the question of political strategy of argument rather than assertion. Benjamin criticises tendency-

literature on these grounds: 'One can declare that a work which exhibits the right tendency need show no further quality. Or one can decree that a work which exhibits the right tendency must, of necessity, show every other quality as well. This second formulation is not without interest; more, it is correct. I make it my own' (Benjamin 1973b, p. 86).[55] He goes on to argue that 'the tendency of a work of literature can be politically correct only if it is also correct in the literary sense' (p. 86). Tendency-literature, then, is usually rejected both because it over-simplifies political analysis, and because it distorts and abuses the literary form in merely using it as a vehicle for propaganda.

Still, the question is about cultural politics, and this is above all a question of education and mobilisation through culture. If crude tendency-literature (and its parallels in film and the other arts) is to be rejected, what Steiner calls the para-Marxist tradition may not have much to put in its place. The major figures in this tradition, among whom I would include Lukács and Goldmann, were not actually much concerned with cultural politics, but more with the sociological definition of 'great' works of literature.[56] Thus, the evaluation of texts is on the basis of whether or not they depict existing social contradictions and tendencies in a realistic manner, and not on the basis of whether they will thereby have any social and political effects. For a concern with the latter, we have to look at another direction taken by Marxist aesthetics, not discussed by Steiner, namely the neo-Marxism of members and associates of the Frankfurt School.[57]

The neo-Marxist approach and the Frankfurt School

Despite some other very great differences between them, Adorno, Marcuse and Brecht shared the view that the radical potential of the arts lies in innovation in artistic form.[58] In this connection, Adorno contrasts the music of Schoenberg with that of Stravinsky. With the invention of the twelve-tone scale, and the refusal to allow audiences and listeners to sit back passively and consume his music, Schoenberg provides the conditions of critical involvement, rather than unthinking assimilation.

Schoenberg's music demands from the very beginning active and concentrated participation, the most acute attention to

simultaneous multiplicity, the renunciation of the customary
crutches of a listening which always knows what to expect . . . It
requires the listener spontaneously to compose its inner move-
ment and demands of him not mere contemplation but praxis.
(Adorno 1967b, pp. 149–50)

Stravinsky's music, on the other hand, although apparently
innovative in its time, is only superficially so, and fails to engage
the listener in an active-critical moment.[59] As for jazz, according
to Adorno, '. . . the so-called improvisations are actually reduced
to the more or less feeble rehashing of basic formulas in which the
scheme shines through at every moment' (Adorno 1967c, p. 123).
Jazz, like other products of what Adorno and Horkheimer
called 'the culture industry', demands 'psychological regression'
(p. 123) and denies individuality and individual needs, while
pretending to acknowledge and gratify them (p. 126). Only that art
is radical which subverts both the traditional, incorporated forms
of art, and the commodity nature of the contemporary production
of art. Otherwise art, whether highbrow or popular, retains its
'affirmative character' (p. 126).

Marcuse elaborates the 'affirmative character of culture' in an
early essay of this title.[60] The arts may express and depict great
inequalities and suffering, but because these are transposed on to
the aesthetic level, they simply act in a cathartic manner, and in the
process *affirm* the existing social relations. They discourage
critical thought, and 'pacify rebellious desire' (Marcuse 1968,
p. 121). Moreover, affirmative culture procures political acqui-
escence by presenting false resolutions of conflict and artificial
harmonies in the aesthetic sphere. The solution, therefore, is to
eliminate affirmative culture. Unlike Adorno, Marcuse does not
have any concrete suggestions in his early essays as to how this
might be done – or how a *negating* culture might be substituted for
affirmative culture. In 1968, he discerned in the student movement
the possibilities for such a cultural negation, in the 'new
sensibility' of blues, jazz and rock'n'roll, of flower power, 'erotic
belligerency' and long hair (Marcuse 1969, p. 36).[61]

What both these writers have in common with Brecht is the
belief that culture can only be challenged, and consciousness
raised, by experimenting with new forms of art, which involve the
audience in a more active manner than the traditional forms.[62]

Brecht's notion of 'epic theatre' depends on devices which constantly shock audiences out of passivity, and also refuse to let them forget that they *are* watching a play. The 'alienation-effect' of epic theatre might use strategies (novel at the time) of getting an actor to break into song, or to address the audience directly in the middle of a scene; of having a woman play a man's rôle; of making scene-shifting visible and obvious.[63] Benjamin refers to this policy of removing the traditional divisions between stage and audience as 'the filling-in of the orchestra pit'.[64] The illusion of theatre is destroyed, and social and political conditions are not so much represented in the play, as revealed to the audience, which is compelled, with the actors, to think about them.

It is perfectly true that, as Marcuse says, a playwright may include the most revolutionary ideas in his or her play, but this will not necessarily make the audience revolutionary. Even if the play is not simply slated in the press and jeered off the stage, audiences can, of course, incorporate such ideas into their everyday view of the world either by regarding them as somebody else's views, or by separating off the world of the play from the *real* world. This is what lies behind the argument that it is only when plays take on a new form that audiences will be unable to leave the theatre without being affected by the social and political critique of the play. Unfortunately, there is a limit to the degree of novelty which the arts can contain, and, particularly in the years since Brecht's first experiments with theatre, dramatic and literary innovation have become a commonplace in the west, at least with certain audiences.[65] Adorno said 'To be true to Schoenberg is to warn against all twelve-tone schools',[66] for what was innovative in the first instance becomes habit and tradition very soon – even by the time Schoenberg wrote his later works. Similarly with drama, it is difficult to see what effects would now 'shock' audiences, after the Living Theatre, and the 'happenings' of the 1960s.[67] Recent work on film has suggested more subtle ways in which the dominant modes of film-making can be subverted, in particular by refusing the traditional 'realistic' codes of representation. In this work, film theorists have explicitly taken Brechtian ideas as their starting point, and have been aided by the considerable developments in semiotics (understanding *how* codes represent reality to us, in order to devise alternatives which expose rather than reflect that reality).[68]

Bourgeois ideology is located not simply in the 'content' of a television programme or film in the orthodox sense – changing plots, narrative or characterisation is inadequate as a strategy. Bourgeois ideology resides precisely in the way that a particular 'reality' is constructed in the media – in the signs or 'chains of signification' which go to make up the 'language' of television or film or the theatre. Things like camera angles, conventions of representation, lighting, editing, 'pace' – all techniques which are seen as 'natural' – act as codes of meaning to construct a particular (bourgeois) reality. Once this is grasped . . . then we can see that a central part of any strategy of 'oppositional' cinema or theatre or music . . . must lie in what has been called 'the subversion of codes', the deconstruction of codes in which a bourgeois worldview, via the media, is located. (Gardner 1979, p. 7)

Socialist film-makers have tried to break the realist illusion of film by using lighting, the camera, editing, casting and so on, in unconventional and disruptive ways.[69]

Reaching the audience

In the end, the debates about political content, or radical form, or subversion of codes, all centre on the question of audiences. It is a question of which technique of cultural intervention will, some-how, affect audiences, and it also is a question of who those audiences are. One of Brecht's arguments with Lukács was based on the changed nature of contemporary audiences, rendering what was 'realist' to a nineteenth-century reader completely lacking in realism to twentieth-century audiences.[70] As he says, 'Reality changes; in order to represent it, modes of representation must change' (Brecht 1974, p. 51). Moreover, 'what was popular yesterday is not today, for the people today are not what they were yesterday' (p. 51). Transformations in cultural practice cannot take place in abstraction from consideration of who these are for. It may be that it is historically more appropriate to concentrate efforts in cultural politics on one medium rather than another, particularly if the intention is to reach as wide an audience as possible. Malcolm Imrie's criticism of the journal *Red Letters* is, amongst other things, on these grounds . . . 'But why *just* 'Litera-

ture'? It is hardly the area in which cultural hegemony is at its strongest' (Imrie 1977, p. 43).

Dave Laing has suggested that it is more important to work in cinema and television than in the theatre, since it is here that we find 'the potent images and forms through which the dominant ideology is diffused' (Laing 1977, p. 56). It has been a familiar criticism made of some Marxists by others that their concentration on the 'high' arts, or on the avant-garde, is élitist, since the majority of the population does not go to listen to Schoenberg's music, watch Brecht's plays, or participate in the student and hippie culture.

There does not have to be a choice made between street theatre and the West End, between writing for television and writing for fringe theatre, or between recording rock music for a commercial record company and playing at Rock against Racism concerts. Obviously in some cases the potential audience is a great deal larger than in others; equally obviously, the organisational constraints of the media and the commercial 'culture industry' will affect and compromise cultural products less in independent and small-scale ventures.[71] It will not always be possible to intervene in any one particular arena, but where it is, then all these areas are important. As Raymond Williams has said in an interview: 'You run radical theatre groups wherever you can but at the same time you really do think seriously about establishment theatre and about establishment broadcasting' (Williams 1979b, p. 26).

Inasmuch as the potentially transformative rôle of art is in changing consciousness, then all these cultural arenas are locations where this may occur, on a smaller or a larger scale. However, apart from the issue of size of audience, there is an important distinction about kinds of audience which should not be overlooked. The charge of the anti-élitists can often be too crude, ignoring the fact that it is also important to consider the ideology of professionals, intellectuals and members of the bourgeoisie, and resting on a kind of cultural 'workerism'. But it is more important, strategically and in the light of the kind of analysis of ideology and its structural determinants which I have been proposing throughout, to consider and engage with the ideology of the dominated classes in society. It is 'popular consciousness' which is essential to the stability of our present society, and which is also vital to any ideological change, from the recognition and rejection of sexism to

the understanding of the class nature of society. For this reason, I agree with Laing's argument of the importance of the assessment of the present location of the determinants of popular consciousness.

This comes back again to the question of modes of representation. There is vexed debate on this, around the issue of whether or not the majority of the population will even take seriously a 'modernist' text or film (like the films of Godard, for example). The subversion of realism in contemporary codes may be a political necessity from one point of view, but this has to be counterposed to the real problem of accessibility to popular audiences. The playwright Trevor Griffiths has used the notion of 'strategic penetration' to explain his own use of traditional, naturalist techniques in writing for television.[72] He argues that it is most important to him that his plays should be accessible to large audiences, to whom he is able to convey his ideas, and that at the moment naturalism, or realism, is the dominant mode in which people see and understand television drama.[73] It is an open question, of course, the answer to which would depend on audience research, as to what the very large audiences who saw his television serial, *Bill Brand*, actually made of it, and whether in any way it changed their ideas about political matters.[74]

The techniques and styles of cultural intervention are therefore closely related to the context and conditions of its occurrence. It is not possible to say, in the abstract, that realist or naturalist modes of representation are always wrong (affirmative, or incorporated, or recuperable), because realism may be the *only* possible language of communication for a particular audience. It is true that the dominant modes of representation, by their very nature, reinforce and confirm existing ideology. But, as Claire Johnston has said in relation to cinema: 'For a Marxist film culture to exist, film theory and film-making practice need to be conceived in terms of a social practice addressing a particular audience in a particular conjuncture' (Johnston 1979, p. 86). The nature of the audience and the way in which it 'reads' cultural products cannot be taken for granted, and certainly cannot be assumed to be unchanging. (The following chapter takes up some questions of the reception of art by audiences.) And the nature of the audience is determined, amongst other things, by the nature and practice of culture in general in that society (Eagleton's 'literary mode of production'

and 'aesthetic ideology'), by the general ideology of that society and of its sub-divisions, and by the general mode of production and relations of production of that society. In other words, the possibility for the reception of radical or 'negative' culture is itself determined by the economic base, and by the extent and type of autonomy accorded to general and aesthetic ideology by the stage of development of that society.

But it is also important to recognise that this is equally true from the point of view of the cultural producer. The cultural producer is not just someone with political understanding, free to experiment in whatever way is most appropriate to reach cultural consumers. The conditions of production are just as much determined by social, ideological and broad cultural structures as the conditions of consumption.[75] The artist/cultural producer is confronted with certain materials with which to work – existing aesthetic codes and conventions, techniques and tools of production – and is, moreover, himself or herself formed in ideology and in social context.[76] The concept of cultural politics is not founded on a notion of the cultural producer as a 'free' agent. In this sense, recognising and analysing the politically effective rôle of art does not amount to rejecting the materialist understanding of ideology and of culture within ideology. The political consciousness of, and the possibilities of aesthetic innovation for, the artist are constructed in the social historical process.

Chapter 5

Interpretation as Re-creation

Consumption produces production... because a product becomes a real product only by being consumed. For example, a garment becomes a real garment only in the act of being worn; a house where no one lives is in fact not a real house; thus the product, unlike a mere natural object, proves itself to be, *becomes*, a product only through consumption. Only by decomposing the product does consumption give the product the finishing touch. (Marx 1973, p. 91)

We have already seen that an important part of the sociological understanding of art and culture is an analysis of the audience – the cultural consumers (pp. 91– 4). This is the case in relation to the question of cultural politics, because the appropriate methods of cultural intervention can only be developed in conjunction with a correct perception of the prospective audience, and the manner in which the intended message will be received. But it is also the case in a much broader sense, indicated by the quotation from Marx. The reader, viewer, or audience is actively involved in the construction of the work of art, and without the act of reception/ consumption, the cultural product is incomplete. This is not to say that consumption is simultaneous with production, but that it complements and completes it. This recognition of the active rôle of the reader has come from a variety of approaches to the sociology of art, including semiotics, hermeneutic theory and the phenomenology of perception. In this chapter I shall review some of these theories, and examine what is meant by the claim that the

reader 'creates' the text, with particular attention to theories of interpretation. I shall also look at some of the problems this raises for any notion of the 'objective' meaning of texts or other cultural products.

The study of audiences

An interest by sociologists in the composition and response of audiences for the arts is by no means new. Ian Watt's book on the rise of the novel pays some attention to the reading public to which the novel was addressed, and Q. D. Leavis's early study of the reading public in Britain in the eighteenth and nineteenth centuries, written in the 1930s, was followed by a number of studies of literacy and of the reading public.[1] Empirical studies of other cultural consumers, of music, painting, and the performing arts in general, are also numerous.[2] The work of Pierre Bourdieu and his associates has combined an empirical interest in arts audiences with a theoretical focus on the nature of culture and its distribution in society, using the notion of 'cultural capital' to demonstrate the interdependence of access to culture with economic and political position.[3]

Limitations of the empirical approach

This sort of investigation is valuable, because it is important for the sociologist of the arts to know the constitution of audiences and the nature of audience response. But many of these studies, possibly with the exception of the work of Bourdieu and his followers, can now be seen to be rather limited in their empiricist focus on audience composition. They have generally taken for granted the cultural product itself, as well as the process of its production, and have assumed as unproblematic many of the issues I have discussed in earlier chapters: the institutions of artistic production, the rôle of the artist, the ideological and the aesthetic nature of the work of art itself.[4] Moreover, they usually operate with an inadequate conception of the audience/reader, failing to analyse the ideological construction of the latter, and often ignoring the broader social and historical determinants of the audience as a particular group. Indeed, the theoretical development of work in the sociology of art has been partly a response to what was felt to be

an inadequacy in the ahistorical and empiricist nature of audience studies.

Limitations of 'materialist aesthetics'

On the other hand, theories of artistic production, including what has been termed 'materialist aesthetics', have too often concentrated either on the nature of cultural production, or on the text or work itself, or on both of these, at the expense of the other vital moment in the process – the reception of works of art.[5] Reception cannot be taken for granted, or treated as unproblematic. Audiences and readers cannot be treated as passive consumers, absorbing the messages communicated in texts, paintings or television programmes which have been constructed by cultural producers and transmitted in a transparent manner through the medium. To use another metaphor, what Andrew Tudor has referred to as the 'hypodermic model' of audiences, where cultural messages (in this case, in the cinema) are 'injected' into audiences, is an entirely incorrect account of what actually happens when people read books, watch films, and listen to television news.[6] In fact, the meaning which audiences 'read' in texts and other cultural products is partly constructed *by* those audiences. Cultural codes, including language itself, are complex and dense systems of meaning, permeated by innumerable sets of connotations and significations. This means that they can be read in different ways, with different emphases, and also in a more or less critical or detached frame of mind.[7] In short, any reading of any cultural product is an act of interpretation. As George Steiner says: 'When we read or hear any language-statement from the past, be it *Leviticus* or last year's best-seller, we translate' (Steiner 1975, p. 28).[8] And the way in which we 'translate' or interpret particular works is always determined by our own perspective and our own position in ideology. This means that the sociology of art cannot simply discuss 'the meaning' of a novel or a painting, without reference to the question of *who* reads or sees it, and *how*. In this sense, a sociology of cultural production must be supplemented with, and integrated into, a sociology of cultural reception.

Hermeneutics and textual interpretation

Hermeneutics is the study, or theory, of interpretation. In its modern form, it includes quite a wide variety of versions of the theory of interpretation, which often differ on crucial issues.[9] In general, hermeneutic studies cover the broad area of the social and cultural sciences, dealing with the problem of interpretation between people, groups of people, and different periods in general. In some cases specific cultural products are taken as paradigm cases of interpretation, chosen for special consideration because they highlight concisely the problems involved in the hermeneutic exercise.[10] Here I am discussing hermeneutic theory specifically for its relevance to the problem of the interpretation of texts and other cultural products. One of the major divergences we find within hermeneutics is on the question of whether there can, in principle, be a *correct* interpretation of a text.

'Correct' textual interpretation: E. D. Hirsch

E. D. Hirsch Jr. has argued strongly in favour of the possibility of valid interpretation.[11] With particular reference to the interpretation of literary texts, he recognises that there are always problems of interpretation, arising from the fact that readers are unfamiliar with the genre, or with the author's repertoire of language, or with the period from which the text dates. Nevertheless, his view is that there is a 'correct' interpretation, which it is the job of literary scholarship to attain. This is the author's own original meaning.[12] While recognising that new readers may always draw new, and unintended, significances from a text, he maintains that this is not the same thing as discovering the original, and intended, *meaning*.[13] Hirsch inveighs against 'dogmatic relativists' and 'cognitive atheists' (Hirsch 1976, p. 3) who believe that meaning necessarily changes with every reader and that there is no determinacy or priority of authorial meaning. In his earlier book, he details the techniques by which we can try to rediscover the author's meaning,[14] although he also admits that we can never know for sure whether our interpretation is in fact correct:

> Even though we can never be certain that our interpretive guesses are correct, we know that they *can* be correct and that the goal of interpretation as a discipline is constantly to increase

the probability that they are correct. . . . Only one interpretive problem can be answered with objectivity: 'What, in all probability, did the author mean to convey?'. (Hirsch 1967, p. 207)

The resolution of the confrontation between Hirsch's position and that of the 'dogmatic relativists', notably H.-G. Gadamer, lies partly in this admission of the impossibility of absolute certainty. But the strongest relativist position maintains that the author's meaning is not even *in principle* recoverable, and it is this view which Hirsch firmly contests.

If Hirsch is right, the implication for the sociology of literature is that the study of readers is a secondary matter. That is to say, because there is an identifiable (though not always attainable) textual determinacy, which consists in the author's intended meaning, then the primary focus for a sociology of literature is this meaning and its production. Only secondarily will we need to investigate the consumption of literature, in order to see how far readers have understood or misunderstood this meaning. However, radical hermeneutics rejects this order of priority, which gives the text and its production a privileged position over the reader in the constitution of textual meaning. Depending on *how* radical a hermeneutics one adopts, the alternative view is either that reader and author (present and past) together constitute meaning (Gadamer); or that only the reader creates the text, the author being totally irrelevant and therefore, as Hirsch says (1967, p. 3) 'ruthlessly banished' (Barthes, certain New Critics). In either case, the central importance of authorial meaning is denied. I shall concentrate here on the moderate version of hermeneutic relativism, particularly as developed by Gadamer,[15] for reasons which I think will become clear later.

Moderate relativism: H.-G. Gadamer

The fundamental proposition of Gadamer's hermeneutics is that understanding is always from the point of view of the person who understands. Historical understanding cannot ever consist in somehow transposing oneself into the past, or in some act of direct empathy with another person (social actor, author or anyone else). One's own present and 'historicity' invariably enter the hermeneu-

tic act, and therefore colour the understanding itself. Gadamer, following Heidegger, argues that it is impossible to eliminate the self from the act of interpretation, and that interpretation is therefore always *re*-interpretation, from the point of view of the present. Since this is an ontological, not a methodological, point (describing the essential nature of human existence and communication), it is not a question of trying to find a better or more 'objective' method of interpretation. Interpretation simply *is* what Gadamer calls 'a fusion of horizons' (of past and present, or author and reader). This is because the consciousness of the contemporary reader, or historian, is itself historical. Gadamer makes respectable again the notion of 'prejudice', which since the Enlightenment has increasingly come to mean something which scientific knowledge will expunge from its methods of enquiry.[16] If we did not have prejudices or preconceptions about what to expect in a text, we would have no way of approaching it in the first place. Prejudices are 'conditions of understanding' (Gadamer 1975, p. 245). What happens when we understand or interpret something is that we begin with a certain idea of what it might mean, or what to look for. This idea arises in our own existential-historical situation. In Gadamer's words: 'Prejudices are not necessarily unjustified and erroneous, so that they inevitably distort the truth. In fact, the historicity of our existence entails that prejudices, in the literal sense of the word, constitute the initial directedness of our whole ability to experience' (Gadamer 1976, p. 9).

As Gadamer rightly points out (and as the philosophy of science has increasingly come to realise[17]), the notion of the investigator as a value-free, ahistorical, pure subject is a myth created by the over-enthusiastic rationalist heritage of the Enlightenment.

This does not result in the complete relativism which Hirsch fears, however. Gadamer distinguishes prejudices from 'false judgments',[18] and maintains that a good historian, while necessarily starting from his or her own prejudices, will make these prejudices conscious, and will also retain an openness to the past, or the text, allowing the initial prejudices to be corrected by what is actually contained in the text. The concept of the 'hermeneutic circle' describes the process of interpretation as an essentially interactive one. The interpreter approaches the material with certain preconceived ideas about it, projecting meanings on to it,

and anticipating its nature. In the light of his or her contact with the material, those preconceptions can then be modified, and a 'circular' process of projection and modification eventually allows the interpreter to achieve a satisfactory understanding:

> If we examine the situation more closely, however, we find that meanings cannot be understood in an arbitrary way. Just as we cannot continually misunderstand the use of a word without its affecting the meaning of the whole, so we cannot hold blindly to our own fore-meaning of the thing if we would understand the meaning of another. . . All that is asked is that we remain open to the meaning of the other person or of the text. (Gadamer 1975, p. 238)

Gadamer also describes this as a logic of question and answer, whereby we 'ask questions' of the text, but remain open to the answers it gives to those questions (p. 326). But it is important to see that what Gadamer means by a 'satisfactory understanding' is not one which is as close as possible to the author's original meaning. It is always a mediation between author and reader, past and present, based on the historicity and preconceptions of the reader, but allowing the text, the author, the 'other' to 'speak for itself/himself'. In this, understanding goes beyond the author of the text: 'Understanding is not merely a reproductive, but always a productive attitude as well' (Gadamer 1975, p. 264).[19]

Clearly Gadamer is not admitting the kind of infinite licence of reading which Hirsch attacks; authorial meaning, or at least textual autonomy, plays an important part in the joint production of meaning which is achieved in the fusion of horizons. Possibly there is a point of reconciliation of their positions. Gadamer argues that it is never possible for a reader to reproduce the author's original meaning, and Hirsch agrees that in practice this may not be possible (and, moreover, that we could never know for sure if we *had* done so). They both agree that the reader's position affects the reading. And Gadamer has not banished the author altogether; his position is not as iconoclastic as Hirsch sometimes suggests. But although in the end they may both accept that textual reading is inevitably permeated with contemporary meanings, and is in this sense *re*-reading, the major difference between them is that for Hirsch this remains an unfortunate fact, which it is the task of the

literary critic to rectify, whereas for Gadamer there is nothing unfortunate about it, and neither is there any question of rectifying it.[20] In this sense, his position is more 'relativist' than Hirsch's, because, without the imperative to pursue original, determinate meaning, hermeneutics accepts that textual meaning is always re-created by new readers. This is not to say, however, that *any* meanings may be imposed on a text, since the logic of 'openness' and of the hermeneutic circle guarantees an anchoring in a certain range of possibilities offered by the text.[21]

The two hermeneutic theories

Although I have concluded that there is an essential difference between these two hermeneutic theories of the text, my own view is that a correct account of the reading of texts involves some kind of compromise between the two positions. Reading is always from the point of view of the historical and existential present of the reader, and therefore it is always a 'production' of meaning in Gadamer's sense. (It may, even with the intention of the author, be a completely 'open' reading, using the text merely as a starting-point from which individual resonances and significances can be allowed to flow for the reader; since this is a more 'radically relativist' position than Gadamer's, I leave it to one side here.) However, it is also a possible task for the literary critic to attempt to reconstruct the author's original meaning, though the critic will always be constrained and directed by his or her own perspective, and this reconstruction will never be complete. To put this a little more strongly, authorial meaning does indeed have some sort of priority over other readings, and therefore biographical and other information about authors is relevant for the study of literature (though not for the *reading* of novels). But this is not an argument for any kind of 'valid' interpretation, and here I disagree with Hirsch. What is far more important than the fact that, as a literary critical exercise, we may attempt to recover an author's meaning, is the fact that this meaning is effectively dead. What an author intended, or even what an author meant to his or her contemporary public and first readers, is only of interest insofar as that original meaning has historically informed the present reading of the text. The way in which we read a particular novel now, for example, may be conditioned by the history of its reception by earlier

readers, as well as by its author's meaning.[22] Whether it is or not, what is important for the sociology of reception is the actual reading of that text by a modern reader. It makes little sense to talk of this as being, or not being, 'valid' or 'correct'. A sociology of literature in general, of course, would incorporate original meaning (and its construction), mediation of that meaning through, for example, a series of critics, and meaning attached to the work by any new reader, as well as the interrelations between these.

The 'critique of ideology'

So far I have argued that the recovery of any 'original' meaning is, at least in practice, not possible, and that the way in which we understand, or 'read', texts, films, or paintings is a function of our own position, and therefore changes from one period to another and one viewpoint to another. This raises the problem of how it is possible to say that one interpretation of, say, a painting is any better than another. For example, on what 'objective' grounds did I earlier approve Berger's interpretation of Gainsborough's painting against that of his critics (pp. 55–6)? Marxism has provided some sort of solution to this problem of relativism, locating 'correct' readings outside the bounds of hermeneutics. This is most explicitly addressed in the work of the descendents of the early Frankfurt School, notably K. O. Apel and Jürgen Habermas.[23] Lucien Goldmann offers a similar analysis, in defence of his claim to have presented an objective reading of Racine's plays.[24] In both cases, it is a question of supplementing hermeneutics with a sociology of knowledge. As well as interpreting meanings (in a text, in some individual action, or in an historical event), the social scientist must also *locate* those meanings in the context which gave rise to them; that is to say, their essentially ideological character should be perceived and penetrated.

Lucien Goldmann

Goldmann distinguishes between understanding and explanation.[25] The former involves the interpretation of Racine's plays, in terms of their content and structural composition. Explanation, on the other hand, consists in situating the plays in the wider

structures in which they originate and which they express (in particular the social and ideological structures of seventeenth-century France). A work of literature is only explained when its historical location is determined. Goldmann is not naîve about the methodological implications for the sociologist, who will also inevitably be situated in a specific historical and class position: 'There is no effective weapon for suppressing implicit preconceptions once and for all' (Goldmann 1969, p. 61). The sociologist must relate all positions, including his or her own, to their social infrastructures, in order to discover their meaning (p. 61).[26]

The Frankfurt School

In the debate between Gadamer and the later members of the Frankfurt School, the concept of 'critique of ideology' is proposed by the latter as a necessary complement to the hermeneutic method. Habermas and Apel both recognise the importance, and indeed the inevitability, of the hermeneutic aspect of sociological enquiry,[27] agreeing with Gadamer that as sociologists we necessarily engage in this interpretative activity in relation to our subject-matter.[28] But they also argue that, as sociologists, we need to go beyond interpretation. Critical social science *explains*[29] meanings and ideologies, by disclosing the social and material interests which give rise to them. This makes it possible, for example, to talk about 'false consciousness' and to see how certain meanings are imposed on society or on certain groups or individuals by complex processes. Hermeneutics can only give us access to meanings (always, of course, from our own point of view, and in our own interpretation of those meanings). As a method, it cannot provide a sociology of meanings. Any changes in ideology, any new developments in aesthetic ideas, any generation of ideological conflict remain unexplained. Meanings, texts, values and ideas are simply taken as given, the task being to interpret them. Critical sociology, however, has to explain their origin, nature and development. As Apel puts it, the critique of ideology refuses to take meanings and beliefs as 'transparent', but undertakes to examine their construction in the real conditions of social life.[30] We refrain from 'taking seriously' what a person thinks or believes, but instead, in an act of 'partially suspended

communication',[31] we take what is said as a *symptom* of the objective situation.[32] This is to step outside the hermeneutic circle in order to situate and explain human meanings. Keat and Urry also take the view that critical sociology must involve 'both interpretive and explanatory understanding'.

> We need interpretive understanding to identify the intentions of individual agents, and the contents of the systems of belief and value that are present in a given society. But this must be combined with an analysis of how an agent's acceptance of such beliefs and values is causally operative in his or her actions; and of how systems of belief are causally related to the structural relations and mechanisms present in specific social formations. (Keat and Urry 1975, p. 227)[33]

A new objectivity

The critique of ideology returns us to the kind of analysis which I have already argued is necessary for the comprehension of culture and of ideas in general. Ideas and beliefs are *not* transparent, but always originate in and conceal social structures and processes. It is the task of sociology to disclose these, and in this way to demonstrate the way in which communication is in fact 'distorted', because it is based on unequal relations and structures of power in society.[34] At the same time, critical sociology is reflexive, in the sense that it makes explicit its own assumptions and their social location, rather than hiding behind a false notion of scientific value-freedom.[35] As a result, the possibility of a new kind of objectivity is presented, and the interpretation of meanings and texts thereby rescued from the relativism of a hermeneutics which insists, rightly, on the inevitable perspectivism of all interpretation. An objective account of meanings here consists not in one interpretation which is better than another, nor in recreating original meanings, but in correctly locating and thus 'explaining' texts and other ideological facts. It is in this light that it is possible to argue, for example, that Berger's interpretation of Gainsborough is 'right', or that Goldmann's account of Racine's plays is better than a more traditional literary critical analysis. In the first place, these analyses make clear their own analytical and value position, which gives them an advantage over accounts which do

not, but which claim to be value-free. In the second place, Berger and Goldmann refuse to take paintings and plays at face value, so to speak, but demonstrate the various aesthetic, ideological and social processes involved in their production. The subjective aspects of meaning and its interpretation are comprehended within an analysis of objective social facts.

The limits of the objective reading

Reading literature as ideology provides us with an 'objective' account in one sense. However, it is a more limited objectivity than some critical theorists have thought. In the first place, as Gadamer has pointed out against his critics, it is not possible, even for critical theory, to 'get outside' language and tradition. As he says, 'the critique of ideology overestimates the competence of reflection and reason'.[36] In talking of the material and social structures in which meaning is constructed, the sociologist is still using language. Our only access to 'reality' is a linguistic one.[37] Secondly, despite the commitment to self-reflexive methods, there is a limit to the extent to which the sociologist *can* stand aside from his or her own perspective. Recognising prejudices does not amount to operating without any prejudices, for as Gadamer has shown, this is impossible in principle. It does not necessarily mean, either, that this particular reflexive method is superior to any other. This is, of course, a perennial problem for any sociology of knowledge, which at the same time shows that all knowledge is perspectival, yet is reluctant to lapse into complete relativism. And thirdly, related to this, critical sociology at least needs to make a case for positing particular processes and institutions at work 'behind' language and meanings, rather than others. Within Marxism, this is a matter of some disagreement, and Habermas has been criticised by others for not placing due emphasis on class as a determining structure.[38] This question is, as I have argued earlier, a matter of historical fact, and to that extent unproblematic in a way which the other kinds of relativism are not. In the end, the fact that we are all contained within language(s), and that any reading, or sociological analysis, we perform is situated and thus perspectival, is indisputable. Theoretical self-consciousness about this is preferable to a naïve scientism, but it does not dissolve the paradox. This is not to suggest that we

abandon the attempt to understand the ideological construction of texts and meanings, which might be Gadamer's conclusion. It is, however, to recognise the limits of what is proposed as an 'objective' reading.

Interpretation by the ordinary reader

This discussion has been about the possibility of correct, or valid, interpretation from the point of view of the literary critic or historian. That is, it really only concerns a very particular, specialised, and analytically motivated reading of texts or other cultural products. Even here we have found that a final account, a comprehensively correct and objective reading or interpretation, is impossible. From the point of view of the ordinary reader (or viewer, or audience), of course, it is not even something which is attempted. Since what I am interested in developing is a sociology of reading (as part of a sociology of art in general), and not a sociology of literary criticism or a sociology of sociology, I shall go on to look at the nature of interpretation on the part of ordinary readers. In Gadamer's account, there is only a difference of degree between historian of literature, literary critic and ordinary reader, all being involved in the *historical*, and hence changing, interpretation from one 'historicity' to another.[39] For Hirsch and for Apel and Habermas, though for completely different reasons, there is an enormous difference between the naïve reader and the analyst, looking for a correct interpretation. What is clear is that the ordinary reader is not trying to recreate the author's original meaning; nor is he or she trying to grasp the ideological nature of the text and to express its concealed structures of power and class. Reading is theoretically innocent and analytically naïve. For this reason, it is a mediation, or fusion of horizons, in the simplest sense.

The dynamic text

Marxist literary criticism, which was once the guarantee of 'objective' readings of texts, has recently produced from a variety of geographical regions and political positions the conclusion that all reading is relative, and that meaning is constructed by reader as much as by author.[40] For example, Jeremy Hawthorn argues that

the identity of a literary work is dependent upon its relationships with its author and with its reader.[41] The work cannot be understood as a fixed and unchanging entity, and neither can its evaluation; both of these change in their changing reception and perception by different audiences.[42]

> Any artistic response involves a dialectical interrelationship between writer, reader, and work. The consciousness of both writer and reader are likewise related to the totality of their worlds, including the 'congealed experience' of the past. Thus the search for any static core around which the literary process can be woven and in the light of which it can be explained, and responses to it evaluated, is the modern equivalent of the search for the philosopher's stone. No unchanging work of art, unchanging human nature, 'legitimate' or 'literary' response can, when investigated, maintain its immutability. (Hawthorn 1973, p. 152)

The East German critic, Robert Weimann, discusses the 're-ciprocal quality in the relationship of "past significance" and "present meaning" ',[43] and concludes that literature must be studied in terms of both *genesis* and *impact* (Weimann 1977, p. 5), linking the writing and reading of literature (p. 10). He stresses the importance of the reader and the reception of literature, while rejecting the more radical position which eliminates authors altogether from the account (p. 4). The structure of literature, he argues, '. . . is correlated to both its past genesis and its present functioning; for the critic to understand the full measure of this correlation is to become conscious of the necessary complexity of structure as history' (Weimann 1977, p. 51).

Both critics maintain that the work of literature must be conceived as a dynamic entity, constructed by the mediation of past and present, or of author and reader. They both also believe that authors and readers can only be comprehended in their own social and historical contexts.[44] And since there are always new and different readers, this means that the text itself is not static, but is constantly re-created. The priority, both interpretative and ontological, of both text and author is denied in an account which gives equal weight in these respects to the reader.

The fact that reading is always re-creating arises from the

polysemic[45] or polysemantic[46] nature of texts, paintings and all cultural products. The various codes which constitute cultural messages are complex, and capable of a variety of interpretations and readings. This applies to visual imagery, linguistic reference, and the connotative meanings attached to sound (for example, the sort of music used as background in the soundtrack of a film). I shall look fairly briefly at three different approaches to the theory of reception and interpretation, all of which rest on this understanding of the polysemic nature of texts. They are (i) semiotics; (ii) the phenomenology of aesthetic response; and (iii) reception aesthetics.

Semiotics

Semiotics is the study of signs, and their operation in codes. It is applicable to language itself, and to any cultural phenomena, from fashion to film.[47] In semiotic terminology, messages and meanings are *coded*, or *encoded*, in cultural products, to be *decoded* by audiences.[48] I take as my example here the television message, because it is a particularly complex set of codes, where the act of decoding is therefore a more complicated matter.[49] (It should be noted, however, that different media raise different problems for semiotic analysis, so that looking at television raises a good many of these, but obscures others. For example, the question of 'original author' does not arise in this case, where production and consumption are, to all intents and purposes, contemporaneous.)

Umberto Eco has shown that a television programme consists of three separate codes: the iconic (visual), the linguistic, and the sound code.[50] Each of these, moreover, contains a number of subcodes. For example, the iconic code includes an erotic subcode; the linguistic code includes a subcode of specialised jargon. The television message operates on the level of all these codes, through which meanings are both denoted and connoted.[51] All these codes and subcodes are applied to the message in the light of a general framework of cultural references.[52] In other words, the way in which the message is read depends on the receiver's own cultural codes. There is nothing absolute about coded meanings.

The cultural reference framework allows us, therefore, to single out the codes and subcodes. A boy wearing a 'blouson noir' can

connote 'an antisocial person' in one iconological subcode, 'an unconventional hero' in another. The choice of criterion is always guided by the ideological framework. (Eco 1972, p. 116)

From the point of view of the message-sender, the risk of 'incorrect' decoding makes necessary what Eco calls 'redundance', that is, the repetition of the message both over time and within the message (possibly by repetition in the various codes or subcodes, although Eco does not suggest this) . But as he says, the 'significance system' of the addressee, who receives the television message, cannot be assumed; it can only be discovered by audience research. Stuart Hall has suggested that television messages are differently 'read' or decoded by different audiences.[53] The polysemic nature of the television discourse means that a single meaning cannot be fixed to a particular message or event, although a 'preferred meaning or reading' may be suggested (by other elements in the discourse and in the code in general).[54] However, depending on their own 'situated logics',[55] certain groups of people may still decode in a different way. They may produce a *negotiated* version of the message, incorporating connotative and contextual 'misunderstandings', which arise from their social position (their 'differential and unequal relation to power'[56]).

This is particularly relevant to the analysis of political and educational 'messages', and in fact Hall's examples of negotiated decodings are to do with industrial relations, and debates on the need to limit wages. But it applies to all television discourses, and to all cultural codes. The degree of polysemic flexibility varies. Some codes are more 'fixed' than others. (Linguistic denotation is less capable of variable decoding than visual connotation, for example.) And some discourses (including television and film) are coded in a more complex manner than others.[57] Nevertheless, the essentially polysemic nature of all cultural codes ensures that any reading will be constructive, in the sense that the reader/receiver decodes using the tools of his or her own 'significance system'.

The phenomenology of aesthetic response

Wolfgang Iser is a contemporary author in this tradition, whose

work has recently been translated into English.[58] He says the following, concerning the act of reading:

> Central to the reading of every literary work is the interaction between its structure and its recipient. This is why the phenomenological theory of art has emphatically drawn attention to the fact that the study of a literary work should concern not only the actual text but also, and in equal measure, the actions involved in responding to that text. The text itself simply offers 'schematized aspects' through which the subject matter of the work can be produced, while the actual production takes place through an act of concretization. (Iser 1978, pp. 20–1)

In this statement, Iser summarises his main arguments about the nature of interpretation, and consequently the nature of literature itself. He distinguishes between the *text*, the *work*, and the *reader* (p. 21). As he puts it, the literary work has 'two poles': the artistic (the author's text) and the aesthetic (the realisation accomplished by the reader). The work is not identical with either, but is 'situated somewhere between the two' (p. 21). The text only takes on life when it is realised in reading, and therefore the work, which comes into existence with the reading, is always more than the text.

> The convergence of text and reader brings the literary work into existence, and this convergence can never be precisely pinpointed, but must always remain virtual, as it is not to be identified either with the reality of the text or with the individual disposition of the reader. (Iser 1974, p. 125)

So to understand the reading process – the actualisation of the work – we need to understand both the nature of texts and the nature of the reading process.

The text necessarily offers 'polysemantic possibilities'.[59] It leaves gaps[60] which the reader fills in reading. Since texts are composed only of sentences and statements,[61] they can only establish various perspectives. They do not correlate exactly with the real world, and there is not one single, hidden meaning, to be recovered in interpretation.[62] Literary texts all contain a certain 'indeterminacy',[63] which renders them open to different readings. The reader therefore fixes meaning in the act of reading. However,

the text is never completely open; the possibility of total subjectivism is avoided because the structure of the text guides the reader.[64] (Iser has here a similar notion to Gadamer's concept of the hermeneutic circle, for he talks about an 'active interweaving of anticipation and retrospection',[65] in which the reader oscillates between the structure of the text and his or her own imagination, readings and re-readings. The indeterminacy of the text enables the reader to recreate the world it presents.[66])

The text, then, is polysemantic, open and indeterminate. The reading process is analysed phenomenologically, and in great detail.[67] Iser shows how the 'virtual dimension' of the text calls into play the intentional activities of the reader, from the 'pre-intentions' or expectations which form the starting-point, through the gradual opening up of horizons by succeeding sentences,[68] modifications, evocation of what has earlier in the reading sunk into memory, and so on.

> The activity of reading can be characterized as a sort of kaleidoscope of perspectives, preintentions, recollections. Every sentence contains a preview of the next and forms a kind of viewfinder for what is to come; and this in turn changes the 'preview' and so becomes a 'viewfinder' for what has been read. (Iser 1974, p. 130)

In all this, the original perspective of the reader is important, for the meaning which is completed in reading, although limited by the structure of the text, is variable and determined by the convergence of text and reader. Iser says that 'the manner in which the reader experiences the text will reflect his own disposition' (p. 132).

Reception aesthetics

Iser criticises theories of reception, because they do not consider the nature of aesthetic response.[69] In his view, these theories take readers as given, and do not investigate, phenomenologically or otherwise, the actual act of reading. Theorists of what is known in German literary studies as 'reception aesthetics' have criticised Iser for ignoring the social and historical dimensions to the act of reading, and for positing the reader as a universal category. In

particular here, I am taking the work of Hans Robert Jauss as representative of this approach, but in doing so must also point out that other writers take different views on some aspects of reception theory.[70]

Jauss agrees that the text has an open structure of indeterminacy, to be completed by the reader. However, he argues that the nature of particular interpretations by readers can only be understood in the context of the historical conditions of reading.[71] Although Iser recognises that reader dispositions, and hence readings, vary, he does not incorporate, or even suggest the need for, a systematic analysis of the conditions of reading, nor of the conditions of production of the text. As Jauss acknowledges, Iser, unlike some writers in the same tradition, does not conceive of an idealised implied reader, and is able to take account of different modes of interpretation and different concretisations of the work in the reader.[72] Against Iser (and also against Gadamer), Jauss maintains that the reconstruction involved in reading must be seen as historical, in terms of literary history and in terms of history in general.[73] The theory of aesthetic reception must see a literary work in its context of literary experience, so that a particular reading can be understood. It must also place it in relationship to general history.[74] 'The new literary work is received and judged against the background of other art forms as well as the background of everyday experience of life' (Jauss 1970b, p. 34). He cites as an example the trial of Flaubert on the publication of *Madame Bovary*, to show the interaction of new aesthetic form and contemporary moral issues, an unusual literary use of indirect speech being taken as an objective statement, glorifying adultery (pp. 34–6). The history of morals, as well as the history of style, has to be taken into account in explaining the particular reception which this book gained.

The importance of reception aesthetics is that, like the other theories I have discussed, it destroys the traditional emphasis on text and its production and the false objectivism accorded to cultural products. Instead, it sees the active rôle of the reader as a central element in any literary theory, and presents the beginnings of a method for the study of literary reception. Although Jauss and others are less interested than Iser in the actual phenomenological processes of aesthetic response, their account represents an advance on the phenomenology of reading, because they under-

stand that readers' dispositions and modes of reading are part of a
general historical situation. As Jauss says:

> A literary work is not an object which stands by itself and which
> offers the same face to each reader in each period. It is not a
> monument which reveals its timeless essence in a monologue. It
> is much more like an orchestration which strikes ever new
> chords among its readers and which frees the text from the
> substance of the words and makes it meaningful for the time.
> (Jauss 1970b, p. 10)

Although Jauss recognises the historical concreteness of literary
reception, from the point of view of a sociology of literature his
theory of reception is inadequate for two reasons. In the first place,
he is not specific enough about the relevant historical conditions
which one must consider.[75] The study of reception would need to
provide a sensitive analysis of social divisions and ideological
features of a period, and not simply assume a unified mode of
literary reception. Secondly, Jauss has been criticised (notably by
certain Marxists in East and West Germany[76]) for over-
emphasising the role of the reader in the literary work, and thus
undermining the materialist basis of aesthetics. That is to say, he
rejects a determinate notion of the text, as unequivocally produced
in real material processes, in favour of a concept of the text as
'open' and available for multiple readings of equal validity. Now
although it would be a mistake to argue that an emphasis on the
reader is less 'materialist' than an emphasis on the producer (for in
both cases the activity should be seen as materially situated and
constructed), and although this appears to have got entangled into
the rather different problem of the *autonomy* of literature and the
power of art to influence social action,[77] it is true on the whole that
reception aesthetics over-compensates for the earlier disregard for
audiences. In arguing that the traditional approach to literature,
concentrating on the literary work and/or the author, must be
abandoned and replaced by an aesthetics of reception,[78] Jauss
obliterates from the analysis the crucial elements of production and
representation, which cannot be taken for granted any more than
audience response. The sociology of literature cannot assume the
priority of production over consumption, or of consumption over
production. As Marx makes clear, in the full passage from which I

have quoted at the beginning of this chapter, production and consumption produce and determine each other in a number of ways. I conclude this section with Hohendahl's comment on this.

> Having fulfilled its polemical function, the rigid opposition between aesthetics of reception and representation which characterized the initial situation is now being resolved. It derived from an unjustified reduction of the concept of literature. More important is the effort to engage the dialectic of production and consumption . . . Nothing indicates that a critical audience sociology, even if it begins with the consumer, must limit itself to describing artistic experiences and processes of distribution and remain blind to the conditions of production. If, according to Marx, production and consumption mediate each other, then it is the whole analysis rather than simply the initial step which decides the adequacy of the procedure. (Hohendahl 1977, p. 62)[79]

The intention in this chapter has been to show the active and creative rôle of readers and audiences in their interpretation of works of art. This is to expose what Hawthorn calls the 'false and misleading fixity' of such works.[80] The author's meaning is irretrievable, and is in any case quite irrelevant to the ordinary reader. Any conventionally accepted 'meaning' of a work is the result of the history of its critical reception, beginning with its first readers.[81] And depending on the relative 'closure' of the work, or on the denotative rigidity of the codes in operation in it, the reader constructs the meaning of the work. This does not result in a voluntarist theory of reading, however. The reader is guided by the structure of the text, which means the range of possible readings is not infinite. More importantly, the way in which the reader engages with the text and constructs meaning is a function of his or her place in ideology and in society. In other words, the rôle of the reader is *creative* but at the same time *situated*.

This means that there is no privileged 'version' of a text. In the following chapter I shall take up the question of what this means for the theory of the author, whose position of centrality has clearly been displaced. There are also implications of this analysis for any

theory of literary value, which cannot be pursued here,[82] because evaluation, as a method of reception, must also be viewed historically. As I have already suggested, this position is more relativist than one might expect a materialist analysis to produce. What rescues it from radical relativism is, first, the refusal of infinite licence in the reading of texts (against, for example, the position of Barthes); secondly, the recognition of the non-arbitrary historical fixing of apparently privileged meanings; and thirdly, the insistence of critical theory that interpretation can be doubly subjected to critical analysis. The ideology of production can be critically examined, in the conditions and structures of the genesis of the work of art. And the ideology of reception can also be analysed, to disclose the origin and construction of readers' frames of reference. The nearest we can get to an 'objective' account, however, in the attempt to escape the hermeneutic circle and the dilemma of any sociology of knowledge, is to ensure that we also subject our own ideology of investigation to critical survey.

Chapter 6

The Death of the Author

> A text is made of multiple writings, drawn from many cultures
> and entering into mutual relations of dialogue, parody, contesta-
> tion, but there is one place where this multiplicity of focused
> and that place is the reader, not, as was hitherto said, the
> author . . . A text's unity lies not in its origin but in its
> destination . . . The birth of the reader must be at the cost of the
> death of the Author. (Barthes 1977, p. 148)

In the essay from which this quotation and the title of this chapter
are taken, Barthes supports the modern tendency towards the
'desacrilization of the image of the Author' (p. 144) in literature.
He argues that the author is a modern figure, created by society as it
created the human person more generally.[1] In the case of literature,
the idea that the author is dominant, the sole origin and source
of authentic meaning of a text, is historically specific, and,
moreover, mistaken. As Barthes puts it: ' . . . a text is not a line of
words releasing a single ''theological'' meaning (the ''message'' of
the Author-God) but a multi-dimensional space in which a variety
of writings, none of them original, blend and clash' (p. 146).

This critique of the centrality of the author as a fixed point of
meaning is very much in line with some of the arguments of the last
chapter. In the present chapter I shall focus on the question of the
author/artist/subject, in the light of the discussion in earlier
sections of this book. I shall begin by reviewing those aspects of
the sociological analysis of art and literature which increasingly
marginalise the author as creative subject. I shall then go on to

consider some of the more radical arguments which, like Barthes',
appear to insist on the complete removal of the concept of
authorship from analysis. After discussing what has been proposed
as a 'new theory of the subject', I shall conclude by suggesting
how we might conceive of 'authors' in an acceptable way, in the
sociology of art.

The myth of the dominant author/artist

Traditionally, as Barthes points out, the study of literature has
been a study of authors, reflected in an interest in biographies,
diaries and interviews, and in the inclination of literary critics to
offer psychoanalytic explanations of author and work.[2] In the
history of painting, according to Hadjinicolaou, one of the major
obstacles to the proper understanding and analysis of art has been
the view of art history as the history of artists.[3] As he shows, this
necessarily ignores important questions of the historical groups to
which artists belong, as well as of styles of painting with which
they work. Like Barthes, he relates this focus on the artist to 'the
bourgeois ideology of the individual as creator',[4] developed
concomitantly with the rise of capitalism in Europe. We have
already seen why the notion of 'artist-as-creator' is open to
objection when the concept of creativity is used in a metaphysical
and non-historical way (pp. 19–25 above). Moreover, in practice
even the situated 'creativity' (in the acceptable sense of 'produc-
tive activity') of artists is limited and mediated by the conditions of
their artistic practice. As I have argued, it is these very conditions,
seen from one point of view as limitations, which make possible
artistic work and individual practice in the first place. Neverthe-
less, the structural conditions of artistic practice clearly offer a
serious challenge to traditional notions of 'authorship'.

The collective nature of artistic production

The dominance of the author/artist is first questioned when we
recognise that all art is collectively produced. In some cases, the
medium obviously necessitates collaborative work, even though a
particular figure (the director, for example) is given credit for the
overall production; this is particularly true of cinema and tele-
vision. Even where artistic production is a more 'individual'

activity, as in painting or writing a novel, the collective nature of this activity consists in the indirect involvement of numerous other people, both preceding the identified 'act' of production (teachers, innovators in the style, patrons, and so on), and mediating between production and reception (critics, dealers, publishers). More generally, the individuality of the artist, and the conditions for his or her specific piece of work, are entirely dependent on the existence of the structures and institutions of artistic practice, which facilitate that work. I referred to the way in which the apparent non-creativity of women as artists and composers is related to the institutions of artistic practice in each case, which operate in such a way as to exclude them (pp. 42–3 above). In all these ways, the individual act of creation is manifestly a social act.

Group consciousness as expressed in the work of art

Secondly, the ideas, beliefs, attitudes and values expressed in cultural products are ideological, in the sense that they are always related in a systematic way to the social and economic structures in which the artist is situated. Without accepting any simplistic theory of reflection, it can be shown that the perspective (or world-view) of any individual is not only biographically constructed, but also the personal mediation of a group consciousness. Conformist, rebellious, and even eccentric views are always a function of the social position (which is often extremely complex) of the individual concerned. Ideas and beliefs which are proposed as value-free or non-partisan are merely those ideas which have assumed the guise of universality, perceiving as natural social facts and relations which are in fact historically specific. To this extent, then, art as a product of consciousness is also permeated with ideology, although it is not reducible to ideology. And to that extent, too, what the author or the artist says in the work of art is actually (or perhaps one should say *also*) the statement of a social group and its world-view.

One reason why art is not reducible to ideology is because of what I have called 'the aesthetic mediation' of the text (p. 60). Styles and conventions of literary and artistic construction confront both artist and ideology, and determine the modes in which ideas can be expressed in art. Ideology, then, is never directly reflected in a painting, or a novel, but is always mediated

by the aesthetic code. But the artist too is constrained by this relative autonomy of the text, and by the existing rules of form and representation: 'The author certainly makes decisions, but . . . his decisions are determined; it would be astonishing if the hero were to vanish after the first few pages, unless by way of parody' (Macherey 1978a, p. 48). For this reason, Macherey also opposes the view of the author as 'creator', preferring to use the word 'producer' or, following Baudelaire, 'compositor' (p. 22).

> The writer, as the producer of a text, does not manufacture the materials with which he works. Neither does he stumble across them as spontaneously available wandering fragments, useful in the building of any sort of edifice; they are not neutral transparent components which have the grace to vanish, to disappear into the totality they contribute to, giving it substance and adopting its forms. The causes that determine the existence of the work are not free implements, useful to elaborate any meaning . . . they have a sort of specific weight, a peculiar power, which means that even when they are used and blended into a totality they retain a certain autonomy . . . Not because there is some absolute and transcendent logic of aesthetic facts, but because their real inscription in a history of forms means that they cannot be defined exclusively by their immediate function in a specific work. (pp. 41–2)

The materials of literary technique and form confront the author, who works on them and transforms them.[5] Any conception of personal inspiration, and its inscription in the text, recedes even further from view.

The rôle of the reader/audience

Lastly, we have seen how it is vital to recognise the active rôle of the reader/audience in the construction of meaning of the cultural work. Reading is always re-reading, and original meaning is inaccessible both to reader and to analyst. As Jeffrey Mehlman has put it, the text must be regarded less as a monument than as a battlefield.[6] The work is now seen as a dialogue between author and reader, and interpretation recognised to be provisional and situationally specific. What Barthes calls the 'birth of the reader'

may not necessarily signify the *death* of the author, but it certainly restricts further his or her 'authority'. I shall try, in what follows, to determine whether or not this obituary notice is premature, and whether the author in fact has any place in the sociology of art.

The nature of authorship

In an essay written ten years ago, Michel Foucault stresses the need to 're-examine the empty space left by the author's disappearance'.[7] He considers one particular aspect of the question of authorship, namely the relationship between author and text, or, as he puts it, 'the manner in which a text apparently points to this figure who is outside and precedes it'.[8] His argument is that the author's name is functional, in a variety of ways. Unlike other proper names, it serves as a means of classification (of texts), and characterises the operation of certain discourses in society. It is also unlike other proper names in that it is not affected by additional, but extra-textual, information about the person referred to . . . 'Unlike a proper name, which moves from the interior of a discourse to the real person outside who produced it, the name of the author remains at the contours of texts' (Foucault 1979, p. 19). For example, Foucault says:

> The disclosure that Shakespeare was not born in the house that tourists now visit would not modify the functioning of the author's name, but if it were proved that he had not written the sonnets that we attribute to him, this would constitute a significant change and affect the manner in which the author's name functions. Moreover, if we establish that Shakespeare wrote Bacon's *Organon* and that the same author was responsible for both the works of Shakespeare and those of Bacon, we would have introduced a third type of alteration which completely modifies the functioning of the author's name. (p. 18)

This peculiarity accorded the name of an author only applies to certain texts in our culture, excluding letters, contracts, and wall posters. On the argument that the 'author' is a function of a specific discourse (and Foucault restricts himself to books and texts with authors), an analysis of the way in which the author's name actually functions is suggested. In particular, it is related to the

'legal and institutional systems that circumscribe, determine and articulate the realm of discourses' (p. 23), including copyright, censorship, and other aspects of texts as 'property'.

The selection of 'relevant' facts about the author

What is interesting about this approach is that it shows how problematic it is to decide exactly *what*, or *who*, an author is. It is difficult to give an account of what constitutes the entity we call the author, since some 'facts' about the person clearly count (texts attributed to him or her), and others do not (where he or she lived). Identifying the person with a list of particular characteristics is an exercise defined by the discourse in which 'authors' are referred to. This is not, of course, to deny that there is in the case of each text a physically identifiable person who wrote that text. It is to point out that the 'personality' of that author is constructed, in terms of certain characteristics which are taken to be relevant, by the historically specific discourse of literary theory.[9] Just as we have ways of determining which of an author's productions to include in his or her *oeuvre* (drafts, marginalia, letters, or notes concerning domestic matters), so we also have ways of deciding which attributes or facts of the person's life to take as relevant to that person as author. In both cases, these practices are prescribed by the discourse of literary history.

The grouping of different works by the author

The notion of an 'author' also operates by uniting a variety of texts, where there may in fact be great differences of style or approach over time. We have already seen that a case can be made for breaking this unifying bond, and allowing the distinct voices of different works to be heard without imposing on them a unity which disguises their crucial differences (p. 60 above). Hadjinicolaou argues that the paintings of David and of Rembrandt are misunderstood if, in each case, the name and biography of the author are used to conceal the different ideologies expressed in the works – in the case of David, dating from different periods of his life, and in the case of Rembrandt, co-existing throughout his life.[10] The concept of the 'author' can thus be used to obscure important aspects of texts or other works, as a particular,

constructed notion of that author's personality, biography and intentions is overlaid on any account of his or her works. It is important to understand that this critique does not necessarily lead to a radical rejection of writers or artists as individuals, in the conception and understanding of works of art. Although Barthes, in the essay quoted at the beginning of this chapter, does conclude that, at least for reading, any notion of authorship is misplaced, I shall argue that the sociology of art, while rejecting the traditional, humanist notion of the author/artist as the fixed source of meaning in the work, must include a theory of the artistic subject. Foucault himself retains the concept of the subject in the study of texts:

> But the subject should not be entirely abandoned. It should be reconsidered, not to restore the theme of an originating subject, but to seize its functions, its intervention in discourse, and its system of dependencies. ...In short, the subject (and its substitutes) must be stripped of its creative rôle and analysed as a complex and variable function of discourse. (Foucault 1979, p. 28)

What is under attack is a concept of 'author' as a determinate and fixed source of artistic works and their meanings. A monolithic and unifying entity, to which all works known to be by a particular person have to be referred, and in terms of whose supposed personality and characteristics they have to be explained, is mistaken both because it usually depends on an unanalytical concept of the subject (as 'free' and creative), and also because it necessarily operates with a partial analysis of the author (constructed in terms of an imputed set of defining characteristics). The way in which authors are produced, or constructed, must be explicated. And the complexity of their works, which escapes any unifying formula, must be capable of recognition.

Diverse voices of the text

In the preceding chapter, I discussed the polysemic nature of texts, which provides the possibility for multiple readings by different readers (pp. 109–15). Theories of reading or of de-coding recognise this essential characteristic of works of art, or cultural products,

and the consequent argument against 'closure' or fixing meaning in a text. With regard to the author of the text, this recognition has a particular relevance. To put it most simply, texts (and other cultural products) contain and express meanings beyond the intended and conscious meaning of their authors. This is not to argue that subsequent readings will draw new relevances from texts, though that is also true. But at the time of its inscription, a text contains and conjoins numerous, possibly contradictory, voices. Macherey has argued that we must always investigate the silences of a text: the things which a text cannot say, and the significant absences of the text.[11] In his essay on English fiction in 1848, Raymond Williams shows that a careful analysis of complex novels like *Wuthering Heights* and *The Tenant of Wildfell Hall* reveals at least a dual perspective – or double narration – in play.[12] In the realist novel, it is usually assumed that we have a single narration, from the point of view of the first person narrator, or from the point of view of the dominant voice of a general narrator, overseeing the totality of events, with access to the thoughts of all the characters, and telling the story in the third person. Williams points out that in the politically and socially complex period around 1848, the contradictions in social experience and in ideology emerge in literary forms. There is a new recognition in literature of class relations and class conflict;[13] there is a new emphasis on subjectivity of experience.[14] But the emergent elements co-exist with other, more traditional, elements of the realist novel. In formal terms, this tension is expressed by the relative abandonment of the dominant authorial voice (whether first or third person). Thus, in *Wuthering Heights* we are presented with the events from the point of view of Nellie Dean, Lockwood and Cathy. In *Dombey and Son*, according to Williams, there is more 'mobility' on the part of the narrator, who 'moves from place to place and from the point of view of one character to another, with much more diversity than any other novelist of his time'.[15] In general,

> . . . Within a structure of this kind you are not asked, as in the ordinary account of bourgeois realistic fiction you are supposed to be asked, to identify with a single point of view on the experience. The opportunities for very complex seeing, both within a given situation and within time through a developing

situation, are absolutely built-in to the form of the novel. (Williams 1978, p. 284)

In a period of social and political transition, like the 1840s in Britain, the complexities of thought about politics and social life may be expected to be more sharply defined in their literary (and other) expression. But what Williams demonstrates about that particular period is, I think, true to a large extent of all complex cultural products. Unless the rules and conventions of literary and artistic production are very tightly defined and circumscribed, which is not the case in contemporary industrial societies, then texts will be the arena for the play of diverse, and perhaps conflicting, ideologies and voices. This may be explicitly recognised by giving different voices to different characters, or by some other mode of renouncing the authorial dominance of the uniform voice. More usually, it has been concealed by the traditional device of a singular narrative.

It may be objected to this that although the social structures of a particular place and period may be complex, containing distinct social forces and conflicting ideologies, nevertheless the author, as an individual, is clearly situated, and is only likely to formulate and represent one point of view. Even in the case where the author (or artist) is marginal to a specific class, or situated in the interstices of the major social divisions, he or she will still only express a limited perspective which is determined by his or her experience. Quentin Skinner has argued that a writer's intentions in writing are crucial to the meaning of the text, even though this may be complicated by the fact that the author fails to say what he or she means, or that the author actually says more than he or she intended.[16] I have also indicated in an earlier chapter (p. 102 above) that the meaning of a text constituted by a sociology of literature necessarily involves author's meaning in some sense, against those theories of reading which exclude authorial meaning in favour of the infinite licence of contemporary interpretation. Before I go on to discuss how we might best conceive of authors in a sociology of literature, I shall try to resolve this apparent contradiction. My argument is that the artist or writer (here Barthes prefers the name 'scriptor' to 'author', the latter carrying all the unacceptable connotations of 'creativity'[17]) is indeed a focal point for the analysis of art and literature, but that this must not be taken

to allow a constructed, and necessarily partial, view of the artist as a simple, rational being with a coherent and uniform set of intentional and biographical features. What speaks in the text which the artist produces is more complex than that. It is for this reason that any history of art as a history of artists has to be rejected.

The limitations imposed by codes and conventions

One reason why the meanings of the text, or of any other work, go beyond the individual writer's intended message is that the very language and aesthetic forms employed already encode the social meanings of a wider constituency. It is not the case that the author, for example, having decided what he or she wants to say in a novel, has a free choice of the words and modes of expression in which to say it. I have already discussed the way in which artistic conventions mediate between ideas and their expression in art, in a general way (see Chapter 3). This is equally true on the specific level of any particular work. Using existing codes and conventions more or less uncritically and unconsciously, the author/artist is nevertheless reproducing aspects of ideology encoded in these. In Chapter 4, I considered the argument that realist forms in art may operate to reinforce the dominant ideology and hence the social structure, and other writers have argued that traditional realism is itself ideological because it presents as fact and as 'real' a world which is in fact constructed in a particular discourse.[18] In one way or another, the need to utilise existing aesthetic and linguistic conventions has already implicated the artist in extra-individual structures of the discourse. This is not to say that such conventions cannot be subverted by particular artists or cultural producers, of course; this is something which has also been discussed earlier in that context (p. 90). But although the occasion of the specific expression – confirming or subversive – resides in individual producers, the mode of expression always draws on the facilitating, non-individual, discourse, and correspondingly carries its resonances and meanings.

The 'polyphonic' novel

The second major reason why texts do not simply reproduce the

single voice of an individual speaker (the author) consists in the complicated way in which individuals are located in ideology. Engels and Lukács agreed that Balzac's novels presented one of the best accounts of the social structure of early nineteenth-century France, and of the ascendancy of the bourgeoisie in that period, although Balzac's own ideological sympathies were with an earlier, and receding, age (see p. 87 above). Apart from demonstrating the fact that 'good' descriptive literature need not, or perhaps should not, be tendency-literature, this also indicates that the text can give literary expression to other ideologies than that of its author. It has recently been taken as given, among certain theorists of literature, that indeed all complex texts, and particularly novels,[19] may comprise a variety of ideological 'voices', and, moreover, when they do not, the veneer of uniform narration is artifically imposed on them. In 1929, the Russian Formalist, Mikhail Bakhtin, wrote a book about Dostoevsky, maintaining that this writer was the creator of the 'polyphonic novel'.[20] This he contrasts with the 'homophonic' or 'monologic' novel, which has dominated the history of literature, and which presents all its characters and events in a unified, objective world, dominated by the author's consciousness and knowledge. The polyphonic or dialogic novel, on the contrary, does not have a single viewpoint, whether of author or of any particular charac-ter . . .

The plurality of independent and unmerged voices and consciousnesses and the genuine polyphony of full-valued voices are in fact characteristics of Dostoevsky's novels. It is not a multitude of characters and fates within a unified objective world, illuminated by the author's unified consciousness that unfolds in his works; but precisely the *plurality of equal consciousnesses and their worlds*, which are combined here into the unity of a given event, while at the same time retaining their unmergedness. (Bakhtin 1973, p. 4. Emphasis in original.)

The hero's voice is equal in status to the author's voice, and is not just its object. There is no external perspective which has the final word. Words are used in a 'double-voiced' way, and there is no single idea, but the opposition of many consciousnesses, expressed through the characters of the novels. Bakhtin relates the

possibility of the polyphonic novel to the multi-levelled and contradictory nature of the objective social world:

> The age itself made the polyphonic novel possible. Dostoevsky was *subjectively* involved in the contradictory multileveledness of his time; he changed camps, he switched from one to another, and in this respect the planes which existed in the objective social life were for him stages on his life's path and in his spiritual evolution. This was a profound personal experience, but Dostoevsky did not give it direct monological expression in his art. It only helped him to more profoundly comprehend the coexistent, extensively manifest contradictions between people, but not between ideas in a single consciousness. Thus the objective contradictions of the age determined Dostoevsky's art not in that he was able to overcome them within the history of his own spirit, but in that he came to objectively view them as simultaneously coexisting forces. (p. 23. Emphasis in original.)

The importance of the polyphonic novel is that it recognises the complexity of the modern world, the dialogic nature of human consciousness, and the 'profound ambiguity' (p. 25) of every voice, gesture and act. The imposition of a monologic structure on a literary work, bringing under a unifying and rational consciousness all the ambiguities and complexities of personal and social life, distorts the latter in the pretence of a singular coherence which is in fact a myth.

Polyphony, and its development in later writers like Joyce, Woolf and Robbe-Grillet, as well as Dostoevsky's contemporaries, Mallarmé and Lautréamont, has been hailed as an important advance in the deconstruction of entrenched ideological forms of literature, and as the starting point for radicalism in art.[21] In the past few years, Bakhtin has been 'rediscovered'.[22] To return to the discussion of the nature of authorship, Bakhtin's work helps us to see it is the monological novel which is deceitful. There is no simple closure of meaning or unilinear logic of development which the text has only to recognise and represent. The writer, despite his or her specific class and social location, experiences the multiplicity of social life and ideological forms, and the honest text allows this diversity expression. But just as Dostoevsky's novels can be read (or mis-read) monologically,[23] we must attempt to read

monologic texts (including films, and other works) dialogically, to draw out, as Macherey recommends, the hidden contradictions in content and form.

New theories of authorship

So far, I have argued that texts and other works of art are polysemic and polyphonic; that they contain and express meanings which extend beyond those of the individuals who authored them. Although the voices in the text clearly originate in the author's pen, their multiplicity derives from the complexity of the social world in which the author is located. In the rest of this chapter, I shall consider recent theories of the author as subject, in order to propose a notion of authorship which is not subject to the criticisms made by Barthes and Foucault. In particular, it will be important to move away from a conception of the author as a fixed and monolithic originator of meanings, whose identity lies in a supposed or projected biographical trajectory. The linearity and the simplicity of such a notion have been rejected. The author must be seen as constructed by social and ideological factors – and moreover, constantly re-constructed in this way – rather than as an entity above these factors, developing by some internal logic of its own. Only then will it be possible to re-evaluate the idea of agency, and examine the relationship between agency and structure.

Althusser and the anti-humanist approach

Althusser has written:

> 'Man' is a myth of bourgeois ideology: Marxism-Leninism cannot *start* from 'man'. It starts 'from the economically given social period'; and, at the end of its analysis, when it 'arrives', *it may find real men*. These men are thus the *point of arrival* of an analysis which starts from the social relations of the existing mode of production, from class relations, and from the class struggle. These men are quite different men from the 'man' of bourgeois ideology. (Althusser 1976, pp. 52–3. Emphasis in original)

As he points out to his critics, taking this anti-humanist stance and rejecting the notion of 'man' does not mean that real people disappear in Marxist analysis (p. 52). His concern is to determine how people are constituted as subjects, once we recognise the essentially metaphysical conception of the subject ('man') with which philosophy and social theory have generally operated. Philosophical humanism begins from an unquestioned concept of human beings as discrete and transcendental entities, whose essence may be distorted or alienated in particular social conditions, but who somehow pre-exist the contingencies of their material and social lives. Existentialism is founded on such a notion of human beings. The subject is regarded as a non-constituted, primary existent, who is more or less affected by ideological or social processes, and transformed by personal and inter-personal experience, but whose existential essence is unquestioned. Most sociology, too, has incorporated a similarly humanist and 'untheorised' (to use Althusserian terminology) concept of the subject, whether in its *verstehende*-phenomenological mode, or in a structural-functionalist framework. But whatever our humanist (in the sense of 'humanitarian') principles in political and moral action, it is clearly illegitimate analytically to take *any* entity as ontologically primary and transcendental. It is not to question or deny, or even discuss, the political or moral priority of human subjects, to recognise that they are constituted in historical processes, and not pure, rational, ahistorical essences.[24]

Althusser formulates this proposition regarding the constitution of subjects by stating that 'ideology hails or interpellates concrete individuals as concrete subjects'[25]. The way in which individuals are addressed as subjects (with a name, and by distinguishing and significant characteristics, which are socially defined) is a function of ideology. Although ideology itself is constituted by the category of the subject, in its turn it constitutes individuals *as* subjects. A quotation from Althusser may make this clearer:

> That an individual is always-already a subject, even before he is born, is nevertheless the plain reality, accessible to everyone and not a paradox at all. Freud shows that individuals are always 'abstract' with respect to the subjects they always-already are, simply by noting the ideological ritual that surrounds the

expectation of a 'birth', that 'happy event'. Everyone knows how much and in what way an unborn child is expected. Which amounts to saying, very prosaically, if we agree to drop the 'sentiments', i.e. the forms of family ideology (paternal/maternal/conjugal/fraternal) in which the unborn child is expected: it is certain in advance that it will bear its Father's Name, and will therefore have an identity and be irreplaceable. Before its birth, the child is therefore always-already a subject, appointed as a subject in and by the specific familial ideological configuration in which it is 'expected' once it has been conceived. (Althusser 1971d, pp. 164–5)

So individuals are always subjects, and, as subjects, are 'constituted' in ideology. There is no 'subjective essence' which escapes this constitution, though, of course, all subjects are unique. (We might add that subjects are constituted also in material practices, since the formulation 'constituted in ideology' could generate an idealist reading. However, Althusser's conception of ideology, as inscribed in material practices, does not lend itself to such a reading.)

I hope it can now be seen why the objections of the humanist critics to Althusserian Marxism are ill-founded. I have already mentioned John Berger's critique of Hadjinicolaou's work and argued that it reintroduces a metaphysical notion of the transcendental subject (p. 69 above). Sartre's critique of 'lazy Marxism' (p. 67), while often quite justified in attacking a Marxism which disallows subjects altogether, also resorts to an existential theory of the subject, which fails to recognise that subject's constitution in social and ideological practices. I have also commented (Chapter 4, Note 76) on the fact that some Marxist theories of cultural intervention ignore this question, and assume artists or authors are more or less 'free', unconstituted agents, who simply have to engage in cultural politics in the most effective way, without examining the actual construction of this possibility in the acting subject.[26] In general, it appears that the resistance to anti-humanist analysis is often based on the misunderstanding of its project and its political implications, and an uncritical attachment to a very specific ethic (which Althusser dismisses as the 'worn-out philosophy of petty-bourgeois liberty'[27]). As Althusser

points out, against his critics, anti-humanism only involves rejecting a concept of human beings who transcend history and their situations.

> That does not mean that Marxism-Leninism *loses sight* for one moment of real men. Quite the contrary! It is precisely in order to *see* them as they are and to free them from class exploitation that Marxism-Leninism brings about this revolution, getting rid of the bourgeois ideology of 'man' as the subject of history, *getting rid of the fetishism of 'man'*. (Althusser 1976, p. 51)

Lacanian psychoanalysis

There are, however, other criticisms of Althusser's theory of the subject which are more damaging to his project, and I shall go on to take up one of them which is particularly important for any account of the creative subject and its relationship to social structures.[28] As it is sometimes put, his theory presupposes an 'empty subject',[29] the actual mechanisms of whose constitution are not elaborated. The subject is conceived as more or less unproblematically filling the subject-positions created by ideology. So although the subject is correctly perceived as a constructed subject, the *way* in which it is constituted is entirely unspecified. It is to supplementing the analysis in this respect that some recent work in psychoanalytic theory, linguistics and discourse theory has addressed itself, on the whole starting from Althusser's comments on ideology and the subject.[30] Althusser himself explicitly incorporates some of the work of the psychoanalytic theorist and psychoanalyst, Jacques Lacan, into his essays,[31] but in a very limited and selective way. Lacan's contribution to the theory of the constitution of the subject in language, identifying the family as the key locus of this production, has provided an important set of tools for this analysis. It has proved particularly useful for feminist analysis and for cultural studies, in the first case because it provides an account of the subject as a *gendered* subject, demonstrating the way in which sexuality and gender are constructed in ideological discourse in the family, and in the second case because, amongst other things, language and representation are themselves given a prominent place in relation to the subject.[32] Here I shall only make some brief

comments on the kind of analysis which is opened up by this work.[33]

In Lacan's re-reading of Freud, the acquisition of language has a central place in the formation of the unconscious and therefore in the construction of the subject. The child passes through various stages in recognising itself as separate from others and, eventually, as a subject. According to Lacan, it is only with the learning of language (the entry into the Symbolic Order) that the child takes its place as subject in the ideological or symbolic relations of the family (and hence of the wider society). Language is characterised by positionality,[34] which is to say that the child learns to identify itself as male or female and as son or daughter.[35] Here, more or less traditional Freudian categories (the Oedipus complex, the castration complex) are incorporated, to explain the centrality of sexuality and gender in the constitution of the subject in the family, and in particular in relation to the authority of the Father. Thus, male and female children are subject to a differential entry into language and the Symbolic, in a culture which is patriarchal.

Psychoanalysis provides a way of exploring how it is that subjects are constituted in ideology. Moreover, it destroys the notion of a unified subject of consciousness – the subject identified with the ego – and replaces it with a complex concept of a 'de-centred' subject.

> The erratic and devious presence of the unconscious, without which the position of the subject cannot be understood, insists on hetereogeneity and contradictions within the subject itself. Therefore it provides the most rigorous criticism of the presupposition of a consistent, fully finished subject, and of the social sciences that base themselves on such a presupposition. (Coward and Ellis 1977, p. 94)

I have not, of course, given any systematic account of Lacan's work, and I am not at all sure that it represents an adequate theory of the constitution of the subject.[36] Nevertheless, it is at the moment the most sophisticated available approach which links individual subject to ideological and social formation, demonstrating the construction of the former in, and in the context of, the latter.[37] It is certainly along some such lines that any acceptable

notion of the subject will have to be developed. Whatever its limitations, Lacanian psychoanalysis has the following major advantages: it conceives of the subject as comprising consciousness and unconscious, without imposing on it a false unity of consciousness; it recognises the primacy of gender in the constitution of the subject in a patriarchal culture; unlike much psychoanalysis and psychology, it cannot be accused of being asociological (or even essentially ahistorical), since it locates the construction of subjects in the family within the ideological order of the broader structures of language and culture; and, in analysing the complex constitution of the subject, it does not subsume subjects under structures, or write them out altogether, but attempts to give an account of them which does not suffer from the weaknesses of the existentialist-humanist approach. I would argue that any sociology, including a sociology of art, has to be based on and include a satisfactory theory of the subject as agent.[38] Traditional 'social action theory' and phenomenological approaches, which appear to take the subject as starting point, are inadequate both because they utilise an untheorised (and therefore metaphysical) concept of the subject, and because the emphasis on subjects almost always involves a downgrading of structures. Psychoanalysis, in its Lacanian form, offers such a theory which appears to be compatible with a general theory of ideology and social structure. This brings me to one final issue, however, which may make demands which Lacan's theory cannot meet.

Limitations of Lacanian psychoanalysis

In another connection, I referred earlier to the criticisms made of theories of representation and signification on the grounds that they were idealist, and failed to ground signs and discourses in the material practices of social life (Chapter 3, Note 69). Insofar as Lacanian psychoanalytic theory is a theory of language and representation, it too has been subjected to these criticisms.[39] Discourse and systems of representation should not simply be recognised in their constitutive role, but also seen as themselves constituted. With the insistence by certain followers of Lacan on the primacy of the signifier and the denial of an independent signified,[40] we run the risk of according total determining power to language and sign systems, which are seen not only to constitute

subjects, but also to constitute the real world which they represent. Now it is true that we have no access to any 'real' world except through the systems of representation which enable us to conceive of it. It is disingenuous to conclude from this that signs, or signifiers, have free play in constructing the world.[41] And when Coward and Ellis say: 'Such an understanding emphasises the activity of the signifier, whose limitation to produce certain signifieds therefore becomes a question of positionality in sociality and social relations' (Coward and Ellis 1977, p. 122), they seem to me to be admitting 'the real' on an independent (non-representational) basis in a way which is essential. Jameson argues that the analysis provided by Lacan is compatible with historical materialism.[42] Any such convergence is dependent on an acceptance of a real world,[43] the nature of whose primacy in the production of ideology I have considered already (Chapter 3). Nicholas Garnham has recently criticised what he sees as 'essentially idealist formulations' of the theory of subjectivity and of ideology in the journal of film studies, *Screen*, and endorses a position whose effect is to

> shift the focus of debate on to the relationship within historical materialism of the mode of production of material life with ideology, with psycho-analytic theory as a subsidiary moment within that broader and more central analysis, rather than arguing about the relationship of psycho-analysis to historical materialism. (Garnham 1979b, pp. 122–3)

He, too, argues that Marxism rests on the 'ultimate primacy of the real' (p. 127), and although his position returns him to a pre-Lacanian, and therefore over-simplified, concept of the individual subject (a consequence he willingly accepts, for pragmatic-political purposes[44]), my view is that his criticism is important and correct. Ideological practices and discourses are determined by material (social and economic) conditions, although it should not be necessary to point out again that this occurs in complex and contradictory ways. The hypostatisation of discourse is, in the end, as illegitimate as the hypostatisation of the 'essential human subject' or of the 'transcendental signifier'.[45] It remains to be seen whether future developments in the theory of the subject can successfully locate its constitution in discourse

and ideology within a materialist, sociological framework.

With regard to the central question of this chapter, that of the author as subject, the arguments I have followed through could be described as 'de-centring and re-focusing' on the author. I have reviewed recent work which has exposed the myth of the unified, transcendental subject/author, and which has attempted to substitute a materialist theory of the subject. (As with the theory of the sign, this has not necessarily been 'materialist' in the Marxist sense, however, as we have seen.) I have followed these arguments without taking them to the extreme of replacing authorial dominance and authorial unity with a vacuum, to be filled by any reader. The centrality of the author in the sociology of literature is a vital matter, and a modified conception of authorship does nothing to alter this fact. As Giddens has argued with regard to sociology more generally: 'The de-centring of the subject must not be made equivalent to its disappearance' (Giddens 1979, p. 45).

The author as fixed, uniform and unconstituted creative source has indeed died. The concept of authorial dominance in the text has also been thrown open to question. But the author, now understood as constituted in language, ideology, and social relations, retains a central relevance, both in relation to the meaning of the text (the author being the first person to fix meaning, which will of course subsequently be subject to redefinition and fixing by all future readers), and in the context of the sociological understanding of literature.[46] And although my concern has been specifically with artistic production, and with the author/artist as subject – perhaps a special case where the notion of 'creativity' requires demystification – this discussion has, I think, wider relevance to sociology in general, and to the problem of how the agency of human subjects may be accounted for.

Conclusion

Cultural Producer and Cultural Product

> The sociology of intellectual and artistic creation must take as its object the creative project as a meeting point and an adjustment between determinism and a determination. (Bourdieu 1971, p. 185)

This statement by Bourdieu reiterates the argument of the past chapter. The sociology of art enables us to see that artistic practice is situated practice, the mediation of aesthetic codes, what Bourdieu calls the 'cultural unconscious' (p. 180), and ideological, social and material processes and institutions. At the same time, it insists that we do not lose sight of the artist as the locus of this mediation and the facilitator of its expression. In the course of this book, I have presented two main arguments for replacing the traditional notion of the artist as creator with one of the artist as producer, recognising the nature of artistic work as located production. These were, first, that an overemphasis on the individual artist as unique creator of a work is misleading, because it writes out of the account the numerous other people involved in the production of any work, and also draws attention away from the various social constituting and determining processes involved. Secondly, the traditional concept of the artist as creator depends on an unexamined view of the subject, which fails to see the manner in which subjects are themselves constituted in social and ideological processes. At the same time, it presents a

simplified account of the subject as a coherent, rational entity, without recognising that any such account depends on an arbitrary selection of biographical and character features, imposing an artificial unity on the individual as subject. For both these reasons, it is impossible to give an account of the artist except in terms of the structures of his or her past and present constitution. Replacing the vocabulary of 'creation', 'artist' and 'work of art' with that of 'cultural or artistic production' (or 'manufacture' – Mayakovsky), 'cultural producer' (or 'scriptor' or 'compositor' – as Barthes and Macherey say) and 'artistic product' is no sacrilegious demotion of the aesthetic to the mundane. It is a way of ensuring that the way in which we talk about art and culture does not allow or encourage us to entertain mystical, idealised and totally unrealistic notions about the nature of this sphere, which the sociology of art has shown to be unacceptable.

> The various 'theories' of creation all ignore the process of making; they omit any account of production. One can create undiminished, so, paradoxically, creation is the release of what is already there; or, one is witness of a sudden apparition, and then creation is an irruption, an epiphany, a mystery. In both instances any possible explanation of the change has been done away with; in the former, nothing has happened; and in the latter what has happened is inexplicable. All speculation over man the creator is intended to eliminate a real knowledge: the 'creative process' is, precisely, not a process, a labour; it is a religious formula to be found on funeral monuments . . . You will understand why, in this book, the word 'creation' is suppressed, and systematically replaced by 'production'. (Macherey 1978a, p. 68)

The artist, as cultural producer, then, has a place in the sociology of art. It is no longer necessary for sociological analysis to have to choose whether to give priority to 'action' or to 'structure', or to argue about voluntarism and determinism. As a number of people have already suggested, we have to operate with a model which posits the mutual interdependence of structure and agency, rather than the primacy of one or other.[1] If the subject is no longer defined as a free, rational agent, he or she need not at the same time be reduced to an effect of structure, or an unthinking,

programmed robot. And insofar as sociology in general must accommodate the actor-subject, properly theorised, the sociology of art is also a theory of the artistic practice of particular subjects.

In the same way, the cultural product ('work of art') loses its character as transcendent, universal fact, whose 'greatness' is unanalysable, but somehow mysteriously and inherently present. It is seen instead as the complex product of economic, social and ideological factors, mediated through the formal structures of the text (literary or other), and owing its existence to the particular practice of the located individual. Moreover, since it is clear that the practices of literary and art criticism are also subject to sociological analysis, and can therefore be located in specific ideological conditions and social institutions, the matter of 'greatness' descends rather more into the reach of analytical understanding. The accredited judges of art and arbiters of taste are themselves socially defined and constituted, and bring to bear in their judgements specific ideological and positional values.[2]

The sociology of art is the study of the practices and institutions of artistic production. I have tried to show that this necessarily involves the study of aesthetic conventions, as well as the specific, socially defined place of the artist at any particular time. It also discloses the ways in which these practices are embedded in and informed by broader social and political processes and institutions, with economic forces historically playing a particularly important rôle.[3] Here, I endorse once again the arguments of those who have recently emphasised the economic determinants of 'discourses' in the media and in the arts in general.[4] It is important to beware of any tendency to overstate the autonomy of codes and discourses, in the commendable refusal to reduce these to mere effects of the social structure. Although it is true that language, representation and ideology play an active part in constituting subjects and fashioning cultural products, they are themselves the product of past practices. Their operation as relatively autonomous systems should not blind us either to their own original constitution in extra-discursive processes, or to their constant susceptibility to the intrusion of material and economic factors as transformative influences.

Questions about the actual relationship of the economic and the ideological, or about the degree of autonomy of art or ideology, or about the transformative potential of a particular style of work, are

always empirical questions, whose answer requires the historical analysis of a concrete situation. That is why it would be a serious misconception to attempt to present a general model of the sociology of art. At most, we have something like a series of generalisations, based on our knowledge of the determinants and co-ordinates of cultural production over a particular historical period. Such generalisations may form the basis for hypotheses concerning the relationship of culture, society and economy in other places or periods, so that, for example, we are directed to look at the effects of the class structure, through patronage, as represented in paintings. But nothing can be assumed, however suggestive such hypotheses may be, and expectations based on past experience should be capable of reversal and surprise where necessary. The value of pursuing a systematic account of the numerous determinants and mediators of cultural production is not to prove that they are always operative in the same way and with the same force, but to sensitise the investigator to the variety of factors which come into play with more or less efficacy at different times. With this prevision, it does not really matter whether one begins from a particular painting, from a focus on an artist or author, or from a broader view of a cultural period. The analysis should be able to incorporate all the 'levels' and factors which have contributed to the production of the works.[5] An initial focus on the micro-level of the work itself will broaden out to encompass producer, aesthetic code, political and social context; an adequate study which begins from a general characterisation of the social structure of a particular period will eventually trace through the workings of ideas and politics in particular texts or paintings. The specific biographical mediation of the cultural producer is one significant element in the analysis in each case.

One of my concerns in this book has been to demystify the concept of 'creativity', particularly as it is used about art. Against this concept, I have referred to a diverse body of work which demonstrates that art is a social product. My final comments concern the implications of this for aesthetics, and in particular any residual suspicion that somehow the effect of the whole of the preceding discussion has been to reduce art to its external co-ordinates, to collapse it into non-aesthetic factors, and thereby to sidestep and omit the question of the nature of art itself. On this there are a number of points to be made.

In the first place, aesthetics as a discipline also has a history. The philosophical study of art as something distinct from other spheres of life depended for its development on the historical separation *of* art from craft and other forms of work. In this sense, there is nothing sacred and eternal about the aesthetic, which a sociology of art profanes; on the contrary, sociology demonstrates its very arbitrariness in laying bare its historical construction.

However, it is an historical fact that there *is*, in contemporary industrial societies, a distinct sphere of life (or level of experience, or discourse) which we designate the aesthetic. We have the generic terms 'art' and 'artist' which may apply not only to the visual arts, but also to literature, music, drama, opera, dance, film and photography. We have galleries, concert halls, art books, mixed-media shows and art colleges. We also have the disciplines of art criticism, aesthetics and the sociology of the arts. All of these things are the result of specific historical developments, which have separated out certain practices from others, and from their connections with 'functional' practices (paintings to hang on a wall, rather than to adorn a ceremonial dish or a church, for example). Whatever the historical processes which have produced this differentiation, it is important to recognise the arts and aesthetics as constituting a distinct, though contingent, realm. I hope that in this study I have managed to do this in at least two respects. In Chapter 3, I paid a good deal of attention to the relative independence and effectivity of aesthetic conventions and codes which, already constituted and confronting particular cultural producers, confirm the aesthetic as a discursive formation which resists any simple determinism of its objects by extra-discursive elements. And in the preceding chapter (Chapter 2), I discussed the rôle of cultural mediators and institutions in the social production of culture. These, too, exist in the specific realm of the aesthetic. In this sense, it would certainly be wrong to reduce the aesthetic to the ideological or the social.

There are two issues conventionally dealt with in aesthetic theory which I have not attempted to address or to account for within a sociological theory of art. These are, first, the question of the nature of the aesthetic experience, and, secondly, the question of the basis of aesthetic judgement and evaluation. The first is the subject of work in the philosophy of mind and in phenomenological aesthetics,[6] and in considering some of the ideas of Iser

(Chapter 5) I have obliquely engaged with it. However, it is those aspects of Iser's work which directly propose the phenomenological categories of aesthetic experience which seem to me to be most alien to a sociological approach, for they resist any historicising tendency and appear to propose these categories, as Kant did, as universal. A similar, often implicit, belief in the irreducible quality of the aesthetic, as an essential human attribute or mode of being, underlies a good deal of more solid sociological work on art, including the contributions of Lukács, Marcuse and Marx himself.[7] On this point, which has not been any central concern for this study, I simply record my agnosticism, with the following remarks. If the aesthetic mode of experience *is* a universal human quality, then this is a contingent and historical fact, in much the same way as I argued for other claims of philosophical anthropology (pp. 15–16 above). Certainly it can be explored well in phenomenological terms, which are expressly designed to investigate the forms of consciousness. But, while not in any way believing I have accounted for the aesthetic experience (the human potentiality to enjoy beauty) by explaining it in terms of ideology or social structure, I would insist that there is no such thing as the 'pure' operation of the aesthetic consciousness. Whatever its phenomenological status as a category of consciousness, in its actual exercise it is always necessarily thoroughly permeated with the experiential and ideological features of social existence. In this sense, I oppose any Kantian notion of 'disinterestedness' as characterising *particular* aesthetic experiences.[8]

With regard to the question of aesthetic value, I have already indicated that I believe this to be rather more problematic than some writers have suggested (p. 7 above). In short, although I would argue that any aesthetic judgement is the product of other, non-aesthetic, values, it does not seem to me to have been demonstrated that it is entirely reducible to these. In the absence of any satisfactory account of what is involved in assigning value to cultural products, I leave this too as an open question.[9]

The sociological study of art does not constitute a denial by exposure of aesthetic enjoyment and aesthetic experience, a denigration of cultural production, or an equalisation of all cultural products. The relative value of different works is determined within the discourse of art and aesthetics, and is not amenable to appropriation by a different discourse (sociology), although the

latter can throw light on the origins and development of the former. In other words, the fact that it is an historically contingent matter that we have a separate 'aesthetic sphere' or discourse of art in no way negates that sphere. The importance of the sociology of art, however, consists in its critique of the ideology of timelessness and value-freedom which characterises art theory and art history in the modern world. It enables us to see that art always encodes values and ideology, and that art criticism itself, though operating within a relatively autonomous discourse, is never innocent of the political and ideological processes in which that discourse has been constituted. The sociology of art opens up a perspective in which we may comprehend the social construction of art and culture – its practitioners, its audiences, its theorists and critics, and its products. It does so not in any spirit of philistinism or iconoclasm, but from a commitment to its subject matter and with a total sensitivity to its special nature. The consequence should be that we both understand and appreciate art the better.

Afterword to the Second Edition

These days, I live in a different country and I work (institutionally at least) in a different discipline. I still think of myself, though, as a sociologist rather than an art historian. To some extent, my situation now is a product of changes in the academic world since the late 1970s. At that time in Britain, there was an energetic growth in cultural studies, media studies, the sociology of the arts, and the development of a social–historical–critical perspective in the humanities, especially literary studies and art history. The 1978 annual conference of the British Sociological Association was devoted to the theme of Culture; annual conferences on the sociology of literature were held at Essex University; courses and publications in media studies, film studies and cultural studies were proliferating; a social history of art, as well as critical studies in literature, were challenging traditional humanities disciplines from within; and feminist work was transforming the ways in which we understood the interaction of the social and cultural.

A number of things have happened since then, which have affected the project of an inter-disciplinary sociology of art. As a result of government policies, higher education in Britain has been radically restructured since the early 1980s, with particularly devastating effects for the humanities and the social sciences; this has resulted in the migration of many academics and scholars to the United States, Canada and other countries. In addition, one of the results of the transformation of tertiary education has been a kind of cost-consciousness which has pushed research and teaching into the direction of more 'useful' work – projects which attract funding, or which can be seen to have more immediate relevance for social problems. Within the discipline of sociology, therefore, the

study of culture has not had a high priority. Most of the work in this area has come from disciplines other than sociology.

In the United States, on the other hand, the sociology of culture and the arts has been thriving in recent years. Annual conferences on Social Theory, Politics and the Arts are held each October, usually on the East Coast. A few years ago, members of the American Sociological Association (ASA) founded a section on the Sociology of Culture; this is already one of the largest sections, with a membership of over 500, an annual book/essay prize, and several specialist sessions at annual meetings of the ASA. Unlike the sociology of the arts in Britain, though, this work remains exceedingly intra-disciplinary, untheoretical, and, often, narrowly empiricist. Not surprisingly, then, American sociology departments have not (with one or two exceptions) proved particularly hospitable to scholars with a more inter-disciplinary, critical approach. A more enthusiastic reception of such work has been evident in humanities programmes and departments, anxious to incorporate critical theory and social–historical approaches into the curriculum. Hence, the migration from Britain has been into media studies, film studies, art history and literary studies, rather than the social sciences. And so I find myself in a department of art history.

This is not, of course, to say that the expansion of critical studies has been motivated by this British invasion. Alongside the growth of a sociology of the arts, critical studies in the humanities have flourished in North America. Feminism continues to be crucially important in this; in more recent years, ethnic studies and post-colonial criticism have made a vital contribution to – indeed have transformed – cultural studies and the sociology of culture. As I will argue later, some of these developments should be regarded critically, in particular the more positivistic tendencies in sociology and the excessively 'textualising' moves in the humanities.[1] Nevertheless, there has been a remarkable interest in critical theory in the arts, popular culture and media studies, evident in the proliferation of publications, centres and graduate programmes. Although for the most part this has taken place outside the discipline of sociology (and although some of the work is more textual than sociological), I do see this as the continuation of the earlier project of a sociology of art, in which this book participated.

It is now thirteen years since the first edition of the book was written, and in deciding whether to prepare a second edition, I

have had to consider whether it was not entirely superseded by developments since then. Certainly if I were to write a new book of this kind it would be somewhat different. Approaches and arguments would be illustrated with other, more up-to-date examples. Developments in theory, especially theories of representation, would be integrated into my discussion, in some cases rendering obsolete or misleading some of my earlier formulations. Although my analysis would still be in a Marxist terms, insisting on the importance of class relations and on the continuing necessity to understand cultural production and reception in the context of a capitalist economy, I would now be able to follow the valuable practice of others who perceive the complex interplay of categories of social differentiation – class, ethnicity, race, gender – without insisting on the primacy of any of these. In this way, questions of gender no longer appear to be an afterthought to, or problem for, class analysis. Although it is not possible (or necessary) to incorporate every dimension and axis of inequality at every point, analysis in terms of articulations and situational factors has proved the most productive. Questions of race and ethnicity are entirely absent, too, in this book, which in retrospect (and with the benefit of a decade of important work in post-colonial criticism) appears as a most serious omission. It is not only that addressing these issues is politically and intellectually imperative; equally importantly, *any* cultural analysis has to take into account the complex ways in which the structures and ideologies of racial difference intersect with gender and class and inform representation.

My decision to go ahead with a second edition of this book is based on the belief that despite these retrospective criticisms it may still be useful as a review of some of the most important ways in which art is a social product. In leaving the text itself unaltered, though, I want to discuss each of the main chapter themes briefly in this Afterword with regard to more recent work in each area. Although I have not changed my mind on any of the main claims I make in this book, this revision is intended to review and restate these issues.

Subjectivity, biography, creativity

As theory continues to de-centre the subject and displace the artist as creator, popular cultural texts have accelerated the opposite tendency. The biopic has become a common genre, with the

circulation of films about artists (van Gogh, Camille Claudel, Frida Kahlo), writers (George Sand, Byron and Shelley, Anais Nin and Henry Miller), composers (Mozart, Chopin) and pop stars (Buddy Holly, Jim Morrison, Ritchie Valens).[2] Pop biographies of artists proliferate (O'Keeffe, Picasso, Kahlo, Jackson Pollock). There are also new biographical studies of artists and authors by scholars working in the academy; Mary Garrard's recent book on Artemisia Gentileschi is one example.[3]

At the same time, new technologies have raised further questions about the artist as creator. This has been an issue (including a legal issue of copyright) especially in pop music, with regard to the practice of sampling.[4] This is merely the most recent development of the 'collective production of art', which I discuss in Chapter 2; earlier, the role of the sound engineer appeared problematic for any notion of pure creativity on the part of the artists themselves. David Hockney's recent art practice, involving the faxing of images, or Sherric Levine's work which appropriates images by established artists, does not really raise any more of a challenge to traditional notions of creativity than does the practice of photographers who get commercial studios to print their work, or sculptors who have assistants to complete their projects – or (perhaps more appropriately) artists who made multiple copies of the same painting, or quote other artists in their work. Inasmuch as the new technologies have been taken up by artists in various media, they have only served to make more visible the myth of total originality which still characterises our notion of art.

In the final chapter of this book, I discuss some of the implications of post-structuralist theories for accounts of authorship, and conclude that in abandoning humanist notions of the author as unconstituted, fixed and originary, we need not at the same time deny the central relevance of the author–artist for a sociology of art. Now I would still argue that there is a middle way between the atheoretical biographical mode and the absent subject. Recent work in the social history of art has suggested that we can still focus on the artist as producer, on the understanding that we reconceptualise subjectivity as provisionally fixed, as fluid and inconsistent, and as itself the product and effect of discourse, ideology and social relations.[5] In other words, the sociology of art still has a place for biography; and creativity, though located, determined, assisted and compromised, operates as a category within this discourse.

The sociology of art

The 'production of culture approach', which I discuss in Chapter 2, is in a healthy state in American sociology. I have already referred to the annual conferences and the ASA sociology of culture section, through which a multiplicity of studies, papers and publications have been processed.[6] The criticisms I made of this work more than a decade ago seem to me still to be appropriate. A good deal of it is positivistic and untheorised, and operates by taking a small-scale example (such as an arts organisation) which is then analysed with no attempt to locate this either in the wider social structure or in its own historical context. Accordingly the studies tend to be very limited in their explanatory accounts. Often such studies are a most valuable source of sociological and other information about the arts. However, the inability of sociologists to take a broader view of cultural practices and institutions, and their refusal to engage in questions of aesthetics, results for the most part in work which is at best narrowly empiricist, and at worst distorted.[7] (I discuss these questions in my book, *Aesthetics and the Sociology of Art*, forthcoming.)

There are some signs that American sociology may be taking seriously the challenge of post-structuralist and postmodern theory.[8] But so far, the sociology of art has been unaffected by this move, with the result that the divide between work in the humanities and work in the social sciences is more or less absolute in this area. In Chapter 2, my criticisms focus on the limitations of an approach which ignores historical and macrosocial features of cultural production. Now I would argue even more strongly that this work is seriously compromised by its ignorance of the discursive construction of the social world itself. Those institutions which provide the subject-matter of the sociology of art are by no means given entities, but are themselves produced and maintained in discourse and systems of representation. This recognition must be integrated into any sociological study of culture.

Art, ideology and discourse

The term 'ideology' has fallen out of favour in cultural studies and the sociology of art in the last decade. The term carries with it the connotations of a cruder mechanistic model, in which systems of

ideas, perceived as more or less monolithic, are the direct product of social relations of inequality. On this view, not only is there no room for negotiation or resistance; it is also impossible to understand the productive role of ideas and representation in the construction of the social world. Gramsci's notion of *hegemony* has proved more useful in accounting for the essentially contested nature of the political, still understood as operating in the context of the unequal social relations of class-divided society. Poststructuralist theories, and the work of Foucault above all, have emphasised the discursive nature of the social world, and the inadequacy of any model, including an unreconstructed Marxism, which posits 'real' entities (classes, social institutions) without acknowledging their articulation in theory, representation and discourse.[9] In addition, the postmodern critique of meta-narratives participates in the challenge to any sociological theory, including Marxism, which presents itself as anything other than a provisional, arbitrary, and more or less useful account of the social world.

In retrospect, I think my discussion in Chapter 3 is at times still too dependent on older (pre-post-structuralist) ways of theorising culture and ideology. Tony Bennett has pointed out that my discussion here attempts the impossible task of combining two incompatible notions of ideology (Bennett 1981), and he is right to identify the remnants there of a commitment to the more mechanistic model. However, I want to consider instead the excesses of the opposite tendency in the sociology of culture, namely an over-enthusiastic abandonment of structure, causality, and the 'real' world. As others have also pointed out, there is a new idealism (that is, anti-materialism) in play in the textualising moves of a good deal of work in the humanities. I do not just mean traditional, unsociological idealism, but, more worryingly, post-Marxist, post-structuralist work which concludes from the fact that structures and social facts are always mediated and produced in representation that such things are *only* discursive articulations.[10] It is one thing to recognise the complex interplay of text, meaning and social structure, a recognition which has informed some important work in recent art history and literary studies.[11] It is another matter, however, to opt for a radical indeterminacy, in which history is perceived as a plurality of texts.[12] In my view, the expansion of cultural studies, especially in the United States, is to some extent based on this textualising shift, whose consequences

are both a certain depoliticisation of the original project of cultural studies, and the transformation of what should be a sociological–critical study into a new hermeneutic.[13] Therefore, although I do think it is important to re-think questions of causality, determinacy and social structure, I also believe that the concept of 'ideology', which is premissed on a certain systematic relationship between ideas and social structure, is far from obsolete.

Postmodernism and cultural politics

In Chapter 4, I discuss the debate about realism and modernism in relation to the politics of culture. During the 1980s, and since I wrote this, the debate has shifted to the opposition of modernism and postmodernism, as political projects and as the basis for cultural politics. Craig Owens, in an influential essay of 1983, explored the progressive and transformative potential of so-called postmodern art practices in the visual arts – strategies of deconstruction, juxtaposition and quotation, which foreground the nature of representation and at the same time expose the political meanings implicit in all texts (Owens 1983). His suggestion that such practices are particularly appropriate for those excluded from the mainstream of representation (feminists, third-world and ethnic minority artists) has been taken up by others.[14] In some ways, it often seems that this is a replay of the realism/modernism issue; in the context of feminist art practice, for example, the charge of elitism has been levelled against some 'postmodern' artists whose work demands effort and (often) a sophisticated theoretical understanding,[15] which recalls the defence of realism against the less accessible modernist text. Here, too, we have a new version of the argument that in order to fragment and deconstruct dominant modes of thought we need to deny closure and employ representational strategies which themselves refuse premature or imaginary resolutions of real contradictions; but now 'closure' refers as much to the modernist text as it does to realism, since the more recent attack is on the commitment of modernism to 'meta-narratives' inherited from Enlightenment thought.

But here lies the difficulty of postmodernism in relation to cultural politics and, indeed, any kind of politics. Postmodern theory, on which postmodern art practice sometimes depends (thought it need not), in its project of undermining grand theories,

can too easily fall into a kind of relativism in which it becomes impossible to adopt or defend any theoretical (and hence political) position. If Marxism is just a narrative, then unless we have some other grounds for proposing it as convincing, there is no basis for the identification of class as a crucial structuring mechanism. Or, without a theoretical justification for any narrative, it appears not to be possible to argue that inequalities of gender permeate social life; an alternative theory can ignore or deny this. With regard to postmodern art practice, the risk is the evacuation of any political ground in the interests of a determinedly ungrounded deconstructive practice.[16] For this reason, I take the view that we would be wrong to give up on modernism. In a variant of my argument earlier about ideology, I would argue that at the same time as recognising the discursive and institutional construction of theories, and their ultimate provisionality, we can still resist relativism in the interests of sociological adequacy (some theories describe the world better) and political priority (some transformative projects must be defended).

In one way, though, I want to repeat my somewhat liberal (in the British rather than American sense) refusal to take sides in the debate between realism and modernism. The case for postmodernism in cultural practice is often made (as it is by Craig Owens) on the basis of the necessity to use representational practices to challenge essentialism and humanism – for example, for feminist art to demonstrate that the very category 'woman' is a cultural construct. There is no doubt that visual and other media provide powerful tools for this important political activity. However, the dismissal of what have been called 'celebratory' art practices, which work by providing positive images (of women, in this case) or textual reversals which refuse the dominant negative meanings has, I think, been too cavalier. Here too it can be argued that there is a place for different art practices, including those which do not engage the deconstructive task of postmodernism. This does not mean, as is sometimes assumed, that they collude with essentialism; the category 'woman' can be a focus of political articulation without a belief in the essential, intrinsic characteristics of women. (These questions are discussed in my recent book, *Feminine Sentences*, 1990.) And, as with the realism/modernism issue, this is often really a question of strategy, location, and specific audiences, to which I now turn.

Interpretation, de-coding and resistance

In Chapter 5, I discuss the active role of the reader/viewer in the encounter with the text. The polysemic nature of texts and the differential situation and de-coding practices of readers mean that textual analysis is never entirely adequate, since the meaning of the text only emerges in its consumption. I do conclude that there are limits to the range of possible readings, both because texts have ways of privileging certain meanings, and because the history of the reception of a text operates to 'fix' meaning in some ways. Politically, the importance of the fact that de-coding is an active process lies in the knowledge that the control of producers of texts is limited, since they can never be sure of manipulating interpretations. As I suggested, the room for negotiation of interpretation can be quite extensive.

In recent years, this argument has been taken much further, as analysts of culture claim to discover examples of readings which are not only not controlled, but also subversive. Even the most conventional genres and texts turn out to have this radical potential, as ethnographers of popular culture produce case after case of readers and television viewers who use texts in unexpected ways to resist everyday life and confirm alternative views.[17] Such accounts are often less than convincing, exhibiting a populist commitment to certain cultural forms and an over-optimistic desire to find political resistance rather than a more measured understanding of what is involved in the more modest activity of the negotiation of meanings in a cultural text. Overall, though, it is clear that in the analysis of cultural reception we should not assume either an unrelenting pessimism in the face of the culture industries, or a naive optimism about the limitless radical potential of any text. The answer, as usual, is a matter of specific analyses of texts themselves and, where possible, of the actual viewing/reading practices of audiences.

Authors, artists and identities

I have already discussed some of the issues of authenticity and creativity raised in recent theory. As I said, I still believe the author/artist has a place in the sociology of art. The multiple sources of displacement of the author from the text (collective

production, textual meanings, readers' licence, and the de-centring of the author as possible unitary source of meaning) does not entail the evaporation of the producing subject, or the irrelevance of biographical information. As I have suggested, we have to reconceptualise the producer as (non-unitary, provisionally fixed, psychically and socially produced) originator of the text.

Questions of the subject and of identity have proved central in discussions of oppositional politics; this relates, too, to the issue of celebratory versus deconstructive cultural practices, referred to above. Some feminist theorists have wanted to take on the insights and analytic strengths of post-structuralist theory, without relinquishing the political and experiential necessity for women to retain the identity 'woman'. In some cases this generic category will be inappropriate, where differences between women are relevant, or where gender difference itself is not at issue. But the self-identification, and the collective political identification, of 'woman' remains crucial.[18] Similar debates about ethnic identity, in the light of theories of representation and anti-essentialism, continue to be engaged.[19] As with 'celebratory' art practice, the point is that we can now understand that identities are crucial without taking them to be somehow essential or fixed. In the case of the cultural producer (or, for that matter, consumer), although it is not a matter here of collective identity, the subject is similarly in play.

If these afterthoughts have taken on a certain quality of defensiveness, it is because I am writing in support of a particular, and continuing, project of a sociology of art against certain tendencies which seem to me to be subverting – or perhaps *diverting* – the intentions of that enterprise. In republishing this book, then, I suppose I am making a particular statement about recent work, and about where I stand with regard to these developments. In this sense, as we already know (and as Chapter 5 ought to have demonstrated), this text, while totally unchanged, is no longer quite the same text.

Notes and References

Introduction

1. Marx (1973, pp. 90–4).
2. Hohendahl (1977, p. 56) is one of the few people who actually addresses this question, and offers some suggestions as to how it might be dealt with.
3. See, for example, Giddens (1979), Lukes (1977) and Cutler *et al*. (1977 and 1978).
4. Althusser (1969c, 1971d and 1976). See also Coward and Ellis (1977), Coward (1977), McLennan *et al*. (1977), and Hindess and Hirst (1977).
5. Giddens (1979) and Lukes (1977).
6. See John Lewis's critique of Althusser (Lewis 1972), and Althusser's reply (Althusser 1976). See also John Berger's critical review of Hadjinicolaou (Berger 1978).
7. Anthony Giddens' latest book makes use of discourse theory and of the theory of the text (Giddens 1979). See also Ricoeur (1971).
8. For example, Laurenson and Swingewood (1972), Burns and Burns (1973), McQuail (1972), Jarvie (1970), Frith (1978). However, some anthologies and readers on the subject have been more eclectic – for example, Albrecht *et al*. (1970), L. Baxandall (1972), Peterson (1976) and Coser (1978).
9. Hadjinicolaou (1978a).
10. Some examples of this are: Therborn (1976), Shaw (1975), Harvey (1972), Nicolaus (1972a and 1972b). See also Eagleton's comment on sociologists in Eagleton (1977).
11. For an account of this, see Swingewood (1972).
12. See, for example Keat and Urry (1975), Benton (1977).
13. Eagleton (1976b).
14. Laing (1978).
15. Eagleton (1976a).
16. Williams (1977a).
17. Hadjinicolaou (1978a).
18. For example, Berger (1972), Hadjinicolaou (1978a), and Eagleton (1975a).

19. I would argue that both Eagleton (1976a) and Hadjinicolaou (1978a) are guilty of this.
20. See Smith (1974) and Fuller (1978).
21. For a collection of essays of this type of work see Barker and Allen (1976a and 1976b). Examples of attempts to begin to re-examine ethnographic studies in a non-sexist way are Frankenberg (1976), Rosaldo and Lamphere (1974) and Caplan and Bujra (1978).
22. Two recent attempts to do so are Morgan (1975) and Poster (1978).
23. For the analysis of images of gender, and of women in particular, see Berger (1972), Pollock (1977), Cowie (1977), Spence (1978/9) and Heath (1978). Studies which concentrate on discrimination within the social structures of artistic production include: Nochlin (1973), Tuchman (1975), Moers (1977), Parker and Pollock (1980) and Woolf (1979, particularly the introductory essay by Michèle Barrett). Jacobus (1979) contains essays which discuss both aspects.
24. See, for example, Kuhn and Wolpe (1978), Barrett (1980), Beechey (1979), Benston (1969), Gardiner (1975 and 1977), Hartman (1979), Molyneux (1979), Middleton (1974) and Seccombe (1974).
25. Hamilton (1978) claims to present such a synthesis, but in fact does no more than offer two separate and distinct analyses of patriarchy and class in seventeenth-century Britain.

Chapter 1: Social Structure and Artistic Creativity

1. Lukács (1965, p. 10).
2. Eagleton (1970). See also Eagleton (1976a, Chapter 4).
3. This is discussed in Vazquez (1973). See below, pp. 18–19.
4. 'Capitalist production is hostile to certain branches of spiritual production, for example, art and poetry.' (Karl Marx, *Theories of Surplus Value*, Progress, Moscow, 1963, p. 285, quoted by Vazquez 1973, p. 155.)
5. See Fischer (1963, Chapter 3: 'Art and capitalism').
6. Watt (1972) discusses this in relation to the rise of the novel. See also Williams (1965).
7. For studies of artists and their patrons, see: M. Baxandall (1972), Haskell (1963), Pevsner (1940, pp. 30ff), and Trevor-Roper (1976). On literary patronage, see Laurenson (1972). Pelles (1963) and White and White (1965) discuss the changes in the position of the artist with the rise of capitalism.
8. See Peter Fuller's notion of the 'megavisual tradition' of advertising. (Fuller 1978/9 and 1979.)
9. Mayakovsky (1970, p. 19).
10. Ibid., pp. 18–19.
11. Vazquez (1973). I do not want to suggest, however, that Vazquez's arguments about art and labour are identical to Mayakovsky's, or that, indeed, the two have a great deal in common in their analyses. In particular, Vazquez does not take the demystification of creative work as far as Mayakovsky indicates is necessary. Nevertheless, I think it useful to begin with Vazquez's analysis of work in general.
12. Marx and Engels (1970, p. 42, and 1973, p. 51).

13. Althusser (1969d).
14. Althusser (1969a, p. 33).
15. Ibid., pp. 34–5.
16. For example, in Marx and Engels (1973), on the section on 'aesthetic sensibility' (pp. 53–4).
17. Vazquez argues that artistic labour is 'superior human labor' (1973, p. 86). Jauss also argues that Marx takes the production of art as the paradigm for all practical activity (1975, pp. 197–200).
18. An alternative reading of Marx's analysis of capitalism is offered in Godelier (1972). The critique is usually linked with those structuralist approaches which follow Althusser in identifying an 'epistemological break' in the chronology of Marx's work; only the early works are faulted for resting on a philosophical anthropology, the later ones not depending on any concept of 'the nature of humans'. For analyses which accept a more unified concept of a 'total Marx', see Fromm (1961), Mészáros (1970) and Ollman (1971).
19. On the division of mental and manual labour, see Marx and Engels (1970, pp. 51–2), and Sohn-Rethel (1978). On the division of labour in general in modern society, see Braverman (1974).
20. However, Vazquez's formulation indicates that he does, in some sense, separate art *from* other forms of labour, by *comparing* them in this way. (He does not say, for example, 'the similarity between art and *other* labour'.)
21. On the question of the decorative arts, see Morris (1973). The relegation of women to the 'lesser arts' is discussed in Parker and Pollock (1980).
22. Vazquez makes the point that there *is* a difference in the particular need served by the product – but this is not a difference in kind (1973, pp. 64–5).
23. Braverman (1974, Chapter 1).
24. Marx (1973, pp. 296–7).
25. On the nature of art as a commodity, see Hess (1976).
26. A two-year enquiry into the economic situation of the visual artist in Britain, funded by the Calouste Gulbenkian Foundation and nearing completion at the time of writing, is investigating this practice, amongst other things.
27. See, for example: Dawe (1970), Benton (1977), Cohen (1968) and Corrigan (1975). The debate about methodological individualism is also relevant (see O'Neill 1973).
28. Berger and Luckmann (1967). A weakness of this book, however, is that it does not consider or explain the particular forms society takes, or the locus of power in specific sectors.
29. For example, in Lukács (1963, p. 61, and 1970, pp. 115ff).
30. Sartre (1971–2). See also Sartre (1963, pp. 57–65, 106–7 and 149–50).
31. The classic example is Freud (1910). On the application of psychoanalysis to art history, see Gombrich (1963).
32. Sartre (1963) often appears to believe that 'freedom' does consist in escaping the determination of social structures, by way of the 'project'. Althusser's criticisms of John Lewis point this out, in aligning Lewis with Sartre: 'John Lewis's man is a little lay god. Like every living being he is "up to his neck" in reality, but endowed with the prodigious power of being able at any moment to step outside of that reality, of being able to change its character. A little Sartrian god, always "*en situation*" in history, endowed with the

amazing power of "transcending" every situation . . .' (Althusser 1976, p. 44).

33. What I now discuss as free action or human agency cross-cuts the earlier discussion of Marx's distinction between 'free, creative labour' and 'alienated labour'. Even an action under type (5) might be performed in false consciousness, though on the whole, actions done in conditions of domination and the alienation of labour would tend to be of types (3) and (4). The focus here, however, is on voluntary acts, as socially, historically situated, as a *general* problem; the specific features of particular social structures and their implications for agents is for these purposes a secondary one, since in principle the analysis of the relationship of agency and structure includes *all* types of situated practices. Even action which capitalism has rendered 'non-creative', in the sense I used this before, is still free in the broader sense.

34. Giddens (1976, pp. 103, 121, 157).

35. 'Men make their own history, but they do not make it just as they please; they do not make it under circumstances chosen by themselves, but under circumstances directly encountered, given and transmitted from the past' (From *The Eighteenth Brumaire of Louis Bonaparte*, in Marx and Engels 1968, p. 96).

36. Giddens (1979, particularly Chapter 2).

37. I therefore disagree with the view (taken by Cutler *et al.*) that 'subjects', whether individual or collective, should be treated in the same way in analysis (1977, Vol. 1, p. 263). This position necessarily, and intentionally, ignores the question of the specific nature of individual human agency.

Chapter 2: The Social Production of Art

1. See Laurenson (1972, pp. 105 16).
2. See Decker (1974).
3. Hauser (1968), Antal (1948), Kettle (1951–3).
4. Clark (1974).
5. For example, Hess (1976) and Tagg (1977).
6. Williams (1965, 1977a), Eagleton (1976a, 1976b, 1977). See also Cohen (1974).
7. *Red Letters* is the Communist Party literature journal, and the first issue appeared in 1976. *Literature & History* is a twice-yearly journal, published at Thames Polytechnic; the first issue appeared in 1975.
8. A useful account of traditional English literary studies, and the emergence of a Marxist approach is in Dyer *et al.* (1973).
9. Examples of this convergence have been the conferences on literature and society held at Essex University in the summers of 1973 and 1976–8, and the British Sociological Association annual conference, held in Sussex in April 1978 and on the theme of 'culture.'
10. See *Working Papers in Cultural Studies*, 1–13, produced at the Centre for Contemporary Cultural Studies at the University of Birmingham.
11. Leavis (1972).
12. See Eagleton (1978b).

13. Some examples are: Berger (1972), Clark (1973), G. Williams (1976), R. Williams (1978).
14. Eagleton (1975a).
15. Clark (1973).
16. Laurenson (1978).
17. See Elliott (1972), Burns (1977), Golding and Elliott (1979) and Garnham (1978). Also some of the essays in Curran *et al*. (1977), Tunstall (1970) and McQuail (1972).
18. Eagleton (1976a).
19. See various articles in the journals *Ideology & Consciousness, Screen*, and *m/f*. Also Coward and Ellis (1977). See Chapter 6 for a further discussion of this tendency.
20. Golding and Murdock (1979), Murdock and Golding (1974), Garnham (1977, 1979a and 1979b). See also McDonnell and Robins (1978). There is a danger, however, that this critique of idealism can go too far back in the direction of economism.
21. Garnham (1977 and 1979a). See also Mattelart (1979).
22. Some examples are: Powell (1978), Bystryn (1978), Kealy (1979), Peterson (1975 and 1978), DiMaggio and Useem (1978a, 1978b, 1978c).
23. Peterson (1976), Coser (1978).
24. Rosenblum (1978b, p. 422). See also her book (Rosenblum 1978a).
25. Tony Bennett also makes this point (Bennett 1979, p. 151).
26. There are some examples of more empirical sociological studies in Britain, although this is not the dominant tendency as it is in the United States. See Note 17 (above), for such work in media studies. See also Lane (1970).
27. See Tudor (1974).
28. Elliott (1972).
29. Becker (1974, p. 767).
30. Some examples of these constraints, in relation to the work of a particular playwright (Trevor Griffiths) are discussed in Wolff *et al*. (1977, p. 135).
31. Hauser (1968).
32. Haskell (1963), Antal (1948), Pevsner (1940), Pelles (1963), White and White (1965), on the history of painting. Watt (1972), Coser (1965), Laurenson (1972), Sutherland (1976), on the history of literature.
33. Discussed in Sutherland (1976).
34. Discussed in White and White (1965). See also p. 46 below.
35. Febvre and Martin (1976).
36. Eisenstein (1979, p. 30). For Eisenstein, the revolution brought about by the introduction of printing was far more important than the impact of the use of paper.
37. Eisenstein (1979). See also Eisenstein (1969).
38. Eisenstein (1979, pp. 277–83).
39. Ibid., p. 701. Eisenstein talks of the 'complex and contradictory nature of the communications shift', resisting any temptation to reduce this to a single formula.
40. She takes issue with Febvre and Martin, arguing that the change was more discontinuous than they suggest (Eisenstein 1979, p. 36).
41. James (1976, p. 17).

42. This is documented by James (1974 and 1976), Altick (1957), Vicinus (1974), Neuburg (1977).
43. See Chanan (1978) on the relationship of technology and culture with regard to Kodak and microelectronics.
44. James (1976).
45. Benjamin (1973d) and Berger (1972) consider the effects of the mass reproduction of visual images in reaching wider audiences.
46. Watt (1972).
47. Williams (1974, p. 14).
48. See Treble (1978).
49. For uses of this term, see Bystryn (1978), Rosenblum (1978a, pp. 118–19), and Coser (1965, Chapter 25).
50. Laurenson (1972, p. 136).
51. Laurenson (1972, p. 127). See also Tuchman (1975) and Bonham-Carter (1978, pp. 100–1).
52. Laurenson (1972 and 1969).
53. See Nochlin (1973), Tuchman (1975), Greer (1979).
54. Strauss (1970), Madge and Weinberger (1973), Adler (1979).
55. Critical studies include Hess and Baker (1973), Moers (1977), Showalter (1977). Anthologies of work by women painters and writers include Petersen and Wilson (1976), Tufts (1974), Kaplan (1975).
56. See, for example, Nochlin (1973), Greer (1979), Parker and Pollock (1980), Tuchman (1975).
57. See Pevsner (1940, p. 96).
58. Pevsner (1940, p. 85 and p. 185).
59. Nochlin (1973, pp. 24–6). See also Parker and Pollock (1980).
60. For example, see Showalter (1977, pp. 57–8).
61. See Coser (1965, Chapter 3), Leavis (1979, p. 141), Noyce (1979).
62. Moers (1977, p. 64).
63. Woolf (1945). See also Woolf (1979), introduction by Michèle Barrett.
64. Some fairly straightforward analyses of this type include Spacks (1976), Moers (1977) and Showalter (1977). More complex accounts, often using psychoanalytic categories, include Pollock (1979), Kaplan (1976, and introduction to 1975), and Marxist-feminist literature collective (1978).
65. See M. Baxandall (1972, p. 11), for the use of colours specified in Ghirlandaio's contract. Also, Deinhard (1970, pp. 19–21), regarding a contract with Quarton.
66. Hauser (1968, p. 51).
67. See Haskell (1963), for the case of Baroque Italy, and Trevor-Roper (1976), for the Habsburg patrons of the sixteenth and seventeenth centuries. See also Gear (1977) for a study of English painters and patrons in the late eighteenth and early nineteenth centuries.
68. Laurenson (1972, pp. 104–16).
69. Ibid., p. 108.
70. See Pelles (1963), White and White (1965), Sutherland (1976) and Laurenson (1972). See also Pevsner (1970), on 'freedom' and 'security' under different patronage systems in the seventeenth century.
71. See Lane (1970).

72. Pelles (1963, p. 2).
73. Sutherland (1978, Chapter 12).
74. Rosenblum (1978a, especially Chapters 4 and 5).
75. On industrial patronage, see Berry (1970). On artists working in the community, see Braden (1978) and Mennell (1976).
76. Minihan (1977). See Pearson (1980) for a history of state intervention in the visual arts in Britain.
77. On government patronage in the United States, see Useem (1976) and DiMaggio and Useem (1978b).
78. Pearson (1979) discusses some of the ways in which the concept of 'accountability' operates in public patronage of the arts.
79. See Brighton (1974 and 1977) for some suggestions about how selection is determined at the Royal Academy and the Tate Gallery. Regional Arts Associations, and the Arts Council itself, have sponsored various political theatre groups, albeit in a very limited way, and with occasional, well-publicised, withdrawals of grant aid (for example, the withdrawal of support by the North West Arts Association for North West Spanner for a period recently). The Gulbenkian Foundation has also funded numerous radical enterprises.
80. Sutherland (1976).
81. White and White (1965). See also Boime (1979), for a discussion of the role of entrepreneurs in the arts in France in the nineteenth century.
82. Martorella (1977).
83. See Note 65 (above).
84. Peterson and Berger (1975).
85. See Blaug (1976) for articles concerning a number of related issues. See also Williams (1977c) on economic aspects of the press.
86. Garnham (1977 and 1979a). (See also p. 30 above.)
87. Besides Garnham's articles, see also Golding and Murdock (1979) and Murdock and Golding (1974).
88. Garnham (1977, p. 353, and 1979a, p. 144). See also Mattelart (1979).

Chapter 3: Art as Ideology

1. Eagleton (1976a and 1976b), Hadjinicolaou (1978a), Berger (1972), Williams (1977a), Dyer *et al.* (1973). See also Barrett *et al.* (1979).
2. Clark (1974), Hadjinicolaou (1978a, pp. 17–8), Eagleton (1978b, and 1976a, Chapter 1).
3. Williams (1977a, Part I, Chapter 3), Hadjinicolaou (1978a, Chapters 2–4).
4. Although it is not possible to give any comprehensive survey of these debates here, some useful references are Sumner (1979), Larrain (1979), Adlam *et al.* (1977), Williams (1977a, Part I, Chapter 4, and 1977b), Plamenatz (1971) and Mepham (1974). For a history of the concept, see Lichtheim (1964). For a discussion of the problems of ideology and 'truth' in literature, see Hawthorn (1977).
5. Williams (1977a, p. 4).
6. Hunt (1976).
7. Sumner (1979, p. 5).

8. This epistemological question, needless to say, is vitally important for some purposes. It has seemed to me to be outside the scope of this discussion to enter the science-versus-ideology debate, or to ponder on the vexed question of how any group (proletariat, free-floating intelligentsia, or any other) may transcend ideology, or, as some would put it, how one particular ideology may be 'true'. Solutions to this problem range from denying it *as* a problem for sociology (Bottomore 1956, for example), to redefining epistemology *as* a sociological question (Elias 1971, Mannheim 1960). In the area of the study of literature it also arises; see, for example, Hawthorn's argument against Eagleton, that *some* literature is more 'true' than other (Hawthorn 1977). See also Widdowson *et al.* (1979), on the comparative literary value of two texts. The problem of ideology and science is discussed in Larrain (1979, Chapter 6).
9. Marx and Engels (1970, p. 47).
10. Williams (1977a, p. 66). Sumner talks about 'spontaneous' and 'philosophical' consciousness (1979, p. 16).
11. See Mepham (1974), regarding phenomenal forms and real relations, and the way in which capitalist society 'appears' to people, obscuring the real social relations. However, I agree with Sumner (1979, p. 13) that this process of inversion is not the *central* feature of ideology in general.
12. For the analysis of political power in Britain, see Bloomfield (1977), Hunt (1977), Hibbin (1978), Littlejohn (1978), Parkin (1974).
13. The work of Antonio Gramsci has been of enormous importance for Marxist analysis, in indicating the mechanisms by which the ideology of a particular group maintains its dominance (Gramsci 1971).
14. Marx and Engels (1970, p. 64). See Corrigan *et al.* (1978).
15. See Williams (1977c). Also Garnham (1979a).
16. 'Ideology' here, and throughout, includes all forms of thought – philosophy, religion, science, as well as the narrower concept of political and moral ideas.
17 Marx and Engels (1976, pp. 41–2).
18. Parkin (1972, Chapter 3). See also Hall and Jefferson (1976) for case studies in the 'negotiation' of ideology, and the general introduction on 'subcultures, cultures and class'. See also Corrigan and Sayer (1978, pp. 198–9).
19. Williams (1973, and 1977a, Part II, Chapter 8).
20. Williams (1978). See p. 124 below. For the use of these categories in the study of youth culture, see Hall and Jefferson (1976).
21. 'The sociology of knowledge is one of the youngest branches of sociology; as theory it seeks to analyse the relationship between knowledge and existence; as historical-sociological research it seeks to trace the forms which this relationship has taken in the intellectual development of mankind' (Mannheim 1960, p. 237).
22. Mannheim (1952).
23. Hebdige (1979), Willis (1977 and 1978), Corrigan (1979), Hall and Jefferson (1976).
24. This is argued in the introductory essay in Hall and Jefferson (1976).
25. On the subculture of girls, see McRobbie and Garber (1976).
26. Williams (1977a, p. 69); also Williams (1977b).

27. Marx and Engels (1976, p. 41).
28. See, for example, Williams (1973) and Hall (1977).
29. It is interesting to compare the kind of approach considered here with quite different sociological theories about the relationship of culture, society and economy. See, for example, Gouldner (1976) and Bell (1976).
30. Eagleton's model (1976a) specifies these distinct levels.
31. Berger (1972, pp. 106–8). Hadjinicolaou notes that 'today art history is one of the last outposts of reactionary thought', resisting the recognition of the ideological character of art (Hadjinicolaou, 1978a, p. 4).
32. Although reproduction of paintings is not possible in this book, I have not wanted to allow this to restrict my examples to literary ones. Where I refer to paintings or photographs, I usually cite a text where they are reproduced, or describe those features of the works relevant to my discussion of them.
33. Berger (1972, pp. 36–64). A good deal of feminist analysis has been inspired by this study, although often critically. See Cowie (1977) and Pollock (1977). See also Goffman (1979).
34. Another example is Clark's study of Courbet (Clark 1973), which discloses, largely in the analysis of one central painting in Courbet's career (*The Burial at Ornans*), a particular ideological position which the painter had reached at that stage in his political development. The study is unorthodox not simply in incorporating political and sociological categories into art history, but in reading out of a painting which is ostensibly about a rural theme, a hidden account of the small-town bourgeoisie (ibid., pp. 114–5, et *passim*).
35. See Laurenson (1978), Barker *et al.* (1977 and 1978), Eagleton (1975a), Hill (1979). A group of people working at Portsmouth Polytechnic (John Oakley, Roger Bromley and others), and also at Thames Polytechnic (involved in the journal *Literature & History*) have contributed some important studies to this body of work. (See issues of *Literature & History*, and Barker *et al.* (1977 and 1978).)
36. Lovell (1978).
37. 'Ascendancy' is an odd word to use for a class in decline, however.
38. See, for example, Routh and Wolff (1977), Swingewood (1972), Burns and Burns (1973), Arvon (1973), Laing (1978), Eagleton (1976a and 1976b), Bennett (1979), Macherey (1978a), Jameson (1971 and 1972), Fokkema and Kunne-Ibsch (1977). For some debates on theoretical issues, revived from the 1930s in some cases, see Bloch *et al.* (1977).
39. For example, Eagleton (1970, 1975a and 1978c), Goldmann (1964), Lukács (1965), Williams (1974 and 1978).
40. He died in 1970. See Williams (1971).
41. See Lukács (1963, 1970 and 1971). For the relationship between the two, see Swingewood (1972, pp. 63–77).
42. Goldmann (1964).
43. See Lichtheim (1970), and also Arvon (1973, pp. 92–9). Lukács himself discusses these constraints, in a new Preface he wrote in 1967 to *History and Class Consciousness* (Lukács 1971).
44. Goldmann (1975).
45. Eagleton (1975b), Laing (1978, pp. 87–8).
46. Goldmann (1964, p. 17, and 1969, p. 103).

47. Goldmann (1964, p. 16, and 1969, pp. 101–2).
48. See Wollheim (1970), for some comments on the mediation of social determinants of art through particular consciousnesses.
49. Some of these problems are (i) the question of how 'great literature' is defined, except in a circular way by relating it to 'coherent groups'; (ii) the question of social groups which are *not* classes, but which appear to give rise to meanings expressed in literature; (iii) the notion of 'homologies' of structures, on which Goldmann depends, but which begs a number of questions. See Wolff (1975a, Chapter 5). See Routh (1977) for a sympathetic appraisal of Goldmann's work, which nevertheless recognises many of its limitations.
50. George Lichtheim does not agree, when he refers to the 'sociological clap-trap of the sort later made familiar by Lukács' pupil Lucien Goldmann' (Lichtheim 1970, p. 97).
51. Williams (1978).
52. Early work in Marxist analysis and in non-Marxist sociology was often reflectionist. See Swingewood (1972). Also Eagleton (1976b, pp. 48–54), and Williams (1977a, Part II, Chapter 4).
53. See Adorno (1977) on the need for mediation 'through the total social process'.
54. See Williams (1977a, pp. 35–42), Eagleton (1976a and 1976b), and work published in *Screen*, *m/f* and *Working Papers in Cultural Studies*.
55. For example Kristeva on Bakhtin (Kristeva 1972), Williams on Volosinov (Williams 1977a, Part I, Chapter 2). See also Bennett (1979), Selden (1977), Bann and Bowlt (1973) and Mitchell (1974).
56. Eagleton makes a similar distinction between the 'material and ideological conditions of a work's production' (Eagleton 1977, p. 100). See also his discussion of 'literary mode of production' and 'aesthetic ideology' in *Criticism and ideology* (1976a). Wallach and Duncan (1978) discuss the conditions of consumption of works of art (see Chapter 5 below).
57. Cf. Clark's reference to 'conditions of artistic production' in this sense (Clark 1973, p. 11).
58. E.g. Eagleton (1978a, p. 107). See also Mitchell (1974).
59. See Benjamin's essay of this title (Benjamin 1973b), and Eagleton's chapter of the same title (in Eagleton 1976b).
60. See also Eagleton (1976b, p. 61).
61. For example, see Garnham (1978).
62. One difference is that in the case of Marxist aesthetics, the emphasis on 'the author as producer' is part of an analysis of the revolutionary potential of art. This will be discussed in the next chapter. See Mitchell (1974, and introduction to Benjamin 1973a), Eagleton (1976b), Benjamin (1973b), Enzensberger (1976).
63. Eagleton (1976a, Chapter 2, particularly pp. 48, 49–53, 54–8). See also Bennett (1979, p. 151).
64. Williams (1977a, p. 169). See also Adlam *et al.* (1977, p. 12 and 23); this essay talks of 'the materiality of ideology and its material effectivity', but it is important to realise that these are two quite different matters. (See Eagleton 1978a on this.) Other discussions of the 'materiality' of ideology

can be found in Coward and Ellis (1977), Mercer and Nawrat (1977, p. 59), Chambers (1974, p. 60) and Mercer (1978).

65. Williams (1977a, Part III, Chapter 5).
66. See Rosalind Coward's critique of the work of the Centre for Contemporary Cultural Studies (Coward 1977).
67. Henriques and Sinha (1977, p. 95), in a discussion of Volosinov. See also Bennett (1979, pp. 75–82).
68. 'Codes, like ideas, do not drop from the skies, they arise within the material practices of production' (Chambers 1974, p. 61). See also Heath *et al.* (1971) and Kristeva (1973).
69. The 'idealist' nature of much of this semiotic discussion of the 'materiality of signifiers' has been pointed out by a number of critics. See Eagleton (1978a, p. 22), who talks of the danger of '*de*materializing' the referent, Sumner (1979, pp. 143–4), McDonnell and Robins (1978), Hawthorn (1979), Hall (1978). Garnham (1979a) makes the point that even 'material' is often confused with 'economic'. An analysis which *does* deal with the material determinants of culture is not necessarily thereby an *historical* materialist one; Marxism proposes the primacy of the economic, not just of the material.
70. Eagleton calls them 'ideological conditions' (1977, p. 100), and 'aesthetic ideology' (1976a, p. 60), but I think it could be misleading to talk about ideology, even in this explicitly limited sense.
71. Hadjinicolaou (1978a, Chapter 14, pp. 163–77).
72. Macherey (1978a, particularly Chapter 19, p. 128). Also Macherey (1978b, and 1977b, pp. 52–3). See Eagleton (1976b, pp. 34–5, and 1976a, p. 89).
73. Macherey (1978a, p. 120).
74. See Bennett (1979), for an excellent introduction to both Russian Formalism and Marxist aesthetics, as well as their relationship to one another.
75. See Burgin (1976a); Kristeva (1972). For the influence of Formalism on other approaches, see Mitchell (1974). In some cases, the text is granted a radically new degree of autonomy and determining power, apparently escaping both social structure and author. (See Chapter 6.)
76. For accounts of the Formalist method, and information on work produced in the 1920s, see Bennett (1979), Bann and Bowlt (1973), Erlich (1955), Medvedev/Bakhtin (1978).
77. The metaphoric notion of 'level' is not very satisfactory. It has unfortunate connotations of hierarchy, and also of total independence and separateness.
78. Caute (1974b).
79. Berger (1978, p. 703). This, however, becomes confused with an argument about 'creativity', conceived as somehow going beyond the present and the possible. There are two separate points, which Berger elides: whether art history can give an account of individual painters; and whether it can give an account of the essentially 'creative' aspect of '*great*' painting. See also Kettle (1976) for another defence of the subject/author.
80. Goldmann (1969, pp. 32–3, and 1964, p. 12).
81. Goldmann (1967a).
82. Goldmann (1964, pp. 17–18).
83. Sartre (1971–2, 1952 and 1947).
84. See Sartre (1963, p. 56). See p. 20 above.

85. See Swingewood (1975) for a criticism of this work. But his critique is weakened by the fact that he starts from *authorial* practice as a key moment, and proceeds to devote the rest of his book to the quite different question of the *fictional* practice of heroes *in* books. That is, he switches from a critique of sociology of literature, to a critique of literature itself.
86. See Anderson (1976) for a general review and critique of neo-Marxism, including also members of the Frankfurt School.

Chapter 4: Aesthetic Autonomy and Cultural Politics

1. I have not taken account, in the last chapter, of the view that art has a special relation to ideology, and is not simply an aspect of ideology in general. Althusser argues that art is, in a sense, distanced from ideology, and hence in a position to comment on it (Althusser 1971b). In a totally different way, both Lukács and certain members of the Frankfurt School have also granted a peculiar epistemological status to art. (Lukács 1971, pp. 137–40, Marcuse 1972b and 1978, Adorno 1974.) I have chosen to ignore this argument because (i) I find rather dubious the idea that art has some sort of (usually unclear) privileged epistemological status, granting superior access to 'reality'; (ii) not all theories of ideology share this view, and I am more concerned to discuss the theory in general; (iii) in any case, the category of 'ideology', like that of 'superstructure', is very broad, and it has been argued that it is often important to distinguish between its various components. (See Corrigan and Sayer, 1978.) While not wanting to present it as a uniform and undifferentiated entity, it seemed to me to be legitimate, for the purposes of this book, to talk about ideology in general.
2. One of the earliest was undertaken by Max Weber (1958). See also Adorno (1973 and 1976), Shepherd *et al.* (1977), Small (1977), Frith (1978), Silbermann (1963).
3. It has been argued by Peter Fuller that abstraction has a very specific ideological role to play in the twentieth century (Fuller 1978/9 and 1979). Berger (1960) also discusses a variety of modern painters from this point of view, although usually the ideological is contained in forms which can be read as figurative, not abstract.
4. Elias (1971, p. 367). Birchall (n.d., p. 126) quotes Lukács on 'uneven development'. See also Arvon (1973, pp. 30–3).
5. See Katz and Wedell (1978), on broadcasting in the Third World. Also Mattelart (1979), Garnham (1979a), Tunstall (1977), the last two on how the United States practises 'cultural imperialism' also on the *developed* world.
6. The passage is in the *Grundrisse* (Marx 1973, pp. 110–11). Attempts to resolve the paradox include: Lifshitz (1973, pp. 108–11), Arvon (1973, pp. 7–9), Fischer (1963, pp. 11–13), Laing (1978, pp. 9–12), Eagleton (1976b, pp. 10–13). See also Easthope (1977). Jauss argues that Marxists have to live with this 'idealist embarrassment' (Jauss 1975).
7. For the record, I think that (iii) is the best of these solutions. But their resolution depends on a discussion of art's 'transcendent' value.
8. Borges illustrates how the modern reader reads an identical passage quite differently from a sixteenth-century reader, because of the historical

accumulation of new connotations (Borges 1970). See Bauman (1978, pp. 226–30).

9. In general, it would be expected that any revival of interest in an archaic or abandoned genre or style would be motivated by certain contemporary interests in society. The present renewal of enthusiasm for Victorian academic painting is a good example of this.

10. Their resolution would involve different approaches in each case, ranging from recommending empirical-historical investigation to discussing theories of aesthetic value, which this book necessarily avoids.

11. Sartre (1950), Engels (1976), Lenin (1967b), Mao (1971), Trotsky (1960), Brecht (1965 and 1974).

12. See Fitzpatrick (1970), Brewster (1976), Arvon (1973, Chapter 6), Laing (1978, Chapter 2).

13. For example, the famous Brecht-Lukács debate. (See Lunn 1974, and Arvon 1973, Chapter 7; also Brecht 1974.) For the debate between Adorno and Benjamin, see Adorno (1977), and Benjamin's reply (in Bloch *et al.*, 1977). For Adorno's criticism of Sartre and Brecht, see Adorno (1974).

14. For example: Marcuse (1969), L. Baxandall (1972), Craig (1975), Ehrmann (1967), Bloch *et al.* (1977), Gardner (1979), Egbert (1970), Rühle (1969).

15. David Craig gives, as an example of this, the case of Upton Sinclair's novel, *The Jungle*, which 'raised an outcry about the Chicago meat-packing industry and helped bring about some purefood legislation in the United States' (Craig 1975, p. 22).

16. In the west, such censorship is not usually directly political, as it is, for example, in South Africa and Eastern Europe, but is more concerned with 'moral' issues.

17. Exceptions to this are the work of Macherey, which tries to show how the possibility for artistic intervention lies in the *nature* of literature (Macherey 1978a); and Eagleton's *Marxism and Literary Criticism* (1976b), which also links the two topics more than most writers, although the four chapters on the whole fall neatly into two sections (literature and history, form and content: writer and commitment, author as producer).

18. The sociology of science has amply demonstrated that the development of science is not a 'neutral' affair, propelled by the logic of its own internal process of discovery, but that it is closely related to the needs, values and social and political organisation of society. (See Kuhn, 1962, Barnes, 1977, Lakatos and Musgrave, 1970.) It is, however, a more controversial matter to call science 'ideological' in the sense in which I have *not* been using the term – namely, to mean that it is false or 'untrue'.

19. See Sayer (1979), Corrigan and Sayer (1978), and Corrigan *et al.* (1978, Chapter 1).

20. See Seccombe (1974), Benston (1969), Gardiner (1975), Molyneux (1979). There is also a school of thought which argues that domestic labour constitutes an entirely separate 'mode of production'; as this is explicitly anti-Marxist, it does not contribute to this particular debate. (See Delphy 1977, and, for a critique, Barrett and McIntosh 1979 and Molyneux 1979.)

21. See Beechey (1979), Gardiner (1977), and essays in Kuhn and Wolpe (1978).

22. For an analysis of this, see Cooper *et al.* (1976), Mitchell (1975), Poster (1978, Chapter 4).
23. Johnston (1979).
24. Williams (1973, and 1977a Part II, Chapter 1).
25. Williams (1973, p. 4, and 1977a, p. 85).
26. Williams (1973, p. 7).
27. Ibid., p. 4.
28. Ibid., p. 7.
29. Ibid., p. 8. In his book (1977a), he abandons altogether the idea of the possible usefulness of the concept of 'totality', which does not merit a chapter in his series of basic concepts in cultural theory.
30. See Gramsci (1971) and Hall *et al.* (1977).
31. Williams (1973, p. 7).
32. See Althusser (1969b, pp. 111–28). Goldmann also uses the term (Goldmann 1969, p. 92).
33. Quoted by Althusser (1969b, p. 112).
34. Ibid., p. 111.
35. This criticism is made by Hirst (1977).
36. Althusser (1971d, p. 130).
37. See Hall (1977), on Marx (p. 50) and Althusser (p. 69). Also, see Althusser (1969a, Glossary p. 254), for the concept of a 'structure-in-dominance'.
38. McLennan *et al.* (1977, p. 80), Althusser (1969a, p. 254).
39. Althusser (1971d).
40. Ibid., pp. 136–7.
41. I have not discussed the distinction between *ideology* and *science*, for example; or the concepts of 'overdetermination' and 'structure-in-dominance'. It may be that this extremely selective discussion of Althusser's essays takes too much out of context, however.
42. Hall (1977, p. 69).
43. Hirst (1977, p. 130).
44. I have never been able to see why Hirst moves from the argument that there is no necessary correspondence between economic class and political forces (ibid., p. 130) to the phrase 'necessary non-correspondence'. The latter, more categorically, actually states that there could not possibly (logically?) be any correspondence; the former merely argues that there is no actual reason why there *should* be.
45. Corrigan *et al.* (1978, Chapter 1). Hall also argues that only concrete studies legitimate a base-superstructure model, and suggests that we gain more by looking at Marx's own historical studies than by concentrating on the theoretical statements, like *The German Ideology* (Hall 1977, p. 54).
46. Eagleton (1976a).
47. *Wedge*, the 'revolutionary magazine of cultural practice and theory', has criticised academicism and theoreticism in cultural analysis and argued for a cultural politics, based, nevertheless, on analysis. See *Wedge* 1, Editorial, and Imrie (1977, pp. 43–6). Also, see Stanley Mitchell's letter, asking for the development of cultural politics and not just cultural theory (Mitchell 1976). See also Gardner (1979, p. 13).
48. See Note 13, above. See also Engels (1976) and Benjamin (1973c).

49. See Note 12, above.
50. See also Gardner (1979).
51. Steiner (1969, p. 283).
52. See Lenin (1967b). Dave Laing disagrees with Steiner's implied view that Lenin exempted literature from this requirement (Laing 1978, pp. 23–4).
53. Steiner (1969, p. 271), Arvon (1973, pp. 36–7).
54. It is often argued that the sterility of much Soviet writing is a result of Zhdanov's insistence on this version of 'socialist realism'. See Arvon (1973, Chapter 6), Brewster (1976, p. 9), and Swingewood (1975, Chapter 4), who dates this process much earlier.
55. Marcuse disagrees with Benjamin, and argues that 'the unity of tendency and quality is antagonistic' (Marcuse 1978, p. 53).
56. For this reason, it has often seemed to me that Brecht and Lukács were not really arguing about the same thing, in the famous debate. See Lunn (1974). For the same reason, it is probably unfair to criticise Lukács and Goldmann for elitism, since for their purposes (that is, *not* the radicalisation of readers), it did not really matter who the audiences were for the novels and plays they chose to examine.
57. Actually, he includes Brecht in the category of 'orthodox Marxism', because Brecht incorporated politics directly into literary form. However, he considers Brecht one of the few 'valid and creative' writers in this tradition (Steiner 1969, p. 275).
58. Adorno (1967b), Marcuse (1968), Brecht (1965 and 1974).
59. Frankfurt Institute for Social Research (1973, pp. 111–12).
60. Marcuse (1968).
61. However, later on he saw this as somewhat over-optimistic (Marcuse 1972a). His last work on culture simply asserts that art, by its very nature, has the power to challenge reality, but he does not examine the conditions appropriate for the use of this questionable potential. In general, his work seems to me to progress steadily in the direction of idealism (Marcuse 1978).
62. I hope it is apparent that their *differences*, in most other respects, are enormous. These are made quite clear in most commentaries on the Frankfurt School and on the neo-Marxist approach to culture.
63. See Mitchell (1974) for Brecht's debt to the Formalist concept of 'making-strange' and the device of alienating audiences in this way.
64. Benjamin (1973c, p. 22).
65. See Rosenberg (1970) for a discussion of the institutionalising of innovation in art. As Jameson says: 'An aesthetic of novelty today – already enthroned as the dominant critical and formal ideology – must seek desperately to renew itself by ever more rapid rotations of its own axis' (in Bloch *et al.*, 1977, p. 211).
66. Adorno (1967b, p. 166).
67. See Caute (1974c).
68. See MacCabe (1974 and 1976), and the special issue of *Screen* on 'Brecht and a revolutionary cinema' (*Screen* 15, 2, 1974). See also Gidal (1979), Heath (1979), and F. Thompson (1979).
69. For example, see the interview with Laura Mulvey about her films, and particularly *Riddles of the Sphinx* (Mulvey 1978).

70. Brecht (1974).
71. Though even here, there are such constraints. (See Anon. 1977 and 1978.)
72. Griffiths (1976). However, some of his plays have made use of more modernist techniques too. (See Wolff *et al.*, 1977.)
73. Griffiths (1976). See also Wolff (1978) and Holderness (1977). It is worth pointing out that in this context 'naturalism' and 'realism' are used interchangeably. In the work of Lukács and others they are contrasted, naturalism being that uncritical, photographic and superficial depiction of reality which does not expose the real structures of society. (See Lukács 1970, and Berger 1969, pp. 50–63, for an account of this distinction.)
74. My own view is that art (plays, novels, films) can only articulate and consolidate and formulate ideas which are already held, or latent, but that it cannot, at *any* cultural or social level, change people's minds. See Pollock (1979) on the importance of location and context for conveying radical (in this case, feminist) ideas, too.
75. Claire Johnston likewise makes this point in her essay, where she emphasises the economic and institutional aspects of contemporary film-making in Britain, as well as the ideological issues involved in modes of representation.
76. Benjamin's work on the author as 'producer' is usually cited as the greatest advance in a materialist aesthetics, for he discusses the possibility of cultural practice precisely in relation to the revolutionising of cultural techniques, or the using of those new techniques with revolutionary potential (Benjamin 1973b and 1973d). However, as Rob Burns has pointed out, in a critical but generally sympathetic assessment of Benjamin's work, his analysis of technology is rather unmaterialist (Burns 1978, p. 29), and he fails to analyse the position *of* the artist, who is assumed to be in the privileged position of critic of capitalism (ibid., pp. 27–8).

Chapter 5: Interpretation as Re-creation

1. See Burns and Burns (1973, p. 399), Watt (1972), Leavis (1979), Webb (1955), Altick (1957), Schücking (1944), Escarpit (1958, 4e partie).
2. See, for example, Albrecht *et al.* (1970, Part IV: 'Tastemakers and publics'), and Burns and Burns (1973, Part V: 'Readers and audiences').
3. Bourdieu and Darbel (1969), Bourdieu (1973). See the journal *Actes de la Recherche en Sciences Sociales*, edited by Bourdieu. See also DiMaggio and Useem (1978c), which is influenced by Bourdieu's ideas.
4. Adorno criticises Silbermann's overemphasis on audience response in these terms. (See Hohendahl 1977, p. 31.)
5. This applies to most of the authors discussed so far, with the exceptions of Macherey and Brecht. Though Eagleton follows Macherey in many respects, his 'model' of the science of the text does not include reader's biography or reader's ideology. See also Tolson (1973) on the question of reading.
6. Tudor (1974 pp. 29–37)
7. See, for example, Hartmann (1979); also Parkin (1972, Chapter 3) for the view that meanings may be 'negotiated'.

8. Steiner is mainly concerned with problems of inter-linguistic translation in this book, but he recognises the universality of 'understanding as translation', including *within* a language (Steiner 1975, p. 29).

9. See Bauman (1978) for some of the most important variants. For a history of hermeneutics, see Palmer (1969) and Outhwaite (1975). Also Wolff (1975a, Chapter 7). One important division within hermeneutics is between those who see understanding as a given ontological condition of existence, and hence neither a method nor a removable constraint (Heidegger, Gadamer, Palmer, Ricoeur), and those who conceive of it as a method which one can, or must, choose to adopt for the social and cultural sciences (Weber, Parsons, Habermas, Hirsch). I shall not, however, take up this question, except indirectly. (See Gadamer 1976, p. 26.)

10. Gadamer (1975, First Part), Skinner (1969 and 1975), Ricoeur (1971).

11. Hirsch (1967 and 1976).

12. Hirsch (1967, p. 219, and 1976, p. 8).

13. Hirsch (1976, Chapters 1 and 5).

14. These consist mainly in narrowing down the class of possible references for problematic words, phrases or allusions, using both 'internal' (literary) and 'external' (extra-literary) evidence (Hirsch 1967, pp. 180–98).

15. Gadamer (1975 and 1976). The more radical version of Roland Barthes will be discussed in the following chapter.

16. Gadamer (1975, pp. 238ff).

17. See Chapter 4, Note 18.

18. Gadamer (1975, p. 240).

19. The *possibility* of any understanding resides, for Gadamer, in our common existence in a tradition which binds us to the past (1975, pp. 251 and 258), and also in the essentially *linguistic* nature of experience and interpretation (1976, p. 13, and 1975, pp. 351ff).

20. Hirsch is also talking about literary criticism as a discipline, and not just the ordinary reading of texts, whereas Gadamer is concerned more generally with the nature of reading (*including* by literary critics), and of historical understanding.

21. Hirsch distinguishes between 'meaning' and 'significance', and in his later book of essays suggests that the disagreement between himself and his opponents may rest on a confusion of the two. (Hirsch 1976, Chapters 1 and 5.) Meaning does not change, and remains equated with original (author's) meaning; significance is 'meaning-as-related-to-something-else' (ibid., p. 80), which can change with context and is a function of what the reader *takes* as relevant in the text. ('Significant' here is more or less equivalent to 'meaning*ful*'.) However, although it is an important distinction to make, it is not the one on which his disagreement with Gadamer rests. Gadamer does *not*, as Hirsch says he does, equate the two; and he *does* deny any final 'validity' to what Hirsch calls 'meaning'.

22. Thus, Jauss says: 'The appreciation of the first reader will be continued and enriched through further "receptions" from generation to generation; in this way, the historical significance of a work will be determined and its aesthetic value revealed' (Jauss 1970b, pp. 8–9).

Hadjinicolaou examines the critics' responses to Delacroix's *Liberty Guiding the People* in 1831 (Hadjinicolaou 1979), and argues that a work is never

made for eternity or for future publics, but *starts* from its contemporary public, which assigns 'meanings' to it (ibid., p. 3). However, he also shows how those contemporary meanings no longer coincide with our usual interpretation of that painting. The article goes on to examine the vicissitudes in its history.

23. See Habermas (1966, 1970a, 1970b and 1974), Apel (1971 and 1972–3), Apel *et al.* (1971). For Gadamer's reply to his critics, see Gadamer (1974–5, and 1976, Chapter 2). See also Wolff (1975b).
24. Goldmann (1967b).
25. Ibid.
26. Ricoeur also argues that the theory of the text must be a dialectic of explanation and understanding, each completing and requiring the other (Ricoeur 1978c, pp. 153–5). However, he means something rather different by 'explanation', referring to a *structural* analysis of texts themselves and not a sociological analysis. In other words, explanation still need not go beyond textual elements, although it does go beyond subjective or conscious meanings (of reader or author). He himself admits that structuralism (which is his explanatory method) 'does not transgress the rule of immanence' and that 'remaining within the confines of the story, (it) will not look elsewhere than in the signs of narration' (ibid., p. 154). For an entirely different objectivist hermeneutics, see Betti (1962).
27. Their concern is sociology in general, and not specifically the sociology of art or culture. The critique of ideology covers all ideological practices and products however, and Gadamer makes it clear that what can be said about interpretation in general applies equally to the interpretation of works of art (Gadamer 1975, First Part).
28. Apel (1972–3, pp. 19 and 21), Apel (1971, pp. 10, 27, 32), Habermas (1970a, pp. 251–85).
29. Apel also makes the distinction between explanation and understanding (Apel 1972–3, p. 26).
30. Apel (1971, p. 39).
31. Apel (1971, p. 39).
32. Apel (1971, p. 39) and Habermas (1970b) compare this to the psycho-analytic task of discovering the subconscious causes for certain neurotic symptoms.
33. See also Radnitzky (1973, p. xxxvi).
34. Habermas (1970b).
35. See the earlier exposition of this position, in the work of members of the original Frankfurt School (Frankfurt Institute for Social Research 1973, pp. 7–11).
36. Gadamer (1974–5, p. 315). See also Gadamer (1976, pp. 26–38, particularly p. 35), and Gadamer's essays in Apel *et al.* (1971).
37. Theories of language concur with Gadamer on this point. See Jameson (1972).
38. See, for example, Therborn (1971).
39. Gadamer (1975, p. 305).
40. For example, see Cohen (1974), and various issues of *New Literary History* (from which this collection was composed).
41. Hawthorn (1973, p. 177).

42. Ibid., p. 136.
43. Weimann (1977, Introduction p. 1 and Chapter I). See also Weimann's article in Cohen (1974).
44. Hawthorn (1973, Chapter 8; also pp. 24, 36, 112). Weimann (1977, p. 5).
45. Ricoeur (1978b, p. 92) argues that even language is polysemic. See also Hall (1974, p. 9).
46. Iser (1974, p. 136).
47. See Barthes (1967a, 1967b, 1971, 1972 and 1974), Wollen (1970). More generally, on semiotics, see Eco (1977), Culler (1975), Ehrmann (1970), Macksey and Donato (1972), Tolson (1973).
48. Hall (1974), Eco (1972).
49. Hall (1974, p. 9).
50. Eco (1972).
51. Ibid., p. 110.
52. Ibid., p. 115.
53. Hall (1974).
54. Ibid., p. 9.
55. Ibid., p. 14.
56. Ibid., p. 14.
57. This need not lead to wider scope for numerous readings, since the various codes and sub-codes may overlay and reinforce one another, making _non_-preferred readings _more_ difficult.
58. Iser (1974 and 1978). See Fokkema and Kunne-Ibsch (1977, pp. 145–6). Iser follows and develops the ideas of Roman Ingarden, a better-known phenomenologist of aesthetics. (Ingarden 1931 and 1972.)
59. Iser (1974, p. 136).
60. Ibid., p. 131.
61. Ibid., p. 129.
62. Iser (1978, p. 10).
63. Quoted by Fokkema and Kunne-Ibsch (1977, pp. 145–6).
64. Iser (1978, p. 24).
65. Iser (1974, p. 133).
66. Iser (1978, p. 130).
67. Ibid., Part III. See also Iser (1974).
68. Iser (1974, p. 129).
69. Iser (1978, p. x).
70. See Hohendahl (1977), Fokkema and Kunne-Ibsch (1977, Chapter 5), Jauss (1970a, 1970b and 1975).
71. Fokkema and Kunne-Ibsch (1977, pp. 146–7).
72. Jauss (1975, p. 205). Hohendahl argues that Jauss himself has an 'idealistic construct of the typical reader' (Hohendahl 1977, p. 45).
73. Jauss (1970b, pp. 23 and 31).
74. Ibid., p. 31.
75. Hohendahl (1977, p. 45). Fokkema and Kunne-Ibsch point out that in his later work he recognises this weakness, and that reception theory must be related to a sociology of knowledge (Fokkema and Kunne-Ibsch 1977, pp. 176 and 177).
76. See Hohendahl (1977, pp. 47–56), and Jauss (1975, pp. 200–7).

77. Hohendahl (1977, p. 53), Fokkema and Kunne-Ibsch (1977, p. 155).
78. Jauss (1970b, p. 9).
79. Fokkema and Kunne-Ibsch maintain that reception aesthetics should also be combined with semiotics, in order to grasp the cultural codes (1977, Chapter 6, particularly p. 181).
80. Hawthorn (1973, p. 27).
81. Jauss (1970b, p. 8), Hadjinicolaou (1978b and 1979).
82. See Eagleton (1976a, Chapter 5), Hadjinicolaou (1978a, Chapter 15).

Chapter 6: The Death of the Author

1. See Chapter 2, p. 27, above.
2. Barthes (1977, p. 143).
3. Hadjinicolaou (1978a, Chapter 2).
4. Ibid., p. 40.
5. Eagleton (1976b, p. 69).
6. Mehlman (1977, p. 107).
7. Foucault (1979).
8. Ibid., p. 14.
9. See Griselda Pollock's article on Van Gogh and the construction of an 'artist' by the discourse of art history (Pollock 1980).
10. Hadjinicolaou (1978a, Chapters 13 and 14).
11. Macherey (1978b, p. 11, and 1978a, Chapters 14 and 15), Eagleton (1976b, pp. 34–6).
12. Williams (1978).
13. Ibid., p. 288.
14. Ibid., p. 284.
15. Ibid., p. 286.
16. Skinner (1975, pp. 218–19).
17. Barthes (1977, p. 145).
18. See, for example, MacCabe (1974 and 1976) for examples concerning film discourse.
19. See Bakhtin (1973). He denies that drama can be polyphonic (ibid., p. 28).
20. Bakhtin (1973, p. 4 and throughout).
21. See Kristeva (1972), MacCabe (1974 and 1976), Silverman (1978), Musselwhite (1977), G. Thompson (1979), Burniston and Weedon (1977).
22. Bennett (1979, pp. 75–92).
23. Bakhtin (1973, p. 229).
24. See the Introduction, by Grahame Lock, to Althusser (1976), for a comment on the confusion between humanism and humanitarianism among Althusser's critics (p. 1). Foucault has shown that the idea that subjects *are* such entities, and the very concept of 'man', only date from the eighteenth century (Foucault, 1970, Chapter 9).
25. Althusser (1971d, p. 162).
26. The analysis of subjects as constituted in ideology is *not* equivalent to the account offered by traditional theories of socialisation, for a number of reasons, not least that the latter also operate with a notion of a pure, human kernel, which internalises assorted beliefs and values.

27. Althusser (1976, p. 45).
28. For some of these criticisms see: McLennan *et al.* (1977), Adlam *et al.* (1977), Sumner (1979, Chapter 6), Coward and Ellis (1977, Chapter 5), Cutler *et al.* (1977, Vol. 1, Chapter 11), Hirst (1979, Chapter 3).
29. Coward and Ellis (1977, p. 71).
30. See, for example: Coward and Ellis (1977), Kristeva (1975), Adlam *et al.* (1977), McDonnell & Robins (1978) for a critical account of these developments, Jameson (1977a).
31. See Althusser (1971c).
32. Examples of such work in feminist studies can be found in Cooper *et al.* (1976), Kuhn and Wolpe (1978), and in issues of *m/f*. Examples of work in cultural studies include Eagleton (1978c), Mercer (1978), Burniston and Weedon (1977), and in issues of *Screen*.
33. For the exposition of Lacan's work, see: MacCabe (1975), Coward and Ellis (1977, Chapter 6), Kaplan (1976), Lemaire (1977), Thom (1976), Jameson (1972), Miel (1970) and Mehlman (1972). Work by Lacan available in translation includes: Lacan (1968, 1970, 1972, 1977 and 1979).
34. Coward and Ellis (1977, p. 111).
35. What is therefore *excluded* by language, or repressed, in the child's pre-linguistic experience, is of course taken to be extremely important for psychoanalysis – for example, as it emerges in dreams. It has also been given a centrality in Lacanian-semiotic theories of art and literature, which claim that the pre-Symbolic (or Imaginary, or, in Kristeva's term, the 'semiotic chora') speaks through the creative work, particularly in the modernist text. See Kristeva (1973), and also Metz (1975), Kaplan (1976) and Marxist-feminist literature collective (1978). It is thus also a basis of theories of radicalism, because the possibility of the overthrow of the dominant symbolic (and patriarchal) order is seen to lie in releasing the repressed in literature and art. Although this controversial matter is clearly of interest to the sociology of the arts, it is tangential to the present discussion. Its relevance to an earlier discussion (in Chapter 4) might be pursued.
36. Some of the references in Note 33, above, discuss some problems and weaknesses in Lacan's work.
37. For two fascinating attempts to apply this theory to the study of literature, see Eagleton (1978c) and Mercer (1978).
38. See Giddens (1979, pp. 2 and 49, and Chapter 1). However, he does not appear to think such a theory necessarily involves psychoanalytic categories.
39. See Hall (1978, pp. 119–20), McDonnell and Robins (1978), Garnham (1979b).
40. See, for example, Coward and Ellis (1977, pp. 32, 97, 122).
41. Following Saussure, 'signs' are usually taken to combine both signifier and signified (see, for example, Barthes 1967a, p. 42). However, as Barthes and others make clear, the 'signified' is itself a concept, and not a 'real' object, and hence I have thought it justified here to counterpose both 'sign' and 'signifier', equivalent in this sense, to the real, or material, world.
42. Jameson (1977a).
43. See Barrett (1980, Chapter 1).
44. Garnham (1979b, p. 123).

45. Of course, it could be argued that what I am therefore doing is hypostatising the real, whose construction in discourse has been proven by semiotics (Kristeva, as well as Derrida and Lacan), and also by philosophical hermeneutics (Heidegger, Gadamer). This is true; some of the arguments in support of this position are developed in Chapter 3. See also Barrett (1980, Chapter 1) and Keat and Urry (1975).
46. However, as I have already indicated (p. 107), for the ordinary *reader*, the author is unimportant. My arguments in this chapter have concerned the sociological analysis of literature in general (production and reception) and not just a sociology of reading.

Conclusion: Cultural Producer and Cultural Product

1. See Berger and Luckmann (1967), Giddens (1976), Layder (1979), Lukes (1977).
2. However, as I have already indicated, I would not go so far as to reduce all aesthetic judgement and value to social and political questions (see Introduction, Note 19). But this is a far more complicated issue than can be addressed here. (See below, pp. 142–3.)
3. I refer back to my statement that this is a generalisation based on historical evidence, and not an *a priori* pronouncement (p. 76).
4. See Garnham (1977, 1979a and 1979b). Also Murdock and Gotding (1974).
5. T. J. Clark, for example, begins from a single painting (Clark 1973 and 1977b). See also Barthes (1974), who starts from a short story and increasingly broadens out his analysis. Examples of an initial focus on an artist or author are: Hill (1979), Lovell (1978), Eagleton (1975a); for a more general account of a period, see White and White (1965) and Williams (1978).
6. For the first, see Hospers (1969), Osborne (1972) and Wollheim (1968). For the latter, see Ingarden (1931 and 1972), Dufrenne (1953) and Schutz (1951).
7. See Chapter 4, Note 1. See also Lifshitz (1973).
8. Kant (1952, p. 43).
9. For the problem of the apparently superior 'creativity' of some works, see Chapter 1 (p. 24).

Afterword to the Second Edition

1. I discuss some of these developments in the Introduction and final chapter of *Aesthetics and the Sociology of Art*, second edition (forthcoming).
2. See my article, 'The death of the artist? Biography and authenticity in art history' (Wolff, manuscript).
3. Garrard (1989).
4. See Goodwin (1988). On questions of copyright and ownership of the image in photography and film, see Gaines (1991).
5. See, for example, Pollock (1989) and Christie and Orton (1988).
6. See, for example, Kamerman and Martorella (1983) and Balfe and Wyszomirski (1985).

7. Diana Crane's impressive study of the New York art world is a case in point (Crane 1987). In her attempt to avoid any unscientific entanglement with values, she resorts to the more positivistic practice of adopting categories (in this case, the naming of art movements, and their membership) from existing art criticism. But in doing so she endorses the values of those who produce the categories, rather than undertaking the important task of looking at these critically.

8. See, for example, the special issue of *Sociological Theory* (vol. 9, no. 2, Fall 1991), devoted to rethinking sociology in the light of postmodernism. See also the debate in *Theory and Society* (vol. 21, no. 4, August 1992), on postmodern theory and the city.

9. An important and influential text which re-thought Marxism in terms of theories of representation was Gareth Stedman Jones's book, *Languages of Class* (1983), which redefines 'class' as a discursive construct, rather than a pre-linguistic, 'real' entity. The work of Laclau and Mouffe (1985) has also been crucial in this revision of Marxism.

10. I discuss this tendency in the final chapter of the new edition of *Aesthetics and the Sociology of Art* (forthcoming).

11. See, for example, John Tagg (1992), and the texts of the 'new historicists' (Veeser 1989).

12. Lynn Hunt, in her introduction to a book of essays on 'the new cultural history', says that this practice 'has to establish the objects of historical study as being like those of literature and art' (Hunt 1989: 17).

13. These arguments are developed by Cary Nelson (1991) and John Clarke (1991). See also Palmer (1990).

14. See my discussion of postmodernism and feminism in my essay, 'Postmodern theory and feminist art practice' (1990).

15. See, for example, Deepwell (1987) and Langer (1992).

16. On this, see John Roberts' criticism of a postmodern art practice whose claim to relinquish authorial control he shows to be disingenuous (Roberts 1987).

17. Janice Radway's *Reading the Romance* (1984) was an early example of this. The tendency to find radical counter-interpretations has been particularly evident in media studies. (See, for example, John Fiske, 1989.) In the visual arts, one can always look for potential alternative readings of the text (though ethnographic studies of actual viewers are rare); Griselda Pollock discusses the contradictory meanings of work by Mary Cassatt and Berthe Morisot, for example (Pollock 1988).

18. See Denise Riley (1988).

19. Appignanesi (1987); Rutherford (1990); and *October*, no. 61, Summer 1992, special issue on *The Identity in Question*.

Bibliography

Adlam, Diana *et al.* (1977), 'Psychology, ideology and the human subject', *Ideology and Consciousness*, 1.

Adler, Judith (1979), *Artists in offices: an Ethnography of an Academic Art Scene* (New Jersey: Transaction Books).

Adorno, Theodor W. (1967a), *Prisms* (London: Neville Spearman). (Original German edition 1955.)

Adorno, Theodor W. (1967b), 'Arnold Schoenberg, 1874–1951', in Adorno (1967a).

Adorno, Theodor W. (1967c), 'Perennial fashion – jazz', in Adorno (1967a).

Adorno, Theodor W. (1973), *Philosophy of Modern Music* (London: Sheed & Ward). (Original German edition 1948.)

Adorno, Theodor W. (1974), 'Commitment', *New Left Review*, 87/88. Also in Bloch *et al.* (1977). (Originally published in German 1965.)

Adorno, Theodor W. (1975), 'Culture industry reconsidered', *New German Critique*, 6.

Adorno, Theodor W. (1976), *Introduction to the Sociology of Music* (New York: Seabury Press). (Original German edition 1962.)

Adorno, Theodor W. (1977), 'Letters to Walter Benjamin', in Bloch *et al.* (1977). (Originally published in German 1970.)

Albrecht, Milton C. *et al.* (eds) (1970), *The Sociology of Art and Literature: a Reader* (London: Duckworth).

Althusser, Louis (1969a), *For Marx* (Harmondsworth: Penguin). (Original French edition 1966.)

Althusser, Louis (1969b), 'Contradiction and overdetermination', in Althusser (1969a). (First published in French 1962.)

Althusser, Louis (1969c), 'Marxism and humanism', in Althusser (1969a). (First published in French 1964.)

Althusser, Louis (1969d), '"On the young Marx"', in Althusser (1969a). (First published in French 1961.)

Althusser, Louis (1971a), *Lenin and Philosophy and Other Essays* (London: New Left Books).

Althusser, Louis (1971b), 'A letter on art in reply to André Daspre', in Althusser (1971a). (Originally published in French 1966.)

Althusser, Louis (1971c), 'Freud and Lacan', in Althusser (1971a). (Originally published in French 1964.)

Althusser, Louis (1971d), 'Ideology and ideological state apparatuses. (Notes towards an investigation)', in Althusser (1971a). (Originally published in French 1970.)

Althusser, Louis (1971e), 'Cremonini, painter of the abstract', in Althusser (1971a). (Originally published in French 1966.)

Althusser, Louis (1976), 'Reply to John Lewis', in *Essays in Self-criticism* (London: New Left Books). (Collection first published in translation.)

Altick, Richard D. (1957), *The English Common Reader: a Social History of the Mass Reading Public 1800–1900* (London: University of Chicago Press).

Anderson, Perry (1976), *Considerations on Western Marxism* (London: New Left Books).

Anon, (1977 and 1978), 'Grant aid and political theatre 1968–77', *Wedge* 1 and 2.

Antal, Frederick (1948), *Florentine Painting and its Social Background* (London: Routledge & Kegan Paul).

Apel, Karl-Otto (1971), 'Szientistik, Hermeneutik, Ideologiekritik. Entwurf einer Wissenschaftslehre in erkenntnissanthropologischer Sicht', in Apel *et al.* (1971).

Apel, Karl-Otto (1972–3), 'Communication and the foundation of the humanities', *Acta Sociologica*, 15/16.

Apel, Karl-Otto *et al.* (1971), *Hermeneutik und Ideologiekritik* (Frankfurt: Suhrkamp Verlag).

Appignanesi, Lisa (ed.) (1987), *Identity*, ICA Documents, 6 (London: ICA).

Arato, Andrew and Gebhardt, Eike (eds) (1978), *The Essential Frankfurt School Reader* (Oxford: Blackwell).

Arvon, Henri (1973), *Marxist Esthetics* (London: Cornell University Press). (Original French edition 1970.)

Bakhtin, Mikhail (1970), *Dostoevsky* (Paris: Seuil). (Original Russian edition 1929.) English edition Bakhtin (1973).

Bakhtin, Mikhail (1973), *Problems of Dostoevsky's Poetics* (U.S.A.: Ardis). (Original Russian edition 1929.)

Balfe, Judith H. and Wyszomirski, Margaret (eds) (1985), *Art, Ideology and Politics* (New York: Praeger).

Bann, Stephen and Bowlt, John E. (eds) (1973), *Russian Formalism* (Edinburgh: Scottish Academic Press). (Originally published as *20th Century Studies* 7/8, 1972.)

Baranik, Rudolf *et al.* (1977), *An Anti-catalog* (New York: Catalog Committee of Artists meeting for Cultural Change).

Barker, Diana Leonard and Allen, Sheila (eds) (1976a), *Dependence and Exploitation in Work and Marriage* (London: Longman).

Barker, Diana Leonard and Allen, Sheila (eds) (1976b), *Sexual Divisions and Society: Process and Change* (London: Tavistock).

Barker, Francis *et al.* (eds) (1977), *Literature, Society and the Sociology of Literature* (University of Essex).

Barker, Francis *et al.* (eds) (1978), *1848: the Sociology of Literature* (University of Essex).

Barnes, Barry (1977), *Interest and the Growth of Knowledge* (London: Routledge & Kegan Paul).

Barrett, Michèle (1980), *Women's Oppression Today* (London: New Left Books.)

Barrett, Michèle and McIntosh, Mary (1979), 'Christine Delphy: towards a materialist feminism?', *Feminist Review* 1.

Barrett, Michèle *et al.* (eds) (1979), *Ideology and Cultural Production* (London: Croom Helm).

Barthes, Roland (1967a), *Elements of Semiology* (London: Jonathan Cape). (Original French edition 1964.)

Barthes, Roland (1967b), *Système de la mode* (Paris: Seuil).

Barthes, Roland (1971), 'Rhetoric of the image', *Working Papers in Cultural Studies* 1, Birmingham. Also in *Image-music-text* (Glasgow: Fontana/ Collins). (Originally published in French 1964.)

Barthes, Roland (1972), *Mythologies* (London: Jonathan Cape). (Original French edition 1957.)

Barthes, Roland (1974), *S/Z* (New York: Hill and Wang). (Original French edition 1970.)

Barthes, Roland (1977), 'The death of the author', in *Image-music-text*, (Glasgow: Fontana/Collins). (Originally published in French 1968.)

Bauman, Zygmunt (1978), *Hermeneutics and Social Science: Approaches to Understanding* (London: Hutchinson).

Baxandall, Lee (ed.) (1972), *Radical Perspectives in the Arts* (Harmondsworth: Penguin).

Baxandall, Michael (1972), *Painting and Experience in Fifteenth Century Italy* (Oxford University Press).

Becker, Howard, S. (1974), 'Art as collective action', *American Sociological Review*, 39, 6.

Becker, Howard S. (1978), 'Arts and crafts', *American Journal of Sociology*, 83, 4.

Beechey, Veronica (1979), 'On patriarchy', *Feminist Review* 3.

Beharrell, Peter and Philo, Greg (eds) (1977), *Trade Unions and the Media* (London: Macmillan).

Bell, Daniel (1976), *The Cultural Contradictions of Capitalism* (New York: Basic Books).

Benjamin, Walter (1973a), *Understanding Brecht* (London: New Left Books). (Original German edition 1966.)

Benjamin, Walter (1973b), 'The author as producer', in Benjamin (1973a).

Benjamin, Walter (1973c), 'What is epic theatre?' (second version), in Benjamin (1973a).

Benjamin, Walter (1973d), 'The work of art in the age of mechanical reproduction', in *Illuminations* (London: Fontana). (Original German edition 1955.) Also in Curran *et al.* (1977).

Bennett, Tony (1979), *Formalism and Marxism* (London: Methuen).

Bennett, Tony (1981), 'Producing art: a review of *The Social Production of Art* by Janet Wolff', *Screen*, No. 39, Summer.

Benston, Margaret (1969), 'The political economy of women's liberation',

Monthly Review 21, 4. Also in Leslie B. Tanner, ed. *Voices from women's liberation* (New York: Signet, 1970).

Benton, Ted (1977), *Philosophical Foundations of the Three Sociologies* (London: Routledge & Kegan Paul).

Berger, John (1960), *Permanent Red: Essays in Seeing* (London: Methuen).

Berger, John (1969), *Art and Revolution: Ernst Neizvestny and the Rôle of the Artist in the USSR* (Harmondsworth: Penguin).

Berger, John (1972), *Ways of Seeing* (Harmondsworth: Penguin).

Berger, John (1978), 'In defence of art', *New Society*, 28 September.

Berger, Peter L. and Luckmann, Thomas (1967), *The Social Construction of Reality* (London: Allen Lane).

Berry, Ralph (1970), 'Patronage', in Jean Creedy (ed.) *The Social Context of Art* (London: Tavistock).

Betti, Emilio (1962), *Die Hermeneutik als allgemeine Methodik der Geisteswissenschaften* (Tübingen: J. C. B. Mohr).

Birchall, Ian (n.d.), 'The total Marx and the Marxist theory of literature', in Paul Walton and Stuart Hall (eds) *Situating Marx: Evaluations and Departures* (London: Human Context Books).

Blackburn, Robin (ed.) (1972), *Ideology in Social Science: Readings in Critical Social Theory* (London: Fontana/Collins).

Blaug, Mark (ed.) (1976), *The Economics of the Arts* (London: Martin Robertson).

Bloch, Ernst *et al.* (1977), *Aesthetics and Politics* (London: New Left Books). (Collection first published in translation.)

Bloomfield, Jon (ed.) (1977), *Class, Hegemony and Party* (London: Lawrence & Wishart).

Boime, Albert (1979), 'Les hommes d'affaires et les arts en France au 19e siècle', *Actes de la Recherche en Sciences Sociales* 28.

Bonham-Carter, Victor (1978), *Authors by Profession*, Volume 1 (London: The Society of Authors).

Borges, Jorge Luis (1970), 'Pierre Menard, author of the *Quixote*', in *Labyrinths* (Harmondsworth: Penguin). (Originally published in Spanish.)

Bottomore, Tom (1956), 'Some reflections on the sociology of knowledge', *British Journal of Sociology*, VII.

Bourdieu, Pierre (1971), 'Intellectual field and creative project', in Michael F. D. Young (ed.) *Knowledge and Control: New Directions for the Sociology of Education* (London: Collier-Macmillan).

Bourdieu, Pierre (1973), 'Cultural reproduction and social reproduction', in Richard Brown (ed.) *Knowledge, Education and Cultural Change* (London: Tavistock).

Bourdieu, Pierre and Darbel, Alain (1969), *L'amour de l'art: les musées d'art européens et leur public* (Paris: Editions de Minuit). (First edition 1966.)

Bourdieu, Pierre and Passeron, Jean-Claude (1977), *Reproduction in Education, Society and Culture* (London: Sage). (Original French edition 1970.)

Braden, Su (1978), *Artists and People* (London: Routledge & Kegan Paul).

Braverman, Harry (1974), *Labor and Monopoly Capital: the Degradation of Work in the Twentieth Century* (London: Monthly Review Press).

Brecht, Bertolt (1965), *The Messingkauf Dialogues* (London: Eyre Methuen). (Original German edition 1963.)

Brecht, Bertolt (1974), 'Against Georg Lukács', *New Left Review* 84. Also in Bloch *et al.* (1977).

Brewster, Ben (1976), 'The Soviet state, the Communist Party and the arts 1917–1936', *Red Letters* 3.

Brighton, Andrew (1974), 'Consensus painting and the Royal Academy since 1945', *Studio International*, November.

Brighton, Andrew (1977), 'Official art and the Tate Gallery', *Studio International* 1.

Bulmer, Martin (1975), *Working-class Images of Society* (London: Routledge & Kegan Paul).

Burgin, Victor (1976a), 'Modernism in the *work* of art', *20th Century Studies* 15/16.

Burgin, Victor (1976b), 'Photographic practice and art theory', in *Two Essays on Art Photography and Semiotics*, Robert Self (Publications). (Reprinted from *Studio International* 1975.)

Burniston, Steve and Weedon, Chris (1977), 'Ideology, subjectivity and the artistic text', *On ideology, Cultural Studies* 10, Birmingham.

Burns, Elizabeth and Tom (eds) (1973), *Sociology of Literature and Drama* (Harmondsworth: Penguin).

Burns, Rob (1978), 'Understanding Benjamin', *Red Letters* 7.

Burns, Tom (1977), *The BBC: Public Institution and Private World* (London: Macmillan).

Bystryn, Marcia (1978), 'Art galleries as gatekeepers: the case of the Abstract Expressionists', *Social Research* 45, 2.

Caplan, Patricia and Bujra, Janet M. (eds) (1978), *Women United, Women Divided: Cross-Cultural Perspectives on Female Solidarity* (London: Tavistock).

Caute, David (1974a), *Collisions: Essays and Reviews* (London: Quartet).

Caute, David (1974b), 'A portrait of the artist as midwife: Lucien Goldmann and the "transindividual subject"', in Caute (1974a). (Reprinted from *Times Literary Supplement*, November 1971.)

Caute, David (1974c), 'Author's theatre', in Caute (1974a).

Chambers, Iain (1974), 'Roland Barthes: structuralism/semiotics', *Cultural Studies* 6, Birmingham.

Chanan, Michael (1978), 'The Kodak shift: multinationals, electronics and mass culture', *Wedge* 2.

Christie, J. R. R. and Orton, Fred (1988), 'Writing on a text of the life', *Art History*, Vol. 11, No. 4, December.

Clark, T. J. (1973), *Image of the People: Gustave Courbet and the 1848 Revolution* (London: Thames and Hudson).

Clark, T. J. (1974), 'The conditions of artistic creation', *Times Literary Supplement*, May 24.

Clark, T. J. (1977a), 'Preliminary arguments: work of art and ideology', Papers presented to the Marxism and Art History Session of the College Art Association Meeting, Chicago 1976 (Los Angeles: Caucus for Marxism and Art).

Clark, T. J. (1977b), 'The bar at the Folies-Bergère', in Jacques Beauroy *et al.*
(eds) *Popular Culture in France: From the Old Régime to the Twentieth
Century* (California: Anma Libri).

Clarke, John (1991), *New Times and Old Enemies. Essays on Cultural Studies
in America* (London: HarperCollins).

Clayton, Sue and Curling, Jonathan (1979), 'On authorship', *Screen* 20, 1.

Cohen, Percy S. (1968), *Modern Social Theory*, (London: Heinemann).

Cohen, Ralph (ed.) (1974), *New Directions in Literary History* (London:
Routledge & Kegan Paul).

Cohen, Stan (1976), 'Youth culture: revolt into style, or style into revolt?',
Times Higher Education Supplement, 30 April.

Cooper, Sue *et al.* (eds) (1976), *Papers on Patriarchy* (Sussex: Women's
Publishing Collective).

Corrigan, Paul (1979), *Schooling the Smash Street Kids* (London: Macmillan).

Corrigan, Philip (1975), 'Dichotomy is contradiction: on "society" as con-
straint and construction. Remarks on the doctrine of the "two sociologies"',
Sociological Review 23, 2.

Corrigan, Philip and Sayer, Derek (1978), 'Hindess and Hirst: a critical
review', *Socialist Register* 1978.

Corrigan, Philip, Ramsay, Harvie and Sayer, Derek (1978), *Socialist Con-
struction and Marxist Theory: Bolshevism and its Critique* (London:
Macmillan).

Coser, Lewis A. (1965), *Men of Ideas: a Sociologist's View* (New York: Free
Press).

Coser, Lewis (ed.) (1978), *The Production of Culture, Social Research* 45, 2.

Coward, Rosalind (1977), 'Class, "culture" and the social formation', *Screen*
18, 1.

Coward, Rosalind and Ellis, John (1977), *Language and Materialism: De-
velopments in Semiology and the Theory of the Subject* (London: Routledge
& Kegan Paul).

Cowie, Elizabeth (1977), 'Women, representation and the image', *Screen
Education*, 23.

Craig, David, ed. (1975), *Marxists on Literature: an Anthology* (Harmonds-
worth: Penguin).

Crane, Diana (1987), *The Transformation of the Avant-Garde. The New York
Art World, 1940–1985* (Chicago and London: University of Chicago Press).

Culler, Jonathan (1975), *Structuralist Poetics: Structuralism, Linguistics and
the Study of Literature* (London: Routledge & Kegan Paul).

Curran, James *et al.* (eds) (1977), *Mass Communication and Society* (London:
Edward Arnold).

Cutler, Anthony, *et al.* (1977 and 1978), *Marx's 'Capital' and Capitalism
Today*, 2 Vols. (London: Routledge & Kegan Paul).

Dawe, Alan (1970), 'The two sociologies', *British Journal of Sociology* 21, 2.

Deepwell, Katy (1987), 'In defence of the indefensible: feminism, painting
and post-modernism', *Feminist Arts News*, 2, No. 4.

DeGeorge, Richard T. and DeGeorge, Fernande M. (eds) (1972), *The Struc-
turalists: from Marx to Lévi-Strauss* (New York: Anchor).

Deinhard, Hanna (1970), *Meaning and Expression: Toward a Sociology of Art*
(Boston: Beacon Press). (Original German edition 1967.)

Delphy, Christine (1977), *The Main Enemy: a Materialist Analysis of Women's Oppression* (London: Women's Research and Resources Centre).

Denisoff, R. Serge and Peterson, Richard A. (1972), *The Sounds of Social Change: Studies in Popular Culture* (Chicago: Rand McNally).

DiMaggio, Paul and Useem, Michael (1978a), 'Cultural democracy in a period of cultural expansion: the social composition of arts audiences in the United States', *Social Problems*, 26, 2.

DiMaggio, Paul and Useem, Michael (1978b), 'Cultural property and public policy: emerging tensions in government support for the arts', *Social Research*, 45, 2.

DiMaggio, Paul and Useem, Michael (1978c), 'Social class and arts consumption', *Theory and Society*, 5.

Dufrenne, Mikel (1953), *Phénoménologie de l'Expérience Esthétique*, 2 vols, Paris.

Dyer, Richard *et al.* (1973), 'Literature/society: mapping the field', *Cultural Studies* 4, Birmingham.

Eagleton, Terry (1970), *Exiles and Emigrés* (London: Chatto & Windus).

Eagleton, Terry (1975a), *Myths of Power: a Marxist Study of the Brontës* (London: Macmillan).

Eagleton, Terry (1975b), 'Review of Lucien Goldmann, *Towards a Sociology of the Novel*', *Literature & History* 2.

Eagleton, Terry (1976a), *Criticism and Ideology: a Study in Marxist Literary Theory* (London: New Left Books).

Eagleton, Terry (1976b), *Marxism and Literary Criticism* (London: Methuen).

Eagleton, Terry (1977), 'Marxist literary criticism', in Schiff (1977).

Eagleton, Terry (1978a), '"Aesthetics and Politics"', *New Left Review* 107.

Eagleton, Terry (1978b), 'Liberality and order: the criticism of John Bayley', *New Left Review* 110.

Eagleton, Terry (1978c), 'Tennyson: politics and sexuality in "The princess" and "In memoriam"', in Barker *et al.* (1978).

Easthope, Anthony (1977), 'Marx, Macherey and Greek art', *Red Letters* 6.

Eco, Umberto (1972), 'Towards a semiotic enquiry into the television message', *Cultural Studies* 3, Birmingham.

Eco, Umberto (1977), *A Theory of Semiotics* (London: Macmillan).

Egbert, Donald Drew (1970), *Social Radicalism and the Arts, Western Europe: a Cultural History from the French Revolution to 1968* (London: Duckworth).

Ehrmann, Jacques (ed.) (1967), *Literature and Revolution* (Boston: Beacon Press).

Ehrmann, Jacques (ed.) (1970), *Structuralism* (New York: Anchor). (First published by Yale French Studies in 1966.)

Eisenstein, Elizabeth L. (1969), 'The advent of printing and the problem of the Renaissance', *Past and Present*, 45.

Eisenstein, Elizabeth L. (1979), *The Printing Press as an Agent of Change: Communications and Cultural Transformations in Early-modern Europe* (Cambridge University Press).

Elias, Norbert (1971), 'Sociology of knowledge: new perspectives', *Sociology* 5, 2 and 3.

Elliott, Philip (1972), *The Making of a Television Series: a Case Study in the Sociology of Culture* (London: Constable).

Engels, Frederick (1976), Letter to Minna Kautsky, 1885, and letter to Margaret Harkness, 1888, in Marx and Engels (1976).

Enzensberger, Hans Magnus (1976), 'Constituents of a theory of the media', in *Raids and Reconstructions: Essays in Politics, Crime and Culture* (London: Pluto). Also in McQuail (1972). (Originally published in German 1970.)

Erlich, Victor (1955), *Russian Formalism: History – Doctrine* (The Hague: Mouton).

Escarpit, Robert (1958), *Sociologie de la Littérature* (Paris: Presses Universitaires de France).

Febvre, Lucien and Martin, Henri-Jean (1976), *The Coming of the Book: the Impact of Printing 1450–1800* (London: New Left Books). (Original French edition 1958.)

Fischer, Ernst (1963), *The Necessity of Art: a Marxist Approach* (Harmondsworth: Penguin). (Original German edition 1959.)

Fiske, John (1989), *Understanding Popular Culture* (London: Unwin Hyman).

Fitzpatrick, Sheila (1970), *The Commissariat of Enlightenment: Soviet Organisation of Education and the Arts Under Lunacharsky October 1917–1921* (Cambridge University Press).

Fokkema, D. W. and Kunne-Ibsch, Elrud (1977), *Theories of Literature in the Twentieth Century* (London: C. Hurst & Company).

Foucault, Michel (1970), *The Order of Things: an Archaeology of the Human Sciences* (London: Tavistock). (Original French edition 1966.)

Foucault, Michael (1979), 'What is an author?', *Screen* 20, 1. Also in *Language, Counter-memory, Practice* (Oxford: Blackwell, 1977). (Originally published in French 1969.)

Frankenberg, Ronald (1976), 'In the production of their lives, men . . . sex and gender in British community studies', in Barker and Allen (1976b).

Frankfurt Institute for Social Research (1973), *Aspects of Sociology* (London: Heinemann). (Original German edition 1956.)

Freud, Sigmund (1910), 'Leonardo da Vinci and a memory of his childhood', in *Standard Edition of the Complete Psychological Works*, Vol. XI (London: Hogarth Press).

Frith, Simon (1978), *The Sociology of Rock* (London: Constable).

Fromm, Erich (1961), *Marx's Concept of Man* (New York: Ungar).

Fuller, Mary (1978), 'Sex-rôle stereotyping and social science', in Jane Chetwynd and Oonagh Hartnett (eds.) *The Sex-Rôle System: Psychological and Sociological Perspectives* (London: Routledge & Kegan Paul).

Fuller, Peter (1978/9), 'Economy', *New Arts* 1, Hebden Bridge.

Fuller, Peter (1979), 'The failure of American painting', *Village Voice* August 27 and September 3.

Gadamer, Hans-Georg (1974–5), 'Hermeneutics and social science', *Cultural Hermeneutics*, 2.

Gadamer, Hans-Georg (1975), *Truth and Method* (London: Sheed & Ward). (Original German edition 1960.)

Gadamer, Hans-Georg (1976), *Philosophical Hermeneutics* (London: University of California Press). (Collection first published in translation.)

Gaines, Jane (1991), *Contested Culture. The Image, the Voice, and the Law* (Chapel Hill and London: University of North Carolina Press).

Gardiner, Jean (1975), 'Women's domestic labour', *New Left Review* 89.
Gardiner, Jean (1977), 'Women in the labour process and class structure', in Hunt (1977).
Gardner, Carl (ed.) (1979), *Media, Politics and Culture: a Socialist View* (London: Macmillan).
Garnham, N. (1977), 'Towards a political economy of culture', *New Universities Quarterly* 31, 3.
Garnham, Nicholas (1978), *Structures of Television* (London: British Film Institute Television Monograph).
Garnham, Nicholas (1979a), 'Contribution to a political economy of mass-communication', *Media, Culture and Society* 1, 2.
Garnham, Nicholas (1979b); 'Subjectivity, ideology, class and historical materialism', *Screen* 20, 1.
Garrard, Mary D. (1989), *Artemisia Gentileschi. The Image of the Female Hero in Italian Baroque Art* (Princeton: Princeton University Press).
Gear, Josephine (1977), *Masters or Servants? A Study of Selected English Painters and their Patrons of the Late Eighteenth and Early Nineteenth Centuries* (New York: Garland Publishing). (Ph.D. submitted to Department of Fine Arts, New York University, 1976.)
Geertz, Clifford (1975), *The Interpretation of Cultures* (London: Hutchinson).
Gidal, Peter (1979), 'The anti-narrative', *Screen*, 20, 2.
Giddens, Anthony (1976), *New Rules of Sociological Method* (London: Hutchinson).
Giddens, Anthony (1979), *Central Problems in Social Theory: Action, Structure and Contradiction in Social Analysis* (London: Macmillan).
Godelier, Maurice (1972), 'Structure and contradiction in *Capital*', in Blackburn (1972).
Goffman, Erving (1979), *Gender Advertisements* (London: Macmillan).
Golding, Peter and Elliott, Philip (1979), *Making the News* (London: Longman).
Golding, Peter and Murdock, Graham (1979), 'Ideology and the mass media: the question of determination', in Barrett *et al.* (1979).
Goldmann, Lucien (1964), *The Hidden God: a Study of Tragic Vision in the 'Pensées' of Pascal and the Tragedies of Racine* (London: Routledge & Kegan Paul). (Original French edition 1955.)
Goldmann, Lucien (1967a), 'Ideology and writing', *Times Literary Supplement*, 28 September.
Goldmann, Lucien (1967b), 'Sociology of literature: status and problems of method', *International Social Science Journal*, XIX, 4.
Goldmann, Lucien (1968), 'Criticism and dogmatism in literature', in David Cooper (ed.) *The Dialectics of Liberation* (Harmondsworth: Penguin).
Goldmann, Lucien (1969), *The Human Sciences and Philosophy* (London: Jonathan Cape). (Original French edition 1966.)
Goldmann, Lucien (1975), *Towards a Sociology of the Novel* (London: Tavistock). (Original French edition 1964).
Gombrich, E. H. (1963), 'Psycho-analysis and the history of art', in *Meditations on a Hobby Horse, and Other Essays on the Theory of Art* (London: Phaidon).

Goodwin, Andrew (1988), 'Sample and hold: pop music in the digital age of reproduction', *Critical Quarterly*, 30, 3.

Gouldner, Alvin W. (1976), *The Dialectic of Ideology and Technology: the Origins, Grammar and Future of Ideology* (London: Macmillan).

Gramsci, Antonio (1971), 'The intellectuals', in *Selections from the Prison Notebooks* (London: Lawrence & Wishart).

Greer, Germaine (1979), *The Obstacle Race: the Fortunes of Women Painters and their Work* (London: Secker & Warburg).

Griff, Mason (1970), 'The recruitment and socialization of artists', in Albrecht *et al.* (1970). (Originally published in *International Encyclopedia of the Social Sciences* V, 1968.)

Griffiths, Trevor (1976), 'Trevor and Bill: on putting politics before News at Ten', Interview, *The Leveller* 1.

Habermas, Jürgen (1966), 'Knowledge and interest', *Inquiry* 9. Also in Dorothy Emmet and Alasdair MacIntyre (eds) *Sociological Theory and Philosophical Analysis* (London: Macmillan, 1970).

Habermas, Jürgen (1970a), *Zur Logik der Sozialwissenschaften* (Frankfurt: Suhrkamp Verlag).

Habermas, Jürgen (1970b), 'Toward a theory of communicative competence', in Hans Peter Dreitzel (ed.) *Recent Sociology No. 2: Patterns of Communicative Behavior* (London: Collier-Macmillan).

Habermas, Jürgen (1974), *Theory and Practice* (London: Heinemann). (Collection first published in translation.)

Hadjinicolaou, Nicos (1978a), *Art History and Class Struggle* (London: Pluto). (Original French edition 1973.)

Hadjinicolaou, Nicos (1978b), 'Art history and the history of the appreciation of works of art', Proceedings of the Caucus for Marxism and Art at the College Art Association Convention, January 1978 (Los Angeles: Caucus for Marxism and Art).

Hadjinicolaou, Nicos (1979), '"La liberté guidant le peuple" de Delacroix devant son premier public", *Actes de la Recherche en Sciences Sociales*, 28.

Hall, Stuart (1974), 'The television discourse: encoding and decoding', *Education and Culture*, Review of the Council for Cultural Co-operation of the Council of Europe, No. 25.

Hall, Stuart (1977), 'Rethinking the "base-and-superstructure" metaphor', in Bloomfield (1977).

Hall, Stuart (1978), 'Some problems with the ideology/subject couplet', *Ideology & Consciousness* 3.

Hall, Stuart (n.d.), 'Encoding and decoding in the television discourse', Media Series SP No. 7, Centre for Contemporary Cultural Studies, Birmingham.

Hall, Stuart and Jefferson, Tony (eds) (1976), *Resistance Through Rituals: Youth Subculture in Post-War Britain* (London: Hutchinson). (Originally published as *Cultural Studies* 7/8, Birmingham.)

Hall, Stuart, Lumley, Bob and McLennan, Gregor (1977), 'Politics and ideology: Gramsci', *On Ideology, Cultural Studies* 10, Birmingham.

Hamilton, Roberta (1978), *The Liberation of Women: a Study of Patriarchy and Capitalism* (London: Allen & Unwin).

Hartman, Heidi I. (1979), 'The unhappy marriage of Marxism and feminism:

towards a more progressive union', *Capital & Class* 8.

Hartmann, Paul (1979), 'News and public perceptions of industrial relations,' *Media, Culture and Society* 1, 3.

Harvey, Mark (1972), 'Sociological theory: the production of a bourgeois ideology' in Pateman (1972).

Haskell, Francis (1963), *Patrons and Painters: Art and Society in Baroque Italy* (New York: Harper & Row).

Hauser, Arnold (1968), *The Social History of Art*, Vol. 2 (London: Routledge). (4 vols.) (First English edition 1951.)

Hawthorn, J. M. (1973), *Identity and Relationship: a Contribution to Marxist Theory of Literary Criticism* (London: Lawrence & Wishart).

Hawthorn, Jeremy (1977), 'Ideology, science and literature', *Marxism Today*, 21, 7.

Hawthorn, Jeremy (1979), 'Reply to Colin Mercer's "Culture and ideology in Gramsci"', *Red Letters* 9.

Heath, Stephen (1971), 'Towards textual semiotics', in Heath *et al.* (1971).

Heath, Stephen (1978), 'Difference', *Screen*, 19, 3.

Heath, Stephen (1979), 'Afterword' to Peter Gidal's 'The anti-narrative', *Screen* 20, 2.

Heath, Stephen, MacCabe, Colin and Prendergast, Christopher (eds) (1971), *Signs of the Times: Introductory Readings in Textual Semiotics*, Cambridge.

Hebdige, Dick (1979), *Subculture: the Meaning of Style* (London: Methuen).

Henriques, Julian and Sinha, Chris (1977), 'Language and revolution: Volosinov's *Marxism and the Philosophy of Language*', *Ideology & Consciousness* 1.

Hess, Hans (1976) 'Art and social function', *Marxism Today* 20, 8.

Hess, Thomas B. and Baker, Elizabeth C. (eds) (1973), *Art and Sexual Politics* (London: Collier-Macmillan).

Hibbin, Sally (ed.) (1978), *Politics, Ideology and the State* (London: Lawrence & Wishart).

Hill, Christopher (1979), *Milton and the English Revolution* (London: Faber & Faber).

Hindess, Barry and Hirst, Paul (1977), *Mode of Production and Social Formation* (London: Macmillan).

Hirsch Jr, E. D. (1967), *Validity in Interpretation* (London: Yale University Press).

Hirsch Jr, E. D. (1976), *The Aims of Interpretation* (London: University of Chicago Press).

Hirst, Paul (1977), 'Economic classes and politics', in Hunt (1977).

Hirst, Paul (1979), *On Law and Ideology* (London: Macmillan).

Hohendahl, Peter Uwe (1977), 'Introduction to reception aesthetics', *New German Critique*, 10.

Holderness, Graham (1977), 'Freedom and necessity: the poetry of Marxism', *Red Letters* 6.

Hospers, John (ed.) (1969), *Introductory Readings in Aesthetics* (London: Collier-Macmillan).

Hunt, Alan (1976), 'Ideology and its role in Marxist theory', *Red Letters* 2.

Hunt, Alan (ed.) (1977), *Class and Class Structure* (London: Lawrence & Wishart).

Hunt, Lynn (ed.) (1989), *The New Cultural History* (Berkeley: University of California Press).

Imrie, Malcolm (1977), '*Red Letters*: the academy in peril?', *Wedge* 1.

Ingarden, Roman (1931), *Das Literarische Kunstwerk*, Tübingen.

Ingarden, Roman (1972), 'Artistic and aesthetic values', in Osborne (1972).

Iser, Wolfgang (1974), 'The reading process: a phenomenological approach', in Cohen (1974).

Iser, Wolfgang (1978), *The Act of Reading: a Theory of Aesthetic Responses* (London: Routledge & Kegan Paul). (Original German edition 1976.)

Jacobus, Mary (ed.) (1979), *Women Writing and Writing About Women* (London: Croom Helm).

James, Louis (1974), *Fiction for the Working Man 1830–50* (Harmondsworth: Penguin). (First published 1963.)

James, Louis (1976), *Print and the People 1819–1851* (London: Allen Lane).

Jameson, Fredric (1971), *Marxism and Form: Twentieth-Century Dialectical Theories of Literature* (New Jersey: Princeton University Press).

Jameson, Fredric (1972), *The Prison-House of Language: a Critical Account of Structuralism and Russian Formalism* (New Jersey: Princeton).

Jameson, Fredric (1977a), 'Imaginary and symbolic in Lacan: Marxism, psychoanalytic criticism, and the problem of the subject', *Yale French Studies* 55/56.

Jameson, Fredric (1977b), 'Reflections in conclusion' in Bloch *et al.* (1977).

Jarvie, I. C. (1970), *Towards a Sociology of the Cinema* (London: Routledge & Kegan Paul).

Jauss, Hans Robert (1970a), *Literaturgeschichte als Provokation* (Frankfurt: Suhrkamp Verlag).

Jauss, Hans Robert (1970b), 'Literary history as a challenge to literary theory', *New Literary History*, II, 1. Also in Cohen (ed.) (1974).

Jauss, Hans Robert (1975), 'The idealist embarrassment: observations on Marxist aesthetics', *New Literary History*, VII, 1.

Johnston, Claire (1979), 'British film culture', in Gardner (1979).

Kamerman, Jack B. and Martorella, Rosanne (eds) (1983), *Performers and Performances: The Social Organization of Artistic Work* (New York: Praeger).

Kant, Immanuel (1952), *The Critique of Judgement* (Oxford University Press). (Original German edition 1790.)

Kaplan, Cora (1975), *Salt and Bitter and Good: Three Centuries of English and American Women Poets* (London: Paddington Press).

Kaplan, Cora (1976), 'Language and gender', in Cooper *et al.* (1976).

Katz, Elihu and Wedell, George (1978), *Broadcasting in the Third World: Promise and Performance* (London: Macmillan).

Kealy, Edward R. (1979), 'From craft to art: the case of sound mixers and popular music', *Sociology of Work and Occupations*, 6, 1.

Keat, Russel and Urry, John (1975), *Social Theory as Science* (London: Routledge & Kegan Paul).

Kettle, Arnold (1951–3), *An Introduction to the English Novel*, 2 vols. (London: Hutchinson).

Kettle, Arnold (1976), 'Literature and ideology', *Red Letters* 1.

Kristeva, Julia (1972), 'The ruin of a poetics', *20th Century Studies* 7/8:

Russian Formalism. (Originally published in French, as preface to Bakhtin (1970).)

Kristeva, Julia (1973), 'The semiotic activity', *Screen* 14, 1/2. (Reprinted from Heath *et al.* (1971).)

Kristeva, Julia (1975), 'The system and the speaking subject', in Thomas A. Sebeok (ed.) *The Tell-Tale Sign: a Survey of Semiotics* (Lisse/Netherlands: Peter de Ridder Press). (Originally published in *Times Literary Supplement*, 12 October 1973.)

Kuhn, Annette and Wolpe, AnnMarie (eds) (1978), *Feminism and Materialism* (London: Routledge & Kegan Paul).

Kuhn, Thomas S. (1962), *The Structure of Scientific Revolutions* (London: University of Chicago Press).

Lacan, Jacques (1968), 'The mirror-phase as formative of the function of the "I"', *New Left Review* 51. Also in Lacan (1977). (Originally published in French 1949.)

Lacan, Jacques (1970), 'The insistence of the letter in the unconscious', in Ehrmann (1970). Also in DeGeorge and DeGeorge (1972), and in Lacan (1977). (Originally published in French 1957.)

Lacan, Jacques (1972), 'Of structure as in inmixing of an otherness prerequisite to any subject whatever', in Macksey and Donato (1972).

Lacan, Jacques (1977), *Ecrits: a Selection* (London: Tavistock). (Selected from original French edition 1966.)

Lacan, Jacques (1979), *The Four Fundamental Concepts of Psycho-Analysis* (Harmondsworth: Penguin). (Original French edition 1973.)

Laclau, Ernesto and Mouffe, Chantal (1985), *Hegemony and Socialist Strategy, Towards a Radical Democratic Politics* (London: Verso).

Laing, Dave (1977), 'Brecht's theatre poems: an introduction', *Wedge* 1.

Laing, Dave (1978), *The Marxist Theory of Art* (Sussex: Harvester).

Lakatos, Imre and Musgrave, Alan (1970), *Criticism and the Growth of Knowledge* (Cambridge University Press).

Lane, Michael (1970), 'Books and their publishers', in Tunstall (1970).

Langer, Cassandra (1992), 'Mary Kelly's *Interim*', *Women's Art Journal*, Spring/Summer.

Larrain, Jorge (1979), *The Concept of Ideology* (London: Hutchinson).

Laurenson, D. F. (1969), 'A sociological study of authorship', *British Journal of Sociology*, XX, 3.

Laurenson, Diana (1972), 'The writer and society', in Laurenson and Swingewood (1972).

Laurenson, Diana (ed.) (1978), *The Sociology of Literature: Applied Studies*, Sociological Review Monograph 26, Keele.

Laurenson, Diana and Swingewood, Alan (1972), *The Sociology of Literature* (London: Paladin).

Layder, Derek (1979), 'Problems in accounting for the individual in Marxist-rationalist theoretical discourse', *British Journal of Sociology* XXX, 2.

Leavis, F. R. (1972), *The Great Tradition* (Harmondsworth: Penguin). (Originally published 1948.)

Leavis, Q. D. (1979), *Fiction and the Reading Public* (Harmondsworth: Penguin). (Originally published 1932.)

Lemaire, Anika (1977), *Jacques Lacan* (London: Routledge & Kegan Paul). (Original French edition 1970.)

Lenin, V. I. (1967a), *On Literature and Art* (Moscow: Progress). (Collection first published in translation.)

Lenin, V. I. (1967b), 'Party organisation and party literature', in Lenin (1967a). (Originally published in Russian 1905.)

Lewis, John (1972), 'The Althusser case', *Marxism Today*, 16, 1 and 2.

Lichtheim, George (1964), 'The concept of ideology', *History and Theory* 4.

Lichtheim, George (1970), *Lukács* (London: Fontana/Collins).

Lifshitz, Mikhail (1973), *The Philosophy of Art of Karl Marx* (London: Pluto). (Original Russian edition 1933.)

Littlejohn, Gary *et al.* (eds) (1978), *Power and the State* (London: Croom Helm).

Lovell, Terry (1978), 'Jane Austen and the gentry: a study in literature and ideology', in Laurenson (1978). Also in Barker *et al.* (1977).

Lucas, John (1979), 'A new social condensor', *Books & Issues*, 1, 1.

Lukács, Georg (1963), *The Meaning of Contemporary Realism* (London: Merlin). (Original German edition 1957.)

Lukács, Georg (1965), *Essays on Thomas Mann* (New York: Grosset & Dunlap). (Original German edition 1963.)

Lukács, Georg (1970), 'Narrate or describe?' in *Writer and Critic, and Other Essays* (London: Merlin). (Collection first published in translation.)

Lukács, Georg (1971), *History and Class Consciousness: Studies in Marxist Dialectics* (London: Merlin Press). (Original German edition 1923.)

Lukes, Steven (1977), 'Power and structure', in *Essays in Social Theory* (London: Macmillan).

Lunn, Eugene (1974), 'Marxism and art in the era of Stalin and Hitler: a comparison of Brecht Lukács', *New German Critique* 3.

MacCabe, Colin (1974), 'Realism and the cinema: notes on some Brechtian theses', *Screen* 15, 2.

MacCabe, Colin (1975), 'Presentation of "The imaginary signifier"', *Screen* 16, 2.

MacCabe, Colin (1976), 'Theory and film: principles of realism and pleasure', *Screen* 17, 3.

McDonnell, Kevin and Robins, Kevin (1978), 'The Althusserian smokescreen around Marxist cultural theory in Britain', Paper presented to British Sociological Association annual conference, Sussex. (Mimeo.) Another version, by Robins, appears as 'Althusserian Marxism and media studies: the case of *Screen*', in *Media, Culture and Society*, 1, 4, 1979.

McLennan, Gregor *et al.* (1977), 'Althusser's theory of ideology', *On Ideology, Cultural Studies* 10, Birmingham.

McQuail, Denis, (ed.) (1972), *Sociology of Mass Communications* (Harmondsworth: Penguin).

McRobbie, Angela and Garber, Jenny (1976), 'Girls and sub-cultures: an exploration', in Hall and Jefferson (1976).

Macherey, Pierre, (1977a), 'Interview', *Red Letters* 5.

Macherey, Pierre, (1977b), 'Problems of reflection', in Barker *et al.* (1977).

Macherey, Pierre (1978a), *A Theory of Literary Production* (London: Routledge & Kegan Paul). (Original French edition 1966.)

Macherey, Pierre (1978b), 'The image in the mirror', *Red Letters* 8.

Macksey, Richard and Donato, Eugenio (eds) (1972), *The Structuralist Controversy: the Languages of Criticism and the Sciences of Man* (London: Johns Hopkins Press). (First edition 1970.)

Madge, Charles H. and Weinberger, Barbara (1973), *Art Students Observed* (London: Faber).

Mann, Thomas (1955), *Death in Venice; Tristan; Tonio Kröger* (Harmondsworth: Penguin). (First German edition of *Tonio Kröger* 1903.)

Mannheim, Karl (1952), 'The problem of generations', in *Essays on the Sociology of Knowledge* (London: Routledge & Kegan Paul).

Mannheim, Karl (1960), *Ideology and Utopia: an Introduction to the Sociology of Knowledge* (London: Routledge & Kegan Paul). (Collection first published in translation 1936.)

Mao Tsetung (1971), 'Talks at the Yenan Forum on literature and art, May 1942', in *Selected Readings from the Works of Mao Tsetung* (Peking: Foreign Languages Press).

Marcuse, Herbert (1968), 'The affirmative character of culture', in *Negations: Essays in Critical Theory* (London: Allen Lane). (Collection first published in translation.)

Marcuse, Herbert (1969), *An Essay on Liberation* (Boston: Beacon Press).

Marcuse, Herbert (1972a), *Counterrevolution and Revolt* (Boston: Beacon Press).

Marcuse, Herbert (1972b), 'Art as a form of reality', *New Left Review* 74.

Marcuse, Herbert (1978), *The Aesthetic Dimension: Toward a Critique of Marxist Aesthetics* (Boston: Beacon Press).

Martorella, Rosanne (1977), 'The relationship between box office and repertoire: a case study of opera', *Sociological Quarterly* 18.

Marx, Karl (1970), *Capital: a Critique of Political Economy*, Vol. I (London: Lawrence & Wishart). (Original German edition 1867.)

Marx, Karl (1973), *Grundrisse* (Harmondsworth: Penguin). (Original German edition 1939.)

Marx, Karl and Engels, Frederick (1968), *Selected Works* (London: Lawrence & Wishart).

Marx, Karl and Engels, Frederick (1970), *The German Ideology* (London: Lawrence & Wishart). (Original German edition 1932.)

Marx, Karl and Engels, Frederick (1973), *On Literature and Art* (New York: International General). (Collection first published in translation.)

Marx, Karl and Engels, Frederick (1976), *On Literature and Art*, (Moscow: Progress). (Collection first published in translation.)

Marxist-Feminist Literature Collective (1978), 'Women's writing: *Jane Eyre, Shirley, Villette, Aurora Leigh*', *Ideology & Consciousness* 3. Also in Barker *et al.* (1978).

Mattelart, Armand (1979), *Multinational Corporations and the Control of Culture: the Ideological Apparatuses of Imperialism* (Sussex: Harvester). (Original French edition 1976.)

Mayakovsky, Vladimir (1970), *How are Verses Made?* (London: Jonathan Cape). (Original Russian edition 1926.)

Medvedev, P. N. [and] Bakhtin, M. M. (1978), *The Formal Method in Literary*

Scholarship: a Critical Introduction to Sociological Poetics (London: Johns Hopkins Press).

Mehlman, Jeffrey (ed.) (1972), *French Freud: Structural Studies in Psychoanalysis, Yale French Studies* 48.

Mehlman, Jeffrey (1977), *Revolution and Repetition: Marx/Hugo/Balzac* (London: University of California Press).

Mennell, Stephen (1976), *Cultural Policy in Towns: a Report on the Council of Europe's 'Experimental Study of Cultural Development in European Towns'* (Strasbourg: Council of Europe).

Mepham, John (1974), 'The theory of ideology in *Capital*', *Cultural Studies* 6, Birmingham.

Mercer, Colin (1978), 'Baudelaire and the city: 1848 and the inscription of hegemony', in Barker *et al.* (1978).

Mercer, Colin and Nawrat, Chris (1977), 'Culture, ideology and criticism: a review of recent developments', *Red Letters* 6.

Mészáros, István (1970), *Marx's Theory of Alienation* (London: Merlin).

Metz, Christian (1975), 'The imaginary signifier', *Screen* 16, 2.

Middleton, Chris (1974), 'Sexual inequality and stratification theory', in Parkin (1974).

Miel, Jan (1970), 'Jacques Lacan and the structure of the unconscious', in Ehrmann (1970).

Millman, Marcia and Kanter, Rosabeth Moss (eds) (1975), *Another Voice: Feminist Perspectives on Social Life and Social Science* (New York: Anchor).

Minihan, Janet (1977), *The Nationalization of Culture: the Development of State Subsidies to the Arts in Great Britain* (London: Hamish Hamilton).

Mitchell, Juliet (1975), *Psychoanalysis and Feminism* (Harmondsworth: Penguin).

Mitchell, Stanley (1974), 'From Shklovsky to Brecht: some preliminary remarks towards a history of the politicisation of Russian formalism', *Screen* 15, 2.

Mitchell, Stanley (1976), Letter, *Red Letters* 3.

Moers, Ellen (1977), *Literary Women* (New York: Anchor).

Molyneux, Maxine (1979), 'Beyond the domestic labour debate', *New Left Review*, 116.

Morgan, D. H. J. (1975), *Social Theory and the Family* (London: Routledge & Kegan Paul).

Morris, William (1973), 'The lesser arts', in *Political Writings*, edited by A. L. Morton (London: Lawrence & Wishart). (Originally published 1878.)

Mulvey, Laura (1978), 'Women and representation: a discussion', *Wedge* 2.

Murdock, Graham and Golding, Peter (1974), 'For a political economy of mass communications', *Socialist Register* 1973 (London: Merlin).

Musselwhite, David (1977), 'Towards a political aesthetics', in Barker *et al.* (1977).

Nelson, Cary (1991), 'Always already cultural studies: two conferences and a manifesto', *The Journal of the Midwest Modern Language Association*, Vol. 24, No. 1, Spring.

Neuburg, Victor E. (1977), *Popular Literature: a History and Guide* (Harmondsworth: Penguin).

Nicolaus, Martin (1972a), 'Sociology liberation movement', in Pateman (1972).
Nicolaus, Martin (1972b), 'The professional organization of sociology: a view from below', in Blackburn (1972).
Nochlin, Linda (1973), 'Why have there been no great women artists?', in Hess and Baker (1973).
Noyce, John (1979), 'Radicalism, literacy and a pint of coffee: working people's coffee houses in London 1830-c.1836', in *Working Class Organisations in Everyday Life, Studies in Labour History* No. 4, Brighton.
Ollman, Bertell (1971), *Alienation: Marx's Conception of Man in Capitalist Society* (Cambridge University Press).
O'Neill, John (ed.) (1973), *Modes of Individualism and Collectivism* (London: Heinemann).
Osborne, Harold (ed.) (1972), *Aesthetics* (London: Oxford University Press).
Outhwaite, William (1975), *Understanding Social Life: the Method called 'Verstehen'* (London: Allen & Unwin).
Owens, Craig (1983), 'The discourse of others: feminists and postmodernism', in Hal Foster (ed.), *The Anti-Aesthetic. Essays on Postmodern Culture* (Port Townsend, Washington: Bay Press).
Palmer, Bryan D. (1990), *Descent into Discourse. The Reification of Language and the Writing of Social History* (Philadelphia: Temple University Press).
Palmer, Richard E. (1969), *Hermeneutics: Interpretation Theory in Schleiermacher, Dilthey, Heidegger, and Gadamer* (Evanston: Northwestern University Press).
Parker, Roszika and Pollock, Griselda (1980), *Old Mistresses: Women, Art and Ideology*, forthcoming.
Parkin, Frank (1972), *Class Inequality and Political Order* (St Albans: Paladin).
Parkin, Frank (ed.) (1974), *The Social Analysis of Class Structure* (London: Tavistock).
Pateman, Trevor (ed.) (1972), *Counter Course: a Handbook for Course Criticism* (Harmondsworth: Penguin).
Pearson, Nicholas (1979) 'The Arts Council of Great Britain', *New Arts* 2, Hebden Bridge.
Pearson, Nicholas M. (1980), *The State and the Visual Arts: State Intervention in the Visual Arts Since 1760* (London: Macmillan, forthcoming).
Pelles, Geraldine (1963), *Art, Artists and Society: Origins of a Modern Dilemma. Painting in England and France 1750–1850* (Englewood Cliffs, N. J.: Prentice-Hall).
Petersen, Karen and Wilson, J. J. (1976), *Women Artists: Recognition and Reappraisal From the Early Middle Ages to the Twentieth Century* (New York: Harper & Row).
Peterson, Richard A. (1975), 'Single-industry firm to conglomerate synergistics: alternative strategies for selling insurance and country music', in James Blumstein and Benjamin Walter (eds) *Growing Metropolis: Aspects of Development in Nashville* (Nashville: Vanderbilt University Press).
Peterson, Richard A. (ed.) (1976), *The Production of Culture* (London: Sage).
Peterson, Richard A. (1978), 'The production of cultural change: the case of contemporary country music', *Social Research* 45, 2.
Peterson, Richard A. and Berger, David G. (1975), 'Cycles in symbol production: the case of popular music', *American Sociological Review* 40.

Pevsner, Nikolaus (1940), *Academies of Art Past and Present* (London: Cambridge University Press).

Pevsner, Nikolaus (1970), 'French and Dutch artists in the seventeenth century', in Albrecht *et al.* (1970).

Plamenatz, John (1971), *Ideology* (London: Macmillan).

Plekhanov, G. V. (1957), *Art and Social Life* (Moscow: Progress). (Originally published in Russian 1912–13.)

Pollock, Griselda (1977), 'What's wrong with images of women?', *Screen Education*, 24.

Pollock, Griselda (1979), 'Feminism, femininity and the Hayward Annual Exhibition 1978', *Feminist Review* 2.

Pollock, Griselda (1980), 'Artists, mythologies and media', *Screen*, 21, 1, forthcoming.

Pollock, Griselda (1988), 'Modernity and the spaces of femininity', in *Vision and Difference: Femininity, Feminism and Histories of Art* (London: Routledge).

Pollock, Griselda (1989), 'Agency and the avant-garde', *BLOCK*, 14.

Poster, Mark (1978), *Critical Theory of the Family* (London: Pluto).

Powell, Walter W. (1978), 'Publishers' decision-making: what criteria do they use in deciding which books to publish?', *Social Research* 45, 2.

Radnitzky, Gerard (1973), *Contemporary Schools of Metascience* (Chicago: Henry Regnery). (Original Swedish edition 1968.)

Radway, Janice A. (1984), *Reading the Romance, Women, Patriarchy, and Popular Literature* (Chapel Hill: University of North Carolina Press).

Ricoeur, Paul (1971), 'The model of the text: meaningful action considered as a text', *Social Research*, 38.

Ricoeur, Paul (1978a), *The Philosophy of Paul Ricoeur: an Anthology of his Work*, edited by Charles E. Reagan and David Stewart (Boston: Beacon Press).

Ricoeur, Paul (1978b), 'From existentialism to the philosophy of language', in Ricoeur (1978a). (Reprinted from *Criterion* 10, 1971.)

Ricoeur, Paul (1978c), 'Explanation and understanding', in Ricoeur (1978a).

Riley, Denise (1988), *'Am I That Name?' Feminism and the Category of 'Women' in History* (Minneapolis: University of Minnesota Press).

Roberts, John (1987), 'Postmodern television and the visual arts', *Screen*, Vol. 28, No. 2.

Rosaldo, Michelle Zimbalist and Lamphere, Louise (eds) (1974), *Woman, Culture, and Society* (California: Standford University Press).

Rosenberg, Harold (1970), *The Tradition of the New* (London: Paladin). (Originally published 1959.)

Rosenblum, Barbara (1978a), *Photographers at Work: a Sociology of Photographic Styles* (New York: Holmes & Meier).

Rosenblum, Barbara (1978b), 'Style as social process', *American Sociological Review* 43.

Routh, Jane (1977), 'A reputation made: Lucien Goldmann', in Routh and Wolff (1977).

Routh, Jane and Wolff, Janet (eds) (1977), *The Sociology of Literature: Theoretical Approaches*, Sociological Review Monograph 25, Keele.

Rühle Jürgen (1969), *Literature and Revolution: a Critical Study of the Writer and Communism in the Twentieth Century* (London: Pall Mall Press). (Original German edition 1960.)

Rutherford, Jonathan (ed.) (1990), *Identity: Community, Culture, Difference* (London: Lawrence & Wishart).

Sartre, Jean-Paul (1947), *Baudelaire* (Paris: Gallimard).

Sartre, Jean-Paul (1950), *What is Literature?* (London: Methuen). (Original French edition 1948.)

Sartre, Jean-Paul (1952), *Saint Genet, Comédien et Martyr* (Paris: Gallimard). (Vol. 1 of Jean Genet, *Oeuvres Complètes*, 4 vols, Gallimard, Paris, 1952–69.)

Sartre, Jean-Paul (1963), *The Problem of Method* (London: Methuen).

Sartre, Jean-Paul (1971–2), *L'Idiot de la Famille: Gustave Flaubert de 1821 à 1857*, 3 vols. (Paris: Gallimard).

Sayer, Derek (1979), *Marx's Method: Ideology, Science and Critique in 'Capital'* (Sussex: Harvester).

Schiff, Hilda (ed.) (1977), *Contemporary Approaches to English Studies* (London: Heinemann).

Schücking, L. L. (1944), *The Sociology of Literary Taste* (London: Routledge & Kegan Paul).

Schutz, Alfred (1951), 'Making music together: a study in social relationship', *Social Research* 18, 1. Also in *Collected Papers II: Studies in Social Theory* (The Hague: Nijhoff, 1964).

Seccombe, Wally (1974), 'The housewife and her labour under capitalism', *New Left Review* 83.

Selden, Ray (1977), 'Russian formalism and Marxism: an unconcluded dialogue', in Barker *et al.* (1977).

Shaw, Martin (1975), *Marxism and Social Science: the Roots of Social Knowledge* (London: Pluto).

Shepherd, John *et al.* (1977), *Whose music? A Sociology of Musical Languages* (London: Latimer).

Showalter, Elaine (1977), *A Literature of their Own: British Women Novelists from Brontë to Lessing* (Princeton, N.J.: Princeton University Press).

Silbermann, A. (1963), *The Sociology of Music* (London: Routledge & Kegan Paul). (Original German edition 1957.)

Silverman, David (1978), 'The blood of dreams: Robbe-Grillet's project', Paper presented to the British Sociological Association annual conference, Sussex (mimeo). (To be published as Chapter 12 of David Silverman and Brian Torode, *The Material Word: Some Theories of Language and its Limits* (London: Routledge and Kegan Paul, 1980, forthcoming).)

Skinner, Quentin (1969), 'Meaning and understanding in the history of ideas', *History and Theory*, VIII.

Skinner, Quentin (1972), '" Social meaning" and the explanation of social action', in Peter Laslett, W. G. Runciman and Quentin Skinner (eds) *Philosophy, Politics and Society*, 4th series (Oxford: Blackwell).

Skinner, Quentin (1975), 'Hermeneutics and the role of history', *New Literary History* VII, 1.

Small, Christopher (1977), *Music-Society-Education* (London: John Calder).

Smith, Dorothy E. (1974), 'Women's perspective as a radical critique of sociology', *Sociological Inquiry* 44, 1.

Sohn-Rethel, Alfred (1978), *Intellectual and Manual Labour: a Critique of Epistemology* (London: Macmillan). (Original German edition 1970.)

Spacks, Patricia Meyer (1976), *The Female Imagination* (New York: Avon Books).

Spence, Jo (1978/9), 'What do people do all day? Class and gender in images of women', *Screen Education*, 29.

Stedman Jones, Gareth (1983), *Languages of Class, Studies in English Working Class History 1832–1982* (Cambridge: Cambridge University Press).

Steiner, George (1969), 'Marxism and the literary critic', in *Language and Silence* (Harmondsworth: Penguin). Also in Burns and Burns (1973). Originally published 1958.)

Steiner, George (1975), *After Babel: Aspects of Language and Translation* (Oxford University Press).

Strauss, Anselm (1970), 'The art school and its students: a study and an interpretation', in Albrecht *et al.* (1970).

Sumner, Colin (1979), *Reading Ideologies: an Investigation into the Marxist Theory of Ideology and Law* (London: Academic Press).

Sutherland, J. A. (1976), *Victorian Novelists and Publishers* (Chicago: University of Chicago Press).

Sutherland, J. A. (1978), *Fiction and the Fiction Industry* (London: Athlone Press).

Swingewood, Alan (1972), 'The social theories of literature', in Laurenson and Swingewood (1972).

Swingewood, Alan (1975), *The Novel and Revolution* (London: Macmillan).

Tagg, John (1977), 'Marxism and art history', *Marxism Today*, 21, 6.

Tagg, John (1992), *Grounds of Dispute. Art History, Cultural Politics and the Discursive Field* (London: Macmillan).

Therborn, Göran (1971), 'Jürgen Habermas: a new eclecticism', *New Left Review* 67.

Therborn, Göran (1976), *Science, Class and Society: on the Formation of Sociology and Historical Materialism* (London: New Left Books).

Thom, Martin (1976), 'The unconscious structured like a language', *Economy & Society* 5, 4.

Thompson, Felix (1979), 'Notes on reading of avant-garde films – *Trapline, Syntax*', *Screen* 20, 2.

Thompson, Grahame (1979), 'Television as text: Open University "case-study"', in Barrett *et al.* (1979).

Tolson, Andrew (1973), 'Reading literature as culture', *Cultural Studies* 4, Birmingham.

Treble, Rosemary (1978), 'Introduction', *Great Victorian Pictures: their Paths to Fame* (Catalogue of Arts Council Exhibition).

Trevor-Roper, Hugh (1976), *Princes and Artists: Patronage and Ideology at Four Habsburg Courts 1517–1633* (New York: Harper & Row).

Trotsky, Leon (1960), *Literature and Revolution* (Ann Arbor: University of Michigan). (Original Russian edition 1924.)

Tuchman, Gaye (1975), 'Women and the creation of culture', in Millman and Kanter (1975).

Tudor, Andrew (1974), *Image and Influence: Studies in the Sociology of Film* (London: Allen & Unwin).

Tufts, Eleanor (1974), *Our Hidden Heritage: Five Centuries of Women Artists* (London: Paddington Press).

Tunstall, Jeremy (ed.) (1970), *Media Sociology* (London: Constable).

Tunstall, Jeremy (1977), *The Media are American: Anglo-American Media in the World* (London: Constable).

Urry, John and Wakeford, John (1973), *Power in Britain: Sociological Readings* (London: Heinemann).

Useem, Michael (1976), 'Government patronage of science and art in America', in Peterson (1976).

Vazquez, Adolfo Sanchez (1973), *Art and Society: Essays in Marxist Aesthetics* (London: Merlin Press). (Original Spanish edition 1965.)

Veeser, H. Aram (ed.) (1989), *The New Historicism* (New York and London: Routledge).

Vicinus, Martha (1974), *The Industrial Muse: a Study of Nineteenth Century British Working-Class Literature* (London: Croom-Helm).

Wallach, Alan and Duncan, Carol (1978), 'Ritual and ideology at the museum', Proceedings of the Caucus for Marxism and Art at the College Art Association Convention, January 1978 (Caucus for Marxism and Art, Los Angeles).

Watt, Ian (1972), *The Rise of the Novel: Studies in Defoe, Richardson and Fielding* (Harmondsworth: Penguin). (First edition 1957.)

Webb, R. K. (1955), *The British Working-Class Reader, 1790–1848* (London: Allen & Unwin).

Weber, Max (1958), *The Rational and Social Foundations of Music* (Southern Illinois University Press). (Original German edition 1921.)

Weimann, Robert (1977), *Structure and Society in Literary History: Studies in the History and Theory of Historical Criticism* (London: Lawrence & Wishart).

White, Harrison C. and White, Cynthia A. (1965), *Canvases and Careers: Institutional Change in the French Painting World* (New York: Wiley).

Widdowson, Peter *et al.* (1979), 'History and literary "value": *Adam Bede and Salem Chapel*', *Literature and History* 5, 1.

Williams, Gwyn A. (1976), *Goya and the Impossible Revolution* (London: Allen Lane).

Williams, Raymond (1965), *The Long Revolution* (Harmondsworth: Penguin). (First edition 1961.)

Williams, Raymond (1971), 'Literature and sociology: in memory of Lucien Goldmann', *New Left Review* 67.

Williams, Raymond (1973), 'Base and superstructure in Marxist cultural theory', *New Left Review* 82.

Williams, Raymond (1974), *Television: Technology and Cultural Form* (London: Fontana/Collins).

Williams, Raymond (1977a), *Marxism and Literature* (Oxford University Press).

Williams, Raymond (1977b), 'The paths and pitfalls of ideology as an ideology', *Times Higher Education Supplement*, 10 June.

Williams, Raymond (1977c), 'The rôle of the mass media: a discussion',

Wedge 1. Another version of this article, entitled 'The growth and rôle of the mass media', is reprinted in Gardner (1979).

Williams, Raymond (1978), 'Forms of English fiction in 1848', in Barker *et al.* (1978).

Williams, Raymond (1979a), *Politics and Letters* (London: New Left Books).

Williams, Raymond (1979b), 'Building a socialist culture', Interview in *The Leveller*, 24.

Willis, Paul E. (1977), *Learning to Labour: how Working Class Kids get Working Class Jobs* (Farnborough, Hants: Saxon House).

Willis, Paul E. (1978), *Profane Culture* (London: Routledge & Kegan Paul).

Wolff, Janet (1975a), *Hermeneutic Philosophy and the Sociology of Art* (London: Routledge & Kegan Paul).

Wolff, Janet (1975b), 'Hermeneutics and the critique of ideology', *Sociological Review*, 23, 4.

Wolff, Janet (1978), '"Bill Brand"', Trevor Griffiths and the debate about political theatre', *Red Letters* 8.

Wolff, Janet (1990), 'Postmodern theory and feminist art practice', in *Feminine Sentences. Essays on Women and Culture* (Cambridge: Polity Press).

Wolff, Janet (forthcoming), *Aesthetics and the Sociology of Art*, second edition (Ann Arbor: University of Michigan Press).

Wolff, Janet (manuscript), 'The death of the artist? Biography and authenticity in art history'.

Wolff, Janet *et al.* (1977), 'Problems of radical drama: the plays and productions of Trevor Griffiths', in Barker *et al.* (1977).

Wollen, Peter (1970), *Signs and Meaning in the Cinema* (London: Thames & Hudson). (First edition 1969.)

Wollheim, Richard (1968), *Art and its Objects: an Introduction to Aesthetics* (London: Harper & Row).

Wollheim, Richard (1970), 'Sociological explanation of the arts: some distinctions', in Albrecht *et al.* (1970).

Woolf, Virginia (1945), *A Room of One's Own* (Harmondsworth: Penguin). (First published 1928.)

Woolf, Virginia (1979), *Women and Writing*, edited and with an introduction by Michèle Barrett (London: The Women's Press).

Index